Robert Ryman

ROBERT STORR

Robert Ryman

TATE GALLERY, LONDON

THE MUSEUM OF MODERN ART, NEW YORK

Distributed by Harry N. Abrams, Inc., Publishers, New York

This book is published to accompany an exhibition organized jointly
by the Tate Gallery, London, and The Museum of Modern Art, New York

Tate Gallery, 17 February – 25 April 1993
Museo Nacional Centro de Arte Reina Sofia, Madrid, 25 May – 16 August 1993
The Museum of Modern Art, New York, 22 September 1993 – 4 January 1994
Museum of Modern Art, San Francisco, 3 February – 17 April 1994
Walker Art Center, Minneapolis, 23 July – 2 October 1994

Exhibition at the Tate Gallery shown with assistance from the
Horace W. Goldsmith Foundation and the Patrons of New Art

In the United States, this exhibition is supported in part
by grants from the Lannan Foundation and The Andy Warhol
Foundation for the Visual Arts, Inc.

Cover:
Untitled 1959, details (no.12)

Frontispiece:
Robert Ryman copyright © 1987 Timothy Greenfield-Sanders

Library of Congress Catalog Card Number 93–70197
ISBN 1 85437 114 2 Tate Gallery (paper)
ISBN 0 87070 566 0 The Museum of Modern Art (paper)
ISBN 0 8109 3771 9 Harry N. Abrams, Inc. (cloth)

Cloth edition distributed in the United States of America and Canada
in 1993 by Harry N. Abrams, Inc., New York. A Times Mirror Company

Published by Tate Gallery Publications,
Millbank, London SW1P 4RG
Designed by Caroline Johnston
Copyright © 1993 Tate Gallery
'Simple Gifts' copyright © 1993 Robert Storr
Certain illustrations are covered by claims to copyright
cited in the Photographic Credits on page 236
All rights reserved
Typeset in Monophoto Joanna by August Filmsetting, St Helens
Printed in Great Britain by Balding + Mansell plc, Wisbech, Cambridgeshire

PRINTED IN GREAT BRITAIN

Contents

Foreword

We are delighted that the Tate Gallery and The Museum of Modern Art have been able to collaborate over this major retrospective exhibition of Robert Ryman's work. We are pleased too that there will be a tour to three further places, Museo Nacional Centro de Arte Reina Sofia, Madrid, San Francisco Museum of Modern Art and the Walker Art Center, Minneapolis, thus introducing this important artist's work to a far wider audience.

A project of this importance depends on the generosity and efforts of many people. Our first and deepest thanks go to Robert Ryman who has been so helpful at every stage and who has, in addition, submitted himself to many hours of interviews providing much new material for this publication. We should also like to express our appreciation to his wife, Merrill Wagner, for her constant support. In addition there are numerous colleagues in various departments in both our institutions who have helped to realize the exhibition. We are most grateful to them all.

We should like also to thank many others who have helped us, especially Urs Raussmüller, Christel Sauer and Cornelia Wolf at the Hallen für neue Kunst, Schaffhausen, Bruce McAllister in London, Renato Danese at the Pace Gallery in New York, and Naomi Spector at the Greenwich Collection Ltd in New York.

For their preparation of the catalogue entries, we thank Catherine Kinley and Lynn Zelevansky. And special thanks go to Linda Norden who is working on the Ryman catalogue raisonné and who has generously shared the results of her research. We are so grateful to her and to those others named in the catalogue note.

The exhibition at the Tate Gallery is being mounted with assistance from the Horace W. Goldsmith Foundation and the Patrons of New Art. In the United States the exhibition is supported in part by grants from the Lannan Foundation and The Andy Warhol Foundation for the Visual Arts, Inc.

We are delighted, too, to have had this opportunity of working with our colleagues in the other museums to which the exhibition is touring, with Maria Corral and Marta Gonzalez at the Reina Sofia, Madrid, with John Lane and John Caldwell at San Francisco Museum of Modern Art, and with Kathy Halbreich and Gary Garrels at the Walker Art Center, Minneapolis. We would also like to thank Richard E. Oldenburg, Director of The Museum of Modern Art.

As always, we do rely heavily on the generosity of lenders whether public institutions or private collectors, and especially those museums with important collections of Ryman's work, the Stedelijk Museum, Amsterdam, the Crex Collection, Schaffhausen and the Solomon R. Guggenheim Museum, New York. We are particularly indebted to collectors on this occasion for agreeing to lend for such a long period so that their paintings could be seen not only in London and New York, but also in Madrid, San Francisco and Minneapolis.

Nicholas Serota, *Director, Tate Gallery, London*
Robert Storr, *Curator, Department of Painting and Sculpture, The Museum of Modern Art, New York*

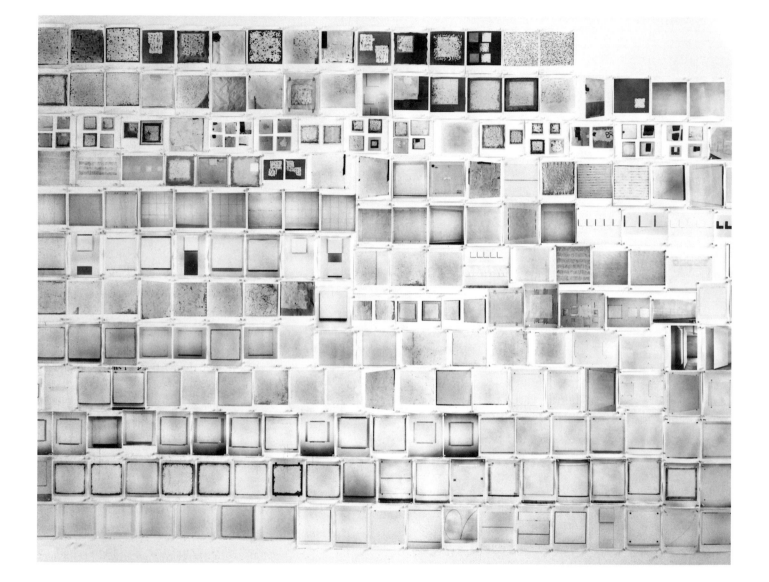

Simple Gifts

ROBERT STORR

I

On a wall of his downtown Manhattan studio, Robert Ryman has assembled a mural of eight by ten inch black and white photographs. It is a good place to begin, since it is to this wall that the artist himself regularly returns to add a new image or to consult old ones. The three hundred or more photographs that compose this still expanding grid document the majority of Ryman's production from his first acknowledged canvas of the 1950s to his most recent oil on fibreglass works. Pictures of paintings, their grey tonalities average out manifold subtleties at which the viewer must guess. The casual impulse to wonder what one is missing grows with the realization that those tantalizingly imperceptible nuances are the vital substance of the complex entity these glossies wanly describe. Colourless, and with textures in many cases only faintly recorded – or in others exaggerated by harsh studio lighting – the photographs give the overall impression of continuous variations on a basic square format, punctuated at intervals by anomalous vertical or horizontal rectangles, a scored circle, or strutted panels mounted at right angles to the wall. The forward flow of these variations is soon interrupted, however, by the viewer's scanning reflexes. Rather than reading the photo sequence left to right and first to last in descending rows, one's glance automatically skips forward and back, up, down and across, remarking on correlations and distinctions while remaining essentially indifferent to their chronological incidence, which, in reality, is approximate at best. Perceived in this manner the wall seems less like the autobiography of the painter and more like a genetic diagram showing how certain dominant and recessive traits have asserted themselves in a species of paintings whose apparent inbreeding has – counter to the rule – enriched rather than diminished the stock, and whose aberrant strains possess an unmistakable family resemblance as well as a singular beauty.

Academic habits of looking and of thought are undone by this hopscotch arrangement. The ensemble's essential cohesion relieves the anxious compulsion to impose provisional order on fragmentary evidence. And so, routine questions about technical or stylistic evolution lag harmlessly behind the darting eye and unburdened mind pleasurably awakened to signs of heterogeneity among these superficially homogeneous images. Chief among the rewards of surrendering to that fascination are the patience it teaches and the calm it instils. Meanwhile, the promise these pictured paintings hold of future change is manifest in their sheer proliferation. Rather than speculating on the 'next' based on the 'last', one is content to wait and see. To wait, that is, the better to see.

Intuitive at its source, Ryman's work respects one strict rule: what is present is what matters and what came before or after matters only insofar as it too makes a unique claim for our attention. Consequently, approaching Ryman's work in terms of his contribution to the advancement of the modernist cause is a mistake, just as it is a mistake to assign importance to given works in terms of their contribution to the painter's progress or to painting's progress. Although Ryman has added much

to our visual experience and is *de facto* a modern artist, his work hasn't progressed so much as elaborated itself under the artist's close watch. This occurs not by means of ever more complex rearrangements of his signature devices, but by an ever-increasing number of similarly concise statements about what paint can do. It is the growing sum of these statements that describe Ryman's widening field of possibility.

Returning to Ryman's photo log, let us change from the genetic model to a mathematical one, always bearing in mind that we are dealing in metaphor applied to the work of a visual artist and not with the laws of logic. Elementary geometry has it that there are two infinities: one is arrived at by perpetual addition, the other by perpetual division. In the modern era concepts of artistic development have been predicated on the first notion. Accordingly, prospects for aesthetic growth exist in an already historicized future and that future exists to the degree that the present can be added to in units of innovation and achievement comparable to those of the past. Failure to match or follow apace with these hope-giving precedents is taken as a sign of diminishing returns, if not imminent exhaustion. Hence, in our day, the incessant talk about the end of art, and the consequent restlessness of those who seek to postpone the event or distract themselves from its approach by a headlong chase after novelty. More hopeless still are those who renounce such a flight forward as futile, opting instead for angry inertia.

Yet contained within the simple mathematical paradigm of step by step linear development is another infinity represented by the unlimited subdivision of any given point on that line. This, in effect, is the hypothetical opportunity Ryman has seized. For him the imagination schedules its own necessities. Simple ideas may at any moment brake ideological or stylistic 'development' to make time for their realization. I say 'brake' not 'break', since the result is an alert pause rather than the dramatic aesthetic rupture of the kind celebrated in modernist myth. By contrast with conservative demurrals however, such pauses are active rather than passive. Wherever an artist like Ryman comes to a halt and fully focuses in this manner, art-making starts rather than ceases – even when 'less' appears to be definitively 'less'.

How many ways, Ryman has repeatedly and pragmatically asked, can one take the most reductive kind of painting – the apparently one-colour-one-format work – and generate from it a complete, indeed protean world. Each painting the artist makes is a partial reponse to that question. Viewed together, their photo surrogates articulate the larger answer. Like a series of open parentheses, each component image and those neighbouring it on the wall suggest other paintings as yet unmade. Indeed, photos of newer paintings that Ryman has tacked at the end of the line-up might just as well have been inserted at numerous intervals within it. Moreover, quite a few prints within the mural grid include several paintings on one eight by ten inch sheet, as if a single image equivalent to a single point in the sequence had been split up further to show the subset of variants that could be directly derived from it.

This said, the linear model is still restrictive. However, the operating principle of endless, non-redundant division holds true in a two-dimensional as well as a one-dimensional framework. Fractal calculations thus allow one to take a simple geometric shape and dilate its contour, revealing myriad previously imperceptible facets, like the magnified dots that trace a form on a video-screen matrix. Applied to geography, for example, an evenly unfolding coastline can be broken into increasingly smaller crenulations – from promontory to rock to grain of sand – thereby

creating a marvelously detailed and eccentric boundary around a previously well-defined territory. That in graphic terms is the procedure Ryman has followed as he has taken painting's measure. His studio mural – inwardly divisible and outwardly expanding – is a composite overview of the aesthetic continent he has discovered where many thought there was only a tiny desert island.

II

The biographical details customarily mentioned in Ryman's exhibition catalogues are so brief as to deter further inquiry. Seldom has less been said or generally known about the background of a major contemporary painter. In America, this is especially striking given the role – most often distracting and distorting – that personality cults have played in the estimation of comparably important artists. The paucity of information about Ryman's life reflects his desire to forestall such mythmaking and follows from his insistence that we focus exclusively on the painting *as* painting.[1] It also results from the fact that Ryman's life has been uneventful. Contrary to romantic tradition, art is far less conditioned by crisis than it is by hunches and chances pursued in cycles of activity whose duration and productivity reveal the artist's nature and will. For anyone making anything over the long haul or the short, getting from thought to thing is difficult and suspenseful enough. Decisiveness is character, and genuine creative drama unfolds in the order that artistic choices are made in service of one's intuitions and in the context of one's opportunities. In Ryman's case, the crucial decisions were forthright and firm from the outset but they were precipitated by a casual experiment.

Born in 1930, Ryman grew up in a middle-class family in Nashville, Tennessee. Such artistic leanings as he had were musical; his mother was an amateur pianist and as a boy Ryman took piano lessons but, as often happens at that age, he hated practising and soon quit. In high school, he started listening to late-night jazz broadcasts from New York, and on entering college in 1948 at the Tennessee Polytechnic Institute, he hung around the music department, made contacts among the students, and soon after took up the saxophone. Switching to the George Peabody College for Teachers because it had a better music school, he concentrated on jazz despite the lack of local opportunities to hear or play it. The Korean War interrupted his education. In anticipation of being drafted for active military service, Ryman joined the Army Reserve Band, in which he spent his tour of duty (1950–2) travelling around the South performing for parades, concerts, and service clubs.

Impatient after this frustrating two-year stint playing marches, pop standards and dance numbers, Ryman abandoned plans to finish college and headed straight for New York to study with a working jazz pianist about whom he had heard from Army friends. Arriving with $250, an untested ambition, and few expectations, Ryman greeted what he found with the unabashed enthusiasm of a Frank Capra provincial on the town. He certainly felt none of the bohemian alienation of 1950's legend. A string of temporary jobs – mail-room clerk on Wall Street, a stock

manager in a chinaware importing firm – earned him the minimum necessary to pay for food, lodging, music lessons, and the freedom to roam the city. By his own account, he saw 'everything, just like a tourist'.[2] 'Everything' included the major art museums, where, except for the odd landscape in a Nashville home, he encountered paintings for the first time.

Meanwhile, Ryman studied his instrument. Bebop was his model. 'They played something you never heard. It was different, it wasn't predictable. [But] I was never interested in free jazz. I was interested in jazz with a structure. It definitely had to have structure.'[3] With lessons once or twice a week and the occasional chance to sit in on sessions at small bars around town, Ryman's musical life was active but only intermittently so, and there was plenty of time left over. During this period he rented a single room in a brownstone facing the loading dock of Bloomingdale's department store, an out-of-the-way address he shared with a cellist and a movie orchestra clarinetist. Down the block on the corner of 60th Street and Lexington Avenue was an art-supply store.

> 'I went in,' he recalled 'and bought some oil paint and canvas board and some brushes – they didn't have acrylic at that time – and some turpentine. I was just seeing how the paint worked, and how the brushes worked. I was just using the paint, putting it on a canvas board, putting it on thinly with turpentine, and thicker to see what that was like, and trying to make something happen without any specific idea what I was painting.'[4]

The experience took immediate hold. And the nearly aimless decisions first taken by this drop-in have ever since prevailed, modified only by the acute concentration that he has directed to that amateur impulse to see 'how paint worked'. Those powers of concentration were paired with an equally stubborn determination to find out 'how' on his own. Aside from a few classes spent drawing from plaster casts, 'Very boring, they had numbers for different shadings', and a brief adult course at The Museum of Modern Art, 'it was a little drawing with the model, sometimes it was working with collage', Ryman shunned art schools.[5] Soon music took a back seat to painting while painting showed him what was basic to its practice. At this crucial point, Ryman's remedial aesthetic education was his employment, or rather the choice of the latter became a function of the former. Attracted by the possibility of spending all his days around art and by a late-morning starting time and short hours conducive to his painting schedule, Ryman signed on as a guard at The Museum of Modern Art in June 1953, a position he kept until May 1960.

As he had on his first excursions around New York, Ryman took everything in this new setting pretty much as it came. 'I was very open, I accepted anything I saw. I mean I didn't reject things, I looked at hundreds of painters. Of course the giants of the time I looked at more, Matisse, Cézanne, Picasso, all of that. But I guess I was very naive. I felt that anything in a museum was worthy of being there. So I looked at everything and got something from everything.'[6] In due course – and making good use of the restricted movement that is typical of a guard's routine – Ryman learned to schedule his looking. A week or so was spent concentrating on one major artist, then another week on the next. Cézanne enthralled him 'because you wouldn't know how he did it, the building up, the structure, the complicated composition'.[7] Matisse, whom he prized above all, fascinated him for almost the opposite reason; his outward simplicity and calm. The appearance of just such confident and unconflicted command of the medium was Matisse's stated ambi-

tion. Writing in 1948, Matisse had said, 'I have always tried to hide my own efforts and wanted my work to have the lightness and joyousness of Springtime, which never lets anyone suspect the labor it has cost'.[8] Ryman has voiced the same intention in much the same language. Matisse, he observed, 'could see more than others could see – he managed to get at problems and solve them in a very straightforward and clear way. Then there was his technical mastery, the way he could handle paint. When he worked, there was no fussing around. He was always direct. There was a sureness about what he did.'[9] Among classic modernists Ryman admired Monet and Klee as well – a Klee picture, for example, inspired him briefly to try mixing wax into his pigments. However, Ryman's far deeper involvement with and debt to Matisse has nothing to do with stylistic influence but instead represents his discovery of an art that is exquisitely controlled without awareness of the skill or authority behind that control detracting from the viewer's direct sensation. However stressful their genesis or seemingly careless their detail, Matisse's works in their final form appear wholly deliberate, economical, and fresh. These qualities, Ryman came to understand, were equally essential to non-figurative painting.

They were qualities Ryman simultaneously found in the work of Mark Rothko. Significantly, the period of Ryman's service at The Museum of Modern Art coincided with that institution's recognition of Rothko and his contemporaries. In those eight years, a series of exhibitions featured Abstract Expressionist works, and in 1958 and 1959 the museum assembled and toured *The New American Painting*, its influential survey of that tendency. During the same period, many of the first examples of New York School paintings entered the museum's holdings. Prior to 1950, only Jackson Pollock, Willem de Kooning, and Arshile Gorky had been properly represented. With the start of the decade, however, Abstract Expressionist works began to be actively acquired and regularly hung in the galleries dedicated to the permanent collection where Ryman was stationed most of the time, although at any moment only one or two works by a given artist would be on view. 'Number 10', 1950, the first Rothko Ryman ever saw, was accessioned by the museum in 1952 – the very year Ryman was hired – as was Franz Kline's 'Chief', 1950, de Kooning's 'Woman II', 1952, and Pollock's 'Full Fathom Five', 1947, and 'Number 12', 1949. By the time Ryman left The Museum of Modern Art one could see examples of work by virtually all the significant artists of that generation, along with additional works by artists already mentioned; Clyfford Still's 'Painting', 1951 was acquired in 1954, Philip Guston's 'Painting', 1954 entered the collection in 1956, Barnett Newman's 'Abraham', 1949 and a second Rothko, 'Red, Brown, and Black', 1958 followed in 1959.[10]

Among the Abstract Expressionists, Ryman respected de Kooning, whose way of putting a painting together impressed him, and Pollock, whose all-over drip painting he thought compellingly strange – though he was 'shocked' by Pollock's late reintroduction of imagery. Ryman also had high regard for Guston and his early light-suffused and oil-encrusted abstractions – 'They were very mysterious and simple and I really liked the way they were painted'[11] – and for Bradley Walker Tomlin, whose gracefully gestural canvases still enthrall him. Ryman's enthusiasm for Kline was even greater. 'Although I wasn't all that influenced by Kline, he was really important. In fact he's underrated . . . He was a magnificent painter.' 'He had the same quality that Matisse had, in a sense of that sureness. It was so open and compositionally so right.'[12] Rothko's comparable assurance and clarity struck a still deeper chord in Ryman. 'When I saw this Rothko, I thought "Wow, what is this? I don't know what's going on but I like it." What was radical with Rothko, of course,

was that there was no reference to any representational influence. There was color, there was form, there was structure, the surface, the light – the nakedness of it, just there. There weren't any paintings like that.'[13] Consistent with that frontal 'naked-ness', Rothko's work was unframed and painted around the edge of the stretcher, so that each canvas offered itself to view as an object rather than as a conventionally flat screen onto which the artist projected light or shapes or marks.

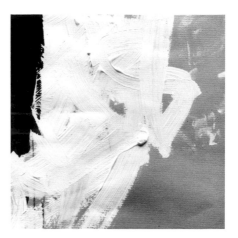

Of the purely abstract paintings and reliefs by Dutch, Russian or German artists of the early modernist period to which Ryman had ready access at The Museum of Modern Art, none, surprisingly, struck him in this way. Thus it was Rothko, not the Neo-Plasticists, the Constructivists or the Bauhaus artists who taught him that paintings must be treated as integrated physical entities. If the other 'field' painters of Rothko's generation have so far gone unmentioned that is because they played little part in Ryman's experience or thinking despite what would seem to be the aptness of their work to his development. Although Ad Reinhardt had been a ubiquitous and combative presence on the New York scene for years, his polemics did not engage Ryman, nor did the increasingly close-valued monochrome paint-ings Reinhardt showed at Betty Parsons Gallery – red or blue scales in 1952 and 1953, all-black scales after 1955. Incidentally, in 1960, when Ryman left the museum, no Reinhardt was yet in its collection. As for Barnett Newman, despite his occasional participation in group shows at Betty Parsons, his work was unseen in quantity between 1951 and 1959, the year of his career-launching one-person show at French & Co. and the year his 'Abraham', 1949 was acquired by the museum. Agnes Martin was likewise unrepresented in one-person shows until 1958, when she exhibited works still containing symbolic shapes akin to those of Adolph Gottlieb. Back from Paris in 1953, Ellsworth Kelly was more visible during Ryman's early New York years, exhibiting at Parsons in 1956, 1957 and 1960, as well as in the Whitney Museum of Art's *Young Americans* show of 1957, and The Museum of Modern Art's *Sixteen Americans* in the winter of 1959–60. Even so, Ryman doesn't recall being aware of Kelly until much later, and in any case Kelly's unin-flected, highly saturated chromatic compositions had nothing in common with Ryman's intensely brushed, tonally muted and largely white work – except for the very different type of connection to Matisse each separate body of work expressed.

Familiarity with the museum's collection and keeping abreast of current gallery exhibitions immersed Ryman in the painting culture of the New York School, but only to the extent that the work attracted his interest. He was entirely detached from its social and philosophical milieus. Unlike many young artists who hastened to hang out with the first-generation Abstract Expressionists, Ryman hung back. 'I was shy. I remember going to the Cedar Bar in the late '50s, and it was so depres-sing because I didn't know very many people in New York. I felt also that, well, I wasn't much of a painter. I couldn't really talk to painters because I felt I wasn't worthy . . . It was a very lonely time for me because I didn't know any painters who were working in an approach like mine.'[14] Nor did he concern himself with the critical discourse around Abstract Expressionism. Ryman thus ignored the existen-tialist literature of creation, even when his earliest paintings superficially resembled work to which such rationales were commonly applied. For example, the dramatic erasures characteristic of much Abstract Expressionist studio proce-dure were widely interpreted at the time as evidence of the imaginative struggle to discover or disengage an image. Although Ryman too was finding his form, he eschewed such readings and followed a different process. De Kooning, Guston and others alternately added and subtracted pigment from their canvases developing a

whole vocabulary of smears and scrape-backs, whereas Ryman added but did not visibly subtract paint. Furthermore, the similarities one can find between Kline's taut achromatic paintings and Ryman's small caseins and oils of 1957–9, in which dark blocks invade a white ground, also derive from fundamentally dissimilar painterly methods and motivations. Ryman's are the product of the fingers and hand, not the arm. Gesture, for him, served paint rather than the painter; painting was a question of application rather than of 'action'. Contrary, then, to Harold Rosenberg's view of abstraction as an exercise in the rhetoric of self-affirmation, Ryman understood it even at that formative stage as a problem of material syntax. What paint had to say was its own name, and it said it best in measured tones.

'It was never a rejection', Ryman maintains. 'Just a different approach to painting. Artists don't think in the way of rejecting something. Abstract Expressionism was fine. I mean they're very good paintings. You can't throw that away. I just couldn't see that much challenge in it. You want to discover something else ... a new way of seeing.'[15] Ryman's indifference to critical debate is characteristic of his autodidactic and unswerving visual course. While at the Modern, he made regular use of the library and after leaving the museum in 1960 worked for a time in the Art Division of the New York Public Library where he perused artists' files, periodicals and books – all in pursuit of new things to look at rather than verbal explanations for them.

Fundamentally, though, Ryman's education consisted of direct and protracted scrutiny of individual paintings. Such a formation is increasingly exceptional at a time when more and more young artists have been trained to see painting through photographic means, and consequently handle or mishandle the medium in anticipation of the same altered transmission of their output. This change in aesthetic context was the predicate for much of post-modern or appropriation-based art made in the 1980s. Yet, at this advanced stage in what the Marxist critic Walter Benjamin in the 1930s dubbed the 'Age of Mechanical Reproduction', Ryman's work distinguishes itself by being all but unreproducible. Hardly due to any ideological intent on the artist's part, this fact nevertheless puts the lie to theoretical canard that the individual handmade image has been superceded or can be entirely assimilated by photo-printing processes. Informed by his own habits of looking at classic modern art, Ryman insists example by example on contemporary painting's equal demand and capacity to exist and be experienced as an irreducibly physical and aesthetic presence.

The aesthetic constants that permitted his 'new way of seeing' were all evident in the artist's initial essays, though his full appreciation of them awaited two basic clarifications. From the outset, Ryman's painterly 'approach' – a favourite word – simply consisted of seeing how his tools and raw materials would behave. Each mark, area, or textural incident tested the characteristics of the pigment, the surface, the brush, or all three simultaneously. Cancellation of one result by another edited these experiments in favour of painterly gestures whose consistency, placement, or sheer unexpectedness merited lasting attention. Ryman's first experimental painting was predominantly green. Started around 1955 and worked on until 1959, the first painting he acknowledged as a fulfilled work (no. 1) is predominantly orange. Since then, white has replaced or largely obliterated all other hues.

Like everything about Ryman's procedure, this decision was arrived at through trial and error, yet like much else about his work, the constant – though wonderfully inconsistent – use of white has been misconstrued as the expression of a concept or symbol. Inevitably an artist's exclusive use of one colour leads to a discussion of modernism's reductionist penchant, and the most extreme statement of that tendency in its binary form. Critic Lucy Lippard, who was married to Ryman during the early 1960s, offers a useful summary of this dichotomy: 'The ultimate in monotone painting is the black or white canvas. As the two extremes, the so-called no-colors, white and black are associated with pure and impure, open and closed. The white painting is a "blank" canvas, where all is potential; the black painting has obviously been painted, but painted out, hidden, destroyed.'[16]

Ryman's recourse to white is paradoxical insofar as he has used it to conceal as well as to disclose his cumulative structure; that is, he has hidden his empirical painterly process under a blanket of white in order to reveal the painting as a whole. Instead of referring to or resolving into virgin blankness, therefore, white brought to light his work's intense surface activity and its underlying preparation. 'As I worked and developed the painting', he recalled, 'I found that I was eliminating a lot. I would put the color down, then paint over the color, trying to get down to a few crucial elements. It was like erasing something to put white over it.'[17] This he already had accomplished with sharply contrasting hues; white especially recommended itself by what it didn't do as well as what it did. 'The use of white in my paintings came about when I realized that it doesn't interfere. It's a neutral color that allows for a clarification of nuances in painting. It makes other aspects of painting visible that would not be so clear with the use of other colors.'[18]

A part of his palette from the beginning, black was disqualified as an overall substitute for or alternative to white by two factors. The first was what seemed to the artist to be its ineluctable symbolism: 'Black is difficult,' Ryman reasoned, 'there was no mysticism involved, nothing like that with white.'[19] The greater liability, though, was how black isolated the painted object from its setting. 'I did an etching once printed in black to see how it would be', he remembered. 'If you use black or any specific color, it makes the structure less visible. You see the color and it makes it look like a shape.'[20] This description nicely defines the difference between Ryman's concerns and those of Reinhardt – whose subtly hued 'monochrome' paintings flicker at the extreme limit of perceptibility – and Kelly, who fuses colour, area and shape into vibrant silhouettes. Reinhardt confined his attention to the darkened interior of the canvas which was set off by that darkness from the wall, while Kelly takes the space around the work very much into account by emphasizing the dynamic contrast between the ordinarily subdued exhibition space and his painted form's saturated colour and often startling axial pitch.

For his part, Ryman treats the immaculate walls of the modern gallery as a given against which he plays with a wide range of substances and tonalities. These have been given the generic name 'white', but each is as distinct from the others as they are from the decorator's white of their intended surroundings. The closer Ryman's choice comes to those utilitarian whites, the more exactly such distinctions are perceived. When he actually shifts from artists' materials to housepainters', the matched pigments correspondingly focus one's eye on nuances in his vehicle's density, method of application, and support. Like a Bedouin who can make out the subtlest shades of sand or an Inuit who can read with precision a comparably narrow spectrum of snow and ice, Ryman has catalogued white's actual variety, thus ironically demonstrating its latent non-neutrality when seen in relation to itself.

Fed up with inattentive observers who collapsed this set of differences into a word which they then used as a homogenizing description of all of his work, Ryman protested: 'I'm not really interested in white as a color, although I have at times used different whites for different purposes. Sometimes I used warm white because I wanted to have a warm absorbing light. At other times I've used colder white . . . it has do to with light – softness, hardness, reflection and movement – all these things'.[21] White is used instrumentally and for itself; but 'whiteness' as such is not the work's subject or essence. 'I don't think of myself as making white paintings. I make paintings; I'm a painter. White paint is my medium.'[22]

Stripped of metaphysical connotations, white's emphatic physical plainness registered whatever was done to or near it. Ryman's reliance on the square as his basic format followed the same principle of opting for maximum neutrality. Altogether only a handful of mature paintings are differently proportioned, and of these several, including the horizontal 'Zenith', 1974 (Solomon R. Guggenheim Museum, New York) and the verticals 'Credential' and 'Express', both 1985 (nos.73–4) are compositionally anchored by interior squares. The most direct benefit to Ryman was that the square obviated the problems of compositional balance entailed by the rectangle. Universally symmetrical, a square is inherently 'composed'.[23] As a corollary, the obvious focal point implied by the coordinates running between the four equal sides or four equal corners, allowed him to operate around and especially off the centre without ever requiring him to fix it in any explicit way. Lastly, the square's unassimilated artificiality was an asset: 'It possibly contrasts with the environment more. Rectangles always were more used in painting, particularly with pictures, because they were more familiar. Windows are rectangles, doors, most of what you see.'[24]

Ryman, of course, had no desire to mimic the format of and thereby trigger the visual responses called for by classical picture-window painting. Nor did he wish to court comparison with traditional easel painting, abstract or figurative. Consequently his paintings have, on the whole, been either quite small or quite large, with those in between setting themselves apart from conventional midsize painting by virtue of pronounced structural or formal characteristics of other kinds. The fact that his earliest paintings on paper or canvas generally measure between seven by seven inches and twelve by twelve inches has as much to do with their basic aesthetics as with the confinement of the living quarters in which they were executed. Throughout his career the artist has continued to work on this scale, regarding the results as commensurate in importance with paintings whose dimensions may reach upwards of twelve by twelve feet. Never have these small paintings been undertaken as mere warm-ups or sketches. Indeed, preparatory studies – when Ryman makes them, which is seldom – are usually the same size as the final version of the piece, and are not preserved after they have served their purpose.

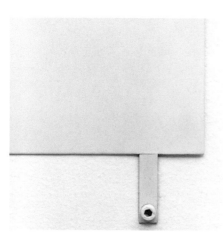

Factors other than the size of the support also help to decide a painting's scale. Brushes are spatial callipers of equal importance. A small surface may be covered by one or more broad strokes or a large surface by a flurry of small strokes: either of these procedural options, and all gradations that lie between them, lead to variously expanding or contracting results. The consistency of the paint also affects one's sense of scale by determining the flow of the brush, the load the brush can carry (hence the length it can travel), and the graphic and light-reflecting imprint the brush leaves behind. Everything that contributes to a painting's creation qualifies its aesthetic make-up, and is in turn qualified by the manner in which the

particular element or material is handled. 'Bigness' can occupy the tiniest piece of paper if painted in a 'big' – that is immediate, open – way. Conversely, a painting twice the height of a viewer can be intimate rather than overwhelming because of the closeness of inspection its luminous and tactilely modulated surface invites.

These considerations – type of white paint and its specific means of application, the square support and its exact disposition and scale – are Ryman's crucial variables. Few in number, they represent a potential range of permutations that it is easy to underestimate. All along, however, modern art has largely been a response to the limitations artists have willingly imposed upon themselves. A significant number of viewers unsympathetic to, or frankly puzzled by such strictures and resistant to argument by artistic precedent, will nevertheless ask: 'Why would anybody make a thing like *that?*' It is a fair question, and textbook answers are of little avail against the scepticism it bespeaks. Moreover, discounting such a response implies that only those inclined to aesthetic or art-historical discourse need concern themselves with the work – a conclusion directly at odds with the artist's own persistent belief that his paintings are there for the eye – tutored or untutored – to examine and enjoy. Turned around, however, the challenge '*What* could anybody make out of things like that?' invites a speculative involvement that may bring such viewers closer to Ryman's problem and so to his actual achievement. Instead of dismissing his endeavour as absurd, dubious members of the public are, like the artist, called upon to imagine what visual riches might be coaxed from such slender means, and how many ways it is possible to materially rephrase a working premise and so extract fresh meaning from it.

All this may strike some people as a woefully unsophisticated way of addressing such a refined body of work. Yet the truth is that Ryman's starting point was, by his own admission, 'naive'.[25] As a practising artist, Ryman remains the equal, not the all-knowing teacher, of the curious spectator. His extraordinary ability to renew his art depends not upon his outgrowing that naiveté but upon heeding its dictates. The near tautological principles he has offered in explanation of his work express that single-minded devotion to 'elementary' pursuits. 'I wanted to paint the paint, you might say', he once told an interviewer.[26] An early formal statement of this aesthetic published is scarcely more complicated, but resolute and sufficient. 'There is never a question of *what* to paint, but only how to paint. The *how* of painting has always been the image.'[27]

Ryman's paintings from the mid-1950s to the very early 1960s contain shapes that sometimes appear to have the status of pictorial images. In 'Untitled', 1957 (no.2) a contoured white area at the centre is attached to the top of the roughly cut canvas by a looping pencil incision in the casein paint, while the bottom margin is loosely hung, puckered by previously stapling and unprimed, prefiguring the artist's unstretched but for the most part 'all-over' canvases of the early 1960s. In 'Untitled', 1958 (no.7) a dark green wedge is fitted inside the semi-organic black mass that juts down from above into the painting's tiny field. Most spacious and spontaneous of the works into which such shapes intrude or occupy the pictorial middle ground is a work on paper named 'To Gertrud Mellon', 1958 (no.9) after the collector who purchased it from an exhibition of work by museum personnel that was assembled outside the Members' Dining Room of the Modern.

Abstract Expressionist figure/ground dynamics of this kind are relatively rare, even at this early stage of Ryman's development. In 'Untitled', 1957 (no.3) and related works on paper or cloth squares, these intrusive block or bars have seemingly retracted from the centre to the margins, indenting the edge of the picture plane at irregular intervals and visually pinning down the painting's surface like the tabs or brackets that come into play after 1976. In stretched canvases such as 'Untitled', 1959 (no.14), those painted notches wrap around the work's sides.

Ryman's use of letters and numbers serves much the same compositional purpose. These graphic embellishments he judged appropriate to his otherwise stripped-down vocabulary on the grounds that the inclusion of the artist's signature and the date of a work's completion are traditional in painting. From the point of view of strict modernist doctrine regarding the genre's 'essential' properties, this reasoning may border on the Jesuitical, but Ryman is more whimsical than that, and at the same time more direct in claiming poetic licence. Compared with Newman's rough scrawl on flat colour fields, or de Kooning's and Guston's stylish script over roiling painterly grounds, Ryman's signature is completely integrated into the structure of his compositions. In this way he neutralized its sign value, to the benefit of the linear variety it affords him and the impact its placement has on other aspects of the painting.

The size of the letters employed by Ryman changes dramatically. Sometimes minute, sometimes spidery but blown way beyond the proportions of normal handwriting, they are drawing motifs. Repetition renders these inscriptions even more abstract. When his patterned inscriptions copy or are copied by the repetition of other elements the result is like a musical riff traded back and forth between ensemble instruments. Numerals and letters thus bridge space, tapping out visual rhythms in response to each other. Chance has helped. The dates 1961 and 1991 have, for example, occasioned the symmetrical reiteration and mirroring of 1s, 6s and 9s. Meanwhile, both the artist's first and last names begin with R, and doubling the initial to RR soon led to tripling the same letter and then to the doubling and tripling of the final N of his surname and so to compressed letter blocks like RRYMANNN that stutter across a painting or down its edge. Or the artist may sign RYMAN twice at the lower right corner of the square, as in 'Untitled', 1959 (no.10) and then answer that beat with three hatched lines in the upper left. Or, as in 'Untitled', 1961 (see no.21), he may vertically align a dozen or so short chalky paint strokes and at the bottom inscribe his name three times in tiered succession as if this delicate flourish were the Corinthian capital of an inverted column, while without them the stubby stripes suggest a painterly prototype of Donald Judd's sculptural wall stacks. Or Ryman may simply fuse date and name into a single unit and run it out like a low entablature relief or, thinning his gesture and emphasizing the bowed Ns, Ms and Rs, transform it into a tracery arcade.

Such architectural analogies are, to be sure, the furthest thing from Ryman's thoughts.[28] Structural more than ornamental, these texts, like their bar and block counterparts, are points of reference within the painting field, hugging the perimeter in one instance, jutting upward or inward from an edge in others. Generally speaking, geometric coordinates in nonobjective painting have been straight, hard-edged and plumb. Even when a pencil matrix undergirds subsequent coats of paint, the spatial marking Ryman superimposes tends to float or optically shiver; signatures slide away from the rigid axis; the square or rectangular notches along the outside of the picture plane are unevenly ruled. Neither locked in like Mondrian's, or quasi-aerodynamic like Malevich's, Ryman's spatial constructs

accommodate a gentle flux akin to Guston's but with less ambivalence and greater objectivity.

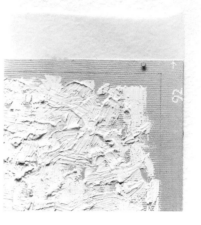

Much of Ryman's work of the 1950s and early 1960s is on paper. The paper often had a yellowish tint or soon acquired one, so that the gaps between shapes, or the broad unpainted areas, create a warm edge around the cooler whites, while the paper's smooth flatness contrasts with the pigment's impasto relief. In addition to the gallery-announcement card-stock he frequently recycled into his paintings, Ryman also purchased higher-quality Bristol board. Nearly all the papers he used had 'fast' untextured surfaces, on which even the slightest variation in the paint's viscosity or the painter's manual energy were evident. Around 1959, Ryman also made a series of collages, 'Untitled' (no.10) and 'Untitled' (no.11) among them. Combining cutout examples of his usual repertoire of marks and shapes with directly drawn lines and painted patches, Ryman was able to compose and recompose these spare designs without relying on the process of 'painting out' preliminary or tentative steps. The transparency of the sheets and scraps of tracing paper in these collages helps to conflate the various layers while emphasizing that all of them ultimately relate to the implicit plane behind them, which in their original, unframed state was the wall.

Ryman's early paintings on canvas make use of the soft tints of unpainted fabric in ways comparable to his exploitation of bare paper. Nearly half of the atypically vertical 'Untitled', 1958 (no.4) is given over to a zone of sized cotton duck on which the only 'painting' is a white signature and date. Just a small triangle of untouched canvas appears in 'Untitled', 1959 (no.12), framing an ochre RRYMAN that protrudes into the choppy white around it like a breakwater banked by a sandbar. In the latter example the light tan of the canvas picks up, but also diffuses, the intense glow of the letters, whereas in the former the blanched lettering and the honey-coloured cloth contrast sharply. In both instances the ageing of materials has altered the colour relationships between applied pigment and the natural pigmentation of the support, with the yellowing of the glue primers reinforcing the normal darkening of the cotton. Furthermore, oil paint itself changes over time, particularly the whites. And yet, these inevitable tonal or chromatic mutations are of only relative consequence. Even if we are no longer looking at these works in their original state, we are nevertheless viewing works that have evolved as coherent wholes and are defined by the chromatic and textural interplay between the assertive presence and the intentional absence of paint.

Inspired by Rothko's truly 'all-over' and all-around canvases, Ryman attended to every facet of his own paintings. Hence the untouched sides of a work were as much part of the whole as those sides that were whitened or accented by colour blocks and letters. To ensure that these easily overlooked passages are taken into account, Ryman has often photographed such works obliquely as well as head-on – for example 'Untitled', 1959 (no.14). Something of the opposite happens in another canvas of the same year, 'Untitled' (no.13), where Ryman sliced into a seam and peeled off a layer of canvas around the upper left-hand corner of the stretcher so that the sides came to meet the painting's face. The resulting ridge creates an aggressive element of relief on the edge where we expect the painting to stop. At a distance, the flayed and rolled-back fabric is easily mistaken for a lip of pigment, and the confusion is encouraged by the raw underpainting its retraction exposes. Fissures and cavities filled with saturated colour are common in his works of this period, providing unexpected depths and highlights to the vibrant white crusts. Far from being a monochrome painter, Ryman in the early years almost

always fleshed out his paintings over a polychrome bed of terracotta browns, blood reds, golden ochres, putty-like Naples yellows, deep leafy or acidic greens, and cool cobalt and cerulean blues. In short, Ryman's palette encompassed a modified but full spectrum of primaries. Before he ever introduced white, the artist laid in these rich hues, and in the finished painting their presence is papable even when they were not actually exposed. In paintings like 'Untitled', 1961 (no.19) a soft green and blue aura can thus be seen at the littoral where washed whites dissolve into buff linen. Peeking through the pitted white terrain of other paintings are flashes of brilliant colour. Where these substrata are most pronounced, the welts of underpainting exert pressure on their white mantle such that one begins to feel the temperature of the buried colour like a pulse or sinuous movement beneath the skin. Submerged colours seem to irradiate and be subsumed by the bleached plane that confronts the viewer, as if one were witnessing white light being created, as it theoretically is, by the chromatic fusion of the total spectrum.

During the period 1955–65, Ryman stuck to traditional media: casein which dries quickly and has finishes from semigloss to glossy; gouache, another water-based paint that dries matt; and oil, which dries slowly, can be applied either thinly like the others or very thickly, and depending on the quality of tube pigment and use of diluting additives leaves a dull or shiny skin. Thus, for example, 'Untitled', 1959 (no.14) is as crusty as 'Wedding Picture', 1961 (no.22) is lush, while the single pasty swipe of the palette knife in 'Untitled', 1961 (no.24) anticipates in its unrevised application the continuous pulled brushstrokes of a few years later. Altogether, the range of the effects achieved with these means is astonishing. Gritty or silky, feathery or caked, tight-woven or unravelling, each work's surface, like its particular cast of white and particular chromatic undertones or accents, is unique, and each is immensely sensuous. Even at their most arid, Ryman's surfaces recall his affinity to Matisse, who often applied his colours in brittle turpentine-thinned washes. Matisse's manner of letting these fragile surfaces breathe visually by leaving irregular blank gaps between filled-in areas and around lines, also found its way into Ryman's approach. Attention to his more severe works of the 1970s, at the expense of what came before, accounts in part for an all-too-pervasive belief that Ryman, preoccupied by intellectual concerns, has actively denied or is simply insensitive to aesthetic pleasures. One critic thus uncomprehendingly disparaged his later systematic paintings as the 'polemical' exercises of an artist bereft of 'natural' talent for the medium.[29] The austere, fine-tuned techniques of Ryman's mid-career all have their source, however, in this original unleashing of painterly instinct.

Around 1961, Ryman began to separate the various layers and physical properties combined in his early paintings. The greyish gesso washes that had been his first step after sealing the raw canvas became the space-defining clouds of tone already mentioned in reference to 'A painting of twelve strokes . . .', 1961 (no.21). There, white hyphens sit starkly on the pale ground, with the lack of transition between the unctuous paste and the desiccated gesso giving extra definition to each. All but obliterating the gesso in 'An all white painting . . .', 1961 (no.25), a smooth oil coat of a type new to his work lends the interior of a linen sheet the uniformity of a porcelain tile, while drawing attention to the hatch-like fringe of threads on its left, and the selvage on the right.

Of the smaller works of the early 1960s, many are on unstretched canvas. It is common for artists to do studies on canvas scraps, but in making these paintings – which are not studies – Ryman considered the weave, the part of the roll from

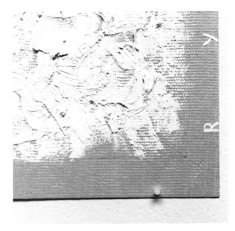

which they were cut and the various ways they responded to pigment as factors crucial to the paintings' composition. Like the frayed and sewn edges previously noted, the double red thread that often binds yard goods is an integral part of the work; a linear element made permissible to Ryman by being inherent in the materials. Coagulating paint buckles the surface of 'Untitled', 1962 (no.28) and irregularly contracts the fabric square, scalloping a bottom edge that is in effect overscored by the 'found drawing' of two red threads. The precedent for this 'stitching' in Ryman's work can be seen in 'Untitled', 1961 (no.20), an oil on Bristol board where the whole bottom and left margins have been dotted with paint squeezed directly from an uncapped tube. In the years 1960–2 Agnes Martin made a series of comparably sized paintings on linen in which she too left an unpainted canvas margin framed by thin bars or lines. Martin's works were stretched, however, and had an ethereal touch quite at odds with the bluntness of Ryman's; hers were intimations of a more perfect order, his the product of physical interactions. Extrapolating from these paintings, Ryman made a number of drawings of which 'Stretched Drawing', 1963 (no.31) is an example. For these he drew with different tools on various stretched textiles – in this case with charcoal on cotton – unstretched them on completing the drawing, and then restretched them until the original regularity of the matrix was restored, in the process demonstrating the pliability and graphic fragility of the 'rigid' image.

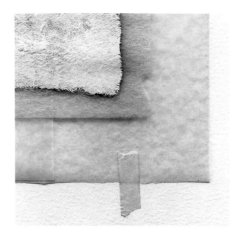

The last full burst of painterly colour in Ryman's work occurred in 1962. Beneath the buttery white curls that pattern the expanse of 'Untitled' (no.29) and 'Untitled' (no.30), and several similar works, are equally dense flourishes of saturated reds, blues, violets, ochres, and greens. For the next few years Ryman unsuccessfully attempted a series of gridded variants on this approach; he emerged at the end with a body of work cleansed of the decorative qualities that obscured his primary engagement with systematic mark-making, overtly structured formats and the tactilely as well as optically determined distribution of paint.

Before the present exhibition, few people in the United States have been in a position to directly evaluate Ryman's work, particularly its early stages. Europeans have fared better, as they generally have with minimalist and post-minimalist artists of his generation. Over the last twenty years, mid-career shows in Holland, England, France and Switzerland have offered more coherent summaries than anything attempted in the United States. As a result Ryman is far better known and more highly regarded abroad than in his own country.[30]

Another consequence of this obscurity is the tendency, even among some supporters, to downgrade Ryman's pre-1965 work.[31] The artist himself dates his maturity from mid-decade, recalling that 'one day in 1965 I felt I had just finished being a student. I felt very confident. I felt I knew exactly what to do. There was no hesitation, no more doubt.'[32] Little hesitancy can be found in his first decade's output, however. Instead, between 1955 and 1962 one witnesses a steady production distinguished by clear formal intent and spontaneous facture. Whatever doubts he entertained – and self-doubt is the occupational hazard of any serious artist, young or old – Ryman's hands-on confidence protected the work against them. Doubt was never the content of his work, as it was in the case of so many first and second generation Abstract Expressionists.

For Ryman the first half of the 1960s were difficult times for other reasons. 'Pop was certainly the dominant avant-garde movement in painting in the early '60s', he once explained. 'All other approaches to painting were not considered. In fact painting was pronounced dead several times. A lot of lesser-known Abstract Expressionists, and there were a lot, did not know what to do. It was a shock thing. Many painters stopped painting and turned to sculpture because they felt they could not continue with the approach that they had been involved with. They felt that sculpture offered more of a way to further the problems that they had been involved with. I felt very much alone in those years. Even though some people may have liked my painting, they didn't know what to do with it because it was not really the correct thing – it didn't fit. Sometimes I myself couldn't see where it was going to lead . . .'[33] In short, pictorial painting had returned as *the* vanguard style, temporarily shoving abstract art aside, and driving some of its practitioners to other media.

The supposed influence of Jasper Johns and Robert Rauschenberg on Ryman warrants mentioning at this point only because there was none. On more than one occasion, however, Rauschenberg's one-colour paintings of 1951–2 have been cited as precedents for Ryman's 'all white' paintings of several years later. This assumption is born of twenty-twenty critical hindsight and the curious belief that working artists are omniscient spectators of art history, as well as its busily preoccupied creators.[34] In general, though, artists only remember the things they can use at a given moment, and Ryman, who was then still a musician, does not recall having seen Rauschenberg's black and white paintings when they were shown at the Stable Gallery in 1953. (Since Ryman is absolutely candid about his early experience of and admiration for other artists there is no reason to suspect a selective memory in this or any other instance.) Furthermore, Rauschenberg's involvement with monochrome was brief and inspired by contingency: the black paintings represent an urban archeology of surfaces; the white paintings hold up an opaque mirror to human movement. Concepts projected onto canvas, Rauschenberg's experiments roughly correspond in that regard to the white 'achrome' reliefs Pietro Manzoni made between 1957 and 1963 and the monochrome paintings Yves Klein made between 1950 and 1962. Ryman was a stranger to all such neo-Dada stratagems.

Parallels between Ryman and Johns are more interesting, despite the lack of actual interchange. Once again, critical comparisons have tended to be superficially 'stylistic', and are usually based on a crude correlation between Ryman's generally even patching of strokes and Johns's patterned gesture, the latter being suggested as the 'obvious' source for the former. Although Johns's earliest distinctive work dates – like Ryman's – to 1955, Johns didn't begin to show until 1957, by which time Ryman's fundamental vocabulary had already expressed itself in small caseins and oils. Notably, the use of bold lettering as a key compositional element appears in Ryman's work of 1957, just a year after it does in Johns's 'Gray Alphabets' of 1956. Indeed the most striking thing about Ryman's and Johns's independent development is their congruence. Both men were born in 1930; both were raised in the South without significant youthful exposure to art; both settled in New York in the early 1950s, just as Abstract Expressionism became dominant. And, in that context, both looked at painting as something to be started from scratch. John's famous *ars poetica* 'Take an object, do something to it. Do something else to it' even accords in some basic ways with Ryman's step-by-step simplification of painterly craft and syntax. Johns's disciplined 'I do this, I do that' sensibility and Ryman's 'take a

brush, take a canvas, take some paint' procedure in turn anticipate an artistic sea change exemplified in the 1970s by Richard Serra's list of the sculptural verbs he intended to put into practice, 'to roll, to crease, to fold, to store'.[35] Between Ryman's attitudes and Johns's there is a crucial disparity, however. Whereas the 'something' Johns initially took was almost always an image or thing-as-image, the 'something' Ryman took was art supplies. And whereas Johns explored the discrepancy between symbol and expressive means, Ryman asserted the literal identity of sign and substance by insisting that the image of painting is first and finally paint itself.

The advent of minimal and conceptual art in the mid-1960s created the climate in which public attention finally fell on Ryman, but that circumstance has slanted perceptions of his work. Minimalism never existed as a cohesive or self-conscious movement. Nor did the alternative rubrics – Specific Objects, Primary Structures, ABC Art, Systems Art – adequately define the phenomenon.[36] Nevertheless, one can speak of a pervasive tendency toward formal severity, serial production, and impersonal facture if not outright manufacture. The primary spokespersons for this tendency – which for want of a better label I will still call minimalism – were theorist-practitioners Donald Judd, Robert Morris and Sol LeWitt. Insofar as all of them were object-makers, minimal art was widely perceived as more of a three-dimensional than two-dimensional project, even though LeWitt's frame of reference was primarily conceptual, hence fundamentally non-dimensional. By and large, its advocates had little use for painting. In 1965, Judd asserted that 'half or more of the best new work in the last few years has been neither painting nor sculpture',[37] thereby echoing Ryman's previously quoted description of the dilemma painters then confronted. Neither then nor since has Ryman's own work qualified for that 'in between' status, however: regardless of how much relief it has taken on or how much hardware has gone into it, paint and its light-responsive properties remain his principal concern.

Ryman's relation to LeWitt was personal and significant. Briefly Ryman's co-worker at the Modern and for many years a close friend, LeWitt shared his belief in the aesthetic promise of obvious propositions patiently articulated.[38] They parted company over the issue of realization. LeWitt was a literalist in his way, believing that aesthetic concepts needn't necessarily be rendered physically. Nor did he think it important whether the artist makes his or her own work or not.[39] Ryman was also a literalist, but in *his* way; painting, he affirmed, was a strictly visual art – everything you could see mattered, nothing you couldn't see did – and the artist was the sole agent for making the work 'visible'. Accordingly, he rejected the subcontracted fabrication that was essential to minimalist sculpture, as he did LeWitt's notion that ideas were machines for making art. These factors distinguish Ryman's aesthetic from minimalism and conceptualism, although changes in taste brought about by those currents opened his way professionally.[40]

This said, starting in 1965 Ryman did pursue avenues parallel to those travelled by the minimalists, whose hallmarks are routinized handwork, modular formats and programmatic production. The 'Winsor' paintings and related works of that year inaugurate that series of series. All the 'Winsor' works were executed on sized but unprimed linen with the same brand of cool white Winsor & Newton oil

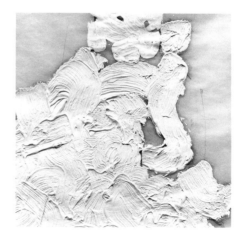

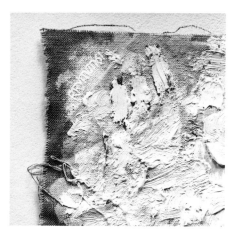

pigment that lends its name to the group. The smaller, untitled paintings are nine to ten inches square, and the larger titled ones run to six and a half feet square. The structure of each results from the tiered addition of strokes pulled across the canvas in close-knit formation, leaving the warm brown of the canvas showing between the strokes, all around the margin, and wherever the paint skips. The size of brush employed varies, affecting the compositional density of the painting relative to the dimensions of its support. The 'Winsors' properly speaking were done with a two inch brush that could cover about six to ten inches before running out (no. 36). Dragged over the dry tooth of the fabric, the opaque white paste leaves a crackling or clotted edge, horizontal bristle tracks, and at the point where it overlaps with the next stroke there is often a thick crest. In 'Mayco' and 'Twin' (both of 1966, nos. 37, 38), Ryman followed the same procedure but employed a specially made twelve-inch-wide brush and thinner, smoother paint, so that the grain would be finer, and the white could be pulled all the way from one side to the other without reloading. The painterly field that results is extraordinarily active. Tripping on the lateral striations in the paint as it would in much magnified fashion off the louvres of a white venetian blind, light vibrates at an intense pitch. Where the paint is thickest, it creates reflective hot-spots and small contrasting shadows; where strokes merge in a upright seam an irregular counter-rhythm to the horizontal segments catches the eye so that the whole painting becomes a sliding grid of stiff white ribbons laid end to end.

Inevitably, the 'Winsors' summon to mind Frank Stella's 'Black Paintings' of 1959. Still a guard at The Museum of Modern Art in 1960 when the Stellas were first shown in Dorothy Miller's *Sixteen Americans*, Ryman was impressed by what he saw. 'A lot of the artists didn't like those at all. They thought 'This is ridiculous'. I thought they were good paintings. I didn't really know exactly what it was about, but I thought they were okay.'[41] Ryman was already acutely conscious of making paint look as good on a painting as it did in the tube, to paraphrase Stella's clever dictum.[42] When, in 1965, Ryman adopted a method similar to the one employed in the 'Black Paintings', his choice of a different paint and application substantially altered the results. These differences in technical approach define their basic aesthetic differences as well. Stella is a theoretically inclined formalist; Ryman is a lyrical pragmatist. Ultimately, that is to say, all Stella's efforts come down to the pursuit of pictorial invention; for him painting as an art exists in order to make form. That is its reason for being, and each individual painting is a demonstration of the spatial equations that govern painting as a historical endeavour. For Ryman, the art of painting is a search for particulars and distinctions; accordingly, composition is an experiment in the behavior of the medium and its sensory effect. Working hypotheses serve the painter but painting defies analysis, and its existence is defined only by the *way of being* of unique examples. Stella tries to make things happen to painting; Ryman paints in order to see things happen. In his 'Black Paintings' – and the later aluminium and copper ones – Stella adumbrated a total conformity of gesture and frame. There are neither subtleties of stroke, nor loose ends that matter, and each work in the series is obviously different in design. In the 'Winsors' Ryman sets his course, monitors the distribution of pigment and discovers in the brush tracks the structure of concentration and the fascination of random incident. All the works in the series have the same design; each depends for its identity on minor shifts in painterly emphasis.

Asked to explain his works' meaning, Stella replied 'What you see is what you see'.[43] The 'Black Paintings' illustrate that principle.[44] Ryman too has said that

painting is about what you can see, but in his case the act of seeing connects the eye to instinct and affect as well as intellect. At this point, Ryman's other enthusiasms enter into play. Small paintings with the wide, waxing lozenges and large ones such as 'Mayco', 1966 (no.37) are clearly informed by Ryman's study of Rothko. Yet, rather than evoke a diffuse and remote 'sublime', the white lozenges in Ryman's paintings mate hypnotic luminosity and tactile immediacy. Standing in front of them, the viewer is at once drawn toward and held in place by the surface of these paintings. Their radiance releases the spirit, but the spirit remembers its body and takes satisfaction in the tangible proportions the body registers.

The 'Standards' of 1967 mark a breakthrough for Ryman on two fronts.[45] Departing from traditional canvas or paper supports for the first time, he painted them on metal, and their prompt exhibition at the Paul Bianchini Gallery in New York that year was his first one-person show.[46] Ryman eventually recognized that a group of paintings he had originally conceived of as related but individual works was in reality a single multi-part entity. The misfortune of selling none of the panels during the show resulted in the good fortune of keeping them together. In its definitive presentation, the 'Standards' comprises 13 four by four foot squares of cold rolled steel loosely swabbed with enamel. To arrive at this number, Ryman painted some fifty such sheets, pulling a three inch brushstroke across them after chemically rinsing and preparing the surface of each so that the slippery paint would adhere. When errors occurred or the sweep of the brush lost its intensity, he destroyed the painting and started again, a reminder that the appearance of ease Ryman strives for in the finished work is far from easily achieved. One might compare the challenge he faced to that of a cellist, who in order to sustain a note, must maintain a constant pressure on the strings of the instrument as the bow arm moves back and forth across the bridge. Intended modulations of tone result from relaxing or increasing that pressure, while inadvertent ones happen when a string binds or the arm slackens its control. To the untrained ear, the difference in sound may be negligible, just as to the casual eye the proper spreading of enamel might be hard to distinguish stroke by stroke, but, as with the flow of musical notes, the overall feel of paintings like the 'Standards' depends upon such fluctuating exactitude. Even when the enamel is opaque as it is in related works on aluminium like 'Untitled', 1973 (no.54), the one-time-only traversal of the surface is essential to the painting's effect.

The corrugated-paper paintings such as 'VII', 1969 (no.42) are similar in their fluidity to these works on metal, although the paint used was Enamelac, a flat white pigmented shellac primer, and the gesture was an oblique scumble extended in rows over several panels. Ryman then divided the five by five foot units into a number of subgroups composed of four, five, and seven parts displayed side by side. 'I preferred the odd numbers,' he said, 'because you had a panel in the center with an odd number. The wall became the center with the even-numbered panels.'[47] For the generation-defining *Anti-Illusion: Procedures/Materials* exhibition at the Whitney Museum in 1969, which presented his work along with that of Philip Glass, Eva Hesse, Bruce Nauman, Richard Serra, and Richard Tuttle among others, Ryman assembled nine of these panels into a square. This format was subsequently broken back down into its horizontal layout and never reconstituted. This square

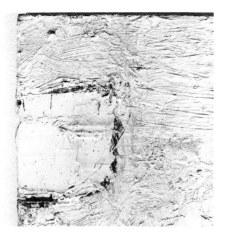

configuration had been used for another suite of multi-part paintings from the previous year, named the 'Classicos', after the brand of paper on which they were done. Typical of the series, 'Classico 5', 1968 (no.41) is made of a dozen vertically orientated sheets taped to the wall three high and four across to create a horizontal composite that is partially covered with a synthetic polymer white. Once the paint dried, the masking tape was removed, exposing small rectangles of untouched paper beneath. This semi-regular pattern of notches reinforces the grid of the abutted pieces of paper and the sectional painted shape. In 'Lugano', 1968 (no.40), named after another type of paper, these tape indentations have been omitted and the tilting white blocks spread loosely across the decal-edged matrix. The off-centre positioning of the blocks within the symmetrical framework of 'Lugano' and 'Classico 5', their oblong rectangularity (rare in Ryman's work), and the rain of white droplets that activates the blank bottom of the adjoined sheets (process traces rather than expressive drips), all give these works an internal expansiveness and painterliness unexpected in such a Spartan construct. The tendency of the semi-gloss white to flutter over and then drop back from the ivory surface of the paper gives these works an equally unexpected depth. As with most of Ryman's work, the recipe could not be more basic. Nor could the variations, involving the nonconcentric nesting of rectilinear elements and the wobble of brushed paint and laid-paper edges, be more vivid.

Rounding out this five-year period of work on regular formats are the 'Generals', 1970 (see no.43). Although each of the fifteen paintings has slightly different dimensions, the standard measurement that distinguishes one in the series from the next is among their common characteristics. Thus the largest of the 'Generals' is fifty-five by fifty-five inches, and they decrease in size by approximately half-inch decrements, with the smallest being forty-four by forty-four inches. All feature a bright white square surrounded by a margin of dull exposed primer the width of the unbevelled three-and-a-half-inch wooden bars over which the cotton canvas is stretched. Applying one unsanded coat of enamel over four sanded ones, Ryman created this evenly glossy surface in the middle, framed by the 'matte, dry, kind of dead-looking' finish he valued in the Enamelac underpainting.[48] Because they are fully symmetrical, although not precision-ruled, the paintings have neither tops nor bottoms, neither left nor right sides. Despite their minor differences in size, each canvas in the series may be substituted for any other – after their initial exhibition, the 'Generals' have never again been presented as a group – since every canvas incorporates the same contrast of absorbency and reflectiveness and thereby functions in the same efficient manner as a light-sensitive membrane.

Beginning with the 'Standard' series in 1967, Ryman increasingly experimented with unconventional materials in pursuit of new painting possibilities. Yet whenever the occasion has called for it, he has returned without hesitation to the more traditional means with which he started. The pigments and primer he has used include: oil, oil-based ink, Interference, casein, gouache, Lascaux acrylic, synthetic polymer, gesso, commercial enamels, baked ceramic enamels, Impervo enamel, Enamelac, Gripz, Elvacite, Varathane, vinyl acetate, rabbit skin glue, charcoal, chalk, india ink, ballpoint pen, graphite pencil, coloured pencil, pastel, and silverpoint. For surfaces and supports Ryman has employed newsprint, gauze,

Chemex coffee-filter paper, Kraft paper, wallpaper, wax paper, tracing paper, Bristol board, corrugated cardboard, handmade rag papers, cotton duck, linen, jute, Featherboard, plywood, hollow-core panels, polystyrene fabric, Plexiglas, Mylar, vinyl, Acrylivin, Gator board, fibreplate, fibreglass mesh, honeycomb fibreglass panels, Lumasite, anodized aluminium, cold-rolled steel, copper, plaster walls. For fasteners he has turned to masking tape, plastic straps, plastic stripping, staples, steel screws, steel flanges, steel pressure plates, aluminium tubing, and various other metal fixtures. The variety of substances and supports on this list is already astonishing and it is constantly being augmented.[49] Given the fact that for some artists materials have expressive connotations or intrinsic virtues associated with either tradition or novelty, it is worth noting the unbiased deliberateness with which Ryman may choose between canvas and an industrial product like Gator board, ballpoint or silverpoint, the latter the preferred graphic tool of Renaissance draftsmen like Leonardo da Vinci and Michelangelo.

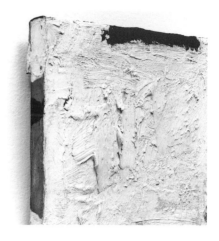

Every material, Ryman argues, has 'a built-in code', or way of 'reacting', that suits or ill-suits it for a given purpose.[50] The choice of media thus preconditions aesthetic opportunity. Criteria for selection vary from the quality of light that bounces off a specific pigment or surface, to that surface's chromatic cast, to its pliability or that of the substance covering it. Charcoal pencil's particulate residue was appropriate to the coarse and relatively stiff weave of cotton used for 'Stretched Drawing', 1963 (no.31), but ballpoint-pen ink was the only graphic medium sufficiently elastic to adhere well to the polyester cloth used for another group of such drawings. Ryman occasionally savours the unlikeliness of a particular mix of ingredients, once confessing that he had set about making one piece because 'it would allow me to have paper and plastic and metal, which is kind of a strange combination for painting'.[51] Exotic conjunctions of materials are rarely the trigger for ideas, however. Usually, expeditions to specialty hardware and paint stores come after a work has taken basic form in his imagination.

Just as the 'Classicos' were named after the stock on which they were painted, other works may have been called 'Allied' after a trucking firm, or 'Capitol' after a steel supplier, 'Acme' after a hardware store, or 'General' after a lumber company.[52] Ryman prefers the concept of 'naming' to that of 'titling', since the former designates a work while the latter suggests a theme. (Seldom has he named a piece unless it was leaving the studio for exhibition, which explains why so many early works are still listed as 'Untitled'.) Some critics have misconstrued the names the artist has assigned paintings as proof of his latent mysticism. But the lofty names he has sometimes used are those commerce has given itself and Ryman's appropriation of them is evidence of his humour rather than of his hermeticism. At very least, Ryman is having fun with the ambiguity. Otherwise, these 'found' names are in keeping with an earlier method of identifying works by description – for example, two 1961 pieces called 'A painting of twelve strokes measuring $11\frac{1}{4}'' \times 11\frac{1}{4}''$ and signed at the bottom right-hand corner' and 'An all white painting measuring $9\frac{1}{2}'' \times 10''$ and signed twice on the left side in umber' (nos.21, 25) – and a way of insisting on the work's objective origins.[53]

A technical innovator, Ryman is not an art technician in the sense expressed by the kinetic gimmickry of the 1960s or, on a higher plane, by the machine-age aesthetics of the Constructivists. Reluctant to place undue emphasis on studio practice, he nonetheless views the options presently confronting painters as challenges to artistic invention on a par with the introduction of oil pigments in the Renaissance. 'A painting begins with materials [and] there are many more mat-

erials now available to painters compared to earlier times. He has to make decisions as to how to use them and what combination of materials to use depending on what result he wants to achieve. People are taught to see painting in a certain way, a way that seems correct. Although there is a basis for this correctness through the history of painting, each painter's way of seeing is from a different perspective and it's part of the painter's task to expand our "way" of seeing to the furthest limits of the painter's vision.'[54]

Closer to the usual tenor of Ryman's thinking on the subject is this deadpan recollection of his introduction to the European scene.

> In the fall of 1968 I did my first show at Konrad Fischer's Gallery in Düsseldorf. The exhibition consisted of six paintings on paper panels, nine panels to a painting. The panels were crated and shipped to Düsseldorf. In the process of getting them through customs (in order to avoid the duty that is paid on the 'Art' arriving in the country) Konrad had listed them as 'paper' and not as paintings. But the customs official said 'But? It is expensive paper (handmade) so you will have to pay so much!' 'Yes, it is expensive paper,' Konrad said, 'but it has been used.' The customs official agreed that it had been used. So the paintings arrived designated as 'Used Paper.' 'Since that time I have wondered about the possibility of paintings being defined as 'Used Paint'. Then there would be 'Used Bronze,' 'Used Canvas, 'Used Steel,' 'Used Lead'.[55]

Such a matter-of-fact attitude wonderfully demystifies art's physical reality. Whether applied to a Matisse, a Rothko, a Ryman or a work by any other artist – thinking about a Velázquez as 'used paint' certainly sharpens the eye – the effect of this levelling adjective, far from diminishing mastery, makes the particular 'use' of paint by such artists all the more evidently individual and remarkable.

A primary impetus for Ryman's recourse to metal plates was the desire for a self-supporting surface that would hug the wall. Having dealt extensively with the edge of stretched canvas, Ryman turned his attention to steel and aluminium because they all but removed the edge and collapsed the visual distance between the painted plane of the work and the painted plane that was its architectural foil. An alternative solution to the same problem of a similar date can be found in works such as 'Adelphi', 1967 (no. 39). Enlarging upon his small unstretched canvases of 1961 and 1962, Ryman stapled unstretched canvas directly to the wall, and framed it with blue-chalked snap-lines, masking tape, and strips of wax paper. Pushing the issue a step further in the 'Prototypes' (1969–70), Ryman affixed thin plastic squares to the wall with four tape hinges and then painted the sheets with polymer white, allowing the stroke to spill over: when dry, the excess paint held the thin, almost weightless panel to the wall after the tape was torn away. Last in this procedural sequence were a number of impermanent paintings, one important group of which was made for Using Walls, an exhibition held at the Jewish Museum in New York in 1970. For that occasion, Ryman laid out a series of masking tape squares and applied his brush directly onto the wall inside them, making sure that it occasionally swiped the tape so as to activate the zone between the painted and unpainted wall, thus handling the once-virgin margin in these flat

walls much as he had the sides of stretched canvases. For the *Rooms P.S. 1* show of 1976, Ryman pasted similarly scaled sheets of paper onto the chipped wall of a classroom in an abandoned public school turned *Kunsthalle*. It is a rare instance of his working in a 'found space' rather than a conventional studio or gallery.

Two other important series belong to this period. One, completed in 1973, consists of five suites of enamel on copper paintings. Unlike with previous works on metal, Ryman left large areas of the copper exposed and oxidized them, bringing out a range of hues from an almost black green to a richly mottled orange. 'Untitled', 1973 (no.52) is an example of the first kind, 'Untitled', 1973 (no.53), the unique instance of the second. The bleeding bluish-green edges of the glassy white square accent the colour of the ground, an effect resulting from baking the ceramic enamel at high temperatures. These paintings mark the first time in Ryman's work that visual density is matched by a sensation of physical weight.

The last series of this period to be discussed was not the last to be undertaken. The 'Surface Veils' (1970–2) were painted at the midpoint between the 'Standards' and the later wall works. However, the importance of the series and the wide range of scale and different types of facture encompassed within it, account for speaking of them out of chronological order. But for their collective name, the 'Surface Veils' might be considered not a single group, but two related ones. The first consists of oils on fibreglass mesh (nos.44–8). A light, fragile material, the loose weave and amber hue of the fibreglass set off the white opacity of the paint, although the paint's tendency to seep into its porous support engenders delicate halftones and textural nuances. Many of the small 'Surface Veils' have taped wax-paper underpinnings to prevent the paint from soaking through the mesh and sticking to the wall. To that extent they resemble 'Adelphi' (no.39) with its waxed-paper margins. But in the small 'Surface Veils', the waxed paper is less a framing device around the painting than a pictorial ground. The most complex of these, 'Surface Veil', 1970 (no.46) and 'Surface Veil 4', 1970–1 (no.48), feature overlapping wax-paper sheets and pattern of a torn lengths of tape that create a sequence of vertical spaces and tabs which one reads in relation to the centred fibreglass sheet and the white squarish shape tipped inside it. In their artfully economical fusion of structure and image, these are among the most beautiful paintings Ryman has ever made and may be compared with his friend Eva Hesse's fibreglass, cheesecloth, and latex 'Contingent', 1969 (Australian National Gallery, Canberra). Compact without bulk or depth, tonally rich without spectral colour, each is a sandwich of superimposed and surrounding spaces, of the wafer-thin intervals separating their floating layers, and of lateral planar intervals between the edge of one surface and the next.

These smaller 'Surface Veils', photographed in clusters on Ryman's studio wall just after their creation, were apparently conceived less as a formal series than as a constellation of unique albeit closely related pieces. By contrast, the four large 'Surface Veils' numbered I to IV are a series. Identical in their twelve by twelve foot size, all are painted in oil with short washy strokes (nos.49–51). Circumscribing them are traces of a blue chalk line the artist laid down to guide him as he filled in the unstretched canvas, since they were stretched only after completion. The overlapping or unpainted seams that define these works' inner structure – like those that appear also in several smaller fibreglass versions – originate in the changes in direction of the artist's gesture, which coincided with the beginning and end of successive working sessions. Traditional fresco also depends upon covering large areas over extended periods, and such divisions are part of the process, but in fresco they are disguised by the continuity of the forms depicted. In Ryman's

'naked' painting, however, the joined sections are plain to see and, by positive default, they become the image. Unevenly contoured in 'Surface Veil I' and 'Surface Veil II', these oblique planes flicker at the edges and seem to adjust themselves against each other and the outlined square. In 'Surface Veil III', with the open suture running horizontally above the middle of the painting, Ryman's ranked vertical marks are more regular, conforming to an even bar pattern reprised in 'Surface Veil IV' (private collection), and further refined and modified in nonserial paintings of the same period such as 'Paragon', 1972 (Crex Collection, Hallen für neue Kunst, Schaffhausen), 'Empire', and 'Capitol', both 1973 (Soloman R. Guggenheim Museum, New York). Drawn forward by their delicately agitated surfaces, one easily loses one's bearings in the towering breadth of the large 'Surface Veils'. When one steps back to retrieve a sense of external physical scale, however, the internal textures dissolve into a vibrant haze, yet because of the paintings' squareness, this sense of atmospheric expanse never evokes the landscape sublime.[56]

Ryman was prompted to make the fibreglass 'Surface Veil' works by a desire to paint on something as close to nothing as possible, yet the tactility and tints of the filament only confirmed his conviction that nothing seen in a painting is extraneous to it. The artist's ambition just to 'paint the paint' has nonetheless persisted. 'I guess if you go into outer space,' he once speculated, 'and paint without gravity, it would be quite amazing. You could do something very clear without any problems – and it would stay together right where you put it, and it would float around and you could see the front and the back and the edge and it would all make sense.'[57] Beguiling as it is, this fantasy deviates from Ryman's belief that not only does everything that contributes to a painting count but that all that impinges on or responds to its presence matters too. In short, paint's inner space is always dependent on its 'outer space'. Otherwise a work of art reverts to being a mere coincidence of used materials instead of a full synthesis of them. Context does more than focus content, therefore; it completes it. 'My paintings don't really exist unless they're on the wall as a part of the wall, as a part of the room. Once it's down from the wall. the painting is not alive.'[58]

Ryman is quick to point out, however, that ' I don't do site-specific paintings. A painting can go different places – in fact I like that.'[59] Changes in location do not alter a painting's character so much as reveal it in all its essential detail and contingent attributes. (As do changes in vantage point. Whatever its depth or shallowness or relative size, a Ryman painting is meant be examined from every angle and every distance; no single view suffices to take it all in.) Only those situations that deprive a painting of sufficient illumination or breathing room hamper perception of its singular nature; in those cases it ceases to 'exist', in Ryman's terms, just as if it had been removed from the wall.

Usually Ryman's work has been hung in the standard type of modern gallery, known generically as the White Cube;[60] often he has had a hand in designing the installation.[61] During its brief history, the White Cube has come to stand for many things, and is consequently the topic of much debate as well as the target of angry denunciation.[62] To some it represents a longed-for detachment from the world, and to others is damnable for precisely that reason. Its appropriateness to a given kind of

work – and its inappropriateness as well – may, nevertheless, hinge on strictly practical artistic criteria. In Ryman's case certainly, the attraction of the White Cube inheres in a straightforward extension of the principle of perceptual neutrality embodied in the white paint he uses. Of course, the kind of uncluttered space his paintings require is the exception to normal urban congestion. But if such emptiness is a contemporary luxury, it is a luxury Ryman democratically invites the public at large to experience. And he intends that space to be as unencumbered by specific metaphysical or political connotations as it is devoid of competing physical objects. Ryman's work is therefore a conditioned but conscious response to a set of prevailing cultural conventions rather than an endorsement of any broad philosophical principle of exclusion. In another society with different conventions of design, the challenge of making paintings that fuse with and react to their environment would give rise to a very different set of answers. As intriguing a basis for speculation about new artistic forms as that prospect is, however, it is not a valid basis for second-guessing Ryman's achievement in respect to what he has always treated as a working rather than symbolic context.

Far from contriving images of an ideal alternative to reality, Ryman is dedicated to making paintings that insist upon their own reality and on that of everything in their proximity. Dissatisfied with the various labels applied to the painterly genre he practices – Absolute, Non-Objective, Concrete, Aniconic – Ryman prefers to call himself a Realist. Realism, as he understands it, is equally distinct from representational art and abstraction.[63] 'Representation is illusion', he argues. 'The aesthetic is an inward aesthetic, it's as if the painting had its own little world and you look into it.'[64] Although abstraction partially or wholly banishes figurative or spatial illusion, in Ryman's view it nonetheless preserves representation's flaw by confining itself to the 'little world' within the frame. In both instances, he observes, 'the frame is there for good reason, to focus the eye into the picture.'[65] By abandoning the frame, painting opens itself up to its environment. 'With Realism the aesthetic is an outward aesthetic instead of an inward aesthetic, since there's no picture, there's no story. And there's no myth. And there's no illusion, above all. So lines are real, the space is real, the surface is real, and there's interaction between the painting and the wall plane unlike abstraction and representation.'[66] The artist's preoccupation with that interaction has determined virtually everything he has done, and has distinguished him from all other painters of his day. Ryman's oeuvre is the large result of that devotion to his own version of what Cézanne called 'my little sensation'.

In his ingenious polemic against minimalism, 'Art and Objecthood', Michael Fried argued that formalist painting and sculpture were predicated on their self-containment – everything necessary to them was complete and constant within the painted or plastic framework – whereas minimalist art could only be experienced as a dramatic presence within an expanded and controlled context.[67] By approaching the conventions of theatre, such art, Fried thought, betrayed its intrinsic nature as painting or sculpture. Ryman in essence agrees with Fried on his limited premise – formalist painting does depend on its enclosure – but disagrees with his conclusion that by acknowledging its situation, painting becomes something else. Quite the opposite; that acknowledgment releases painting from its pictorial bonds – if one were to turn the theatrical analogy around, it eliminates the proscenium arch of the frame – and allows painting to assert its own identity more fully. Writing in 1970, Mel Bochner spelled out the broader implications of the issue, linking Ryman's concerns with those of process sculptors, environmental

artists, and practitioners of other post-minimalist modes:

> Perception is geared to cancel out whatever is stray or unaccountable. 'Background' is characterized negatively as unclear, indistinct, and non-articulated. But background is neither margin nor fringe nor the implicit. It is only through the function of its 'opening out' that we are presented with a passage to the density of things.[68]

Articulate objects in clearly articulated settings, Ryman's paintings open up their inner space and 'open out' the background, even as that widening field of vision focuses back on their internal syntax.

The fasteners Ryman regularly incorporated into his work from 1976 are emphatically real points of contact between painting figure and environmental ground. Resembling the masking tape patches which they supplanted, these fasteners are a bridge to the wall – and back. Among the first works where they appear is 'Embassy I', 1976 (no.55) in which their dual function becomes explicit: besides attaching the work to the wall, they serve as spatial punctuation marks. In 'Untitled Drawing', 1976 (no.56) and 'Untitled', 1976 (no.58) they are connected by fine pencil lines that also block out areas in their immediate vicinity.

Strictly speaking these pastels and pencil on Plexiglas works are drawings. The deciding factor, for Ryman, is the presence of line rather than the media employed or the support – paintings on paper are paintings not drawings. With the exception of dates and signatures, graphic line never appears in his painting; where one is necessary to a composition it is supplied by the edge of another element. For instance, the abutting of the two panels of 'Untitled', 1960 (no.15) creates the hard vertical approached by the soft border of the painted area to the left. Comparison of this work with Newman's 'Stations of the Cross' (1958–66) is instructive. Whether clean or fuzzy, Newman's 'zips' are placed on the blank field in such a way that one must deny their sometimes perfunctory physicality in order to gain access to the optical space they bracket. To that extent, delineation in Newman still involves residual illusion or at least the expectation that one will agree to see things as they were meant to be seen rather than as they are. Ambiguity of this kind is incompatible with Ryman's 'Realism'. Instead of suggesting anything or reinforcing any other element, lines only serve their own end, which is to travel from here to there. They may be rigid as in 'Catalyst III', 1985 (no.68) or flowing as in 'Spectrum II', 1984 (no.67) or 'Courier I', 1985 (no.69). In either case, line is not a spatial artifice for defining the areas that fall on its either side, but an actual space within which a given material has been channelled.

The fasteners vary greatly from painting to painting in their physical prominence and hence in their compositional importance. Although jet black, the bolted pressure plates in 'Embassy I', 1976 (no.55) scarcely extend beyond the edge of the Plexiglas square they pin to the wall. 'Phoenix', 1979 (no.60), however, features four one and a half inch metal tabs that move the attaching screws well away from the work's handkerchief-size central plane. Cut from the same plate as the rest of the painting, these strips are visibly of a piece with it, despite their eccentric elongation and the sharp line created where the thick layer of paint covering the central square stops short of them. 'Advance', 1976 (no.57), by contrast, is held in

place by clear plastic straps that pass over the front of the painted white square. As thin as these paintings and their attachments are, the sides are active elements; thus the bluish edges of the vinyl straps in 'Advance' are a significant colour element, just as the bluish aura in the ceramic whites are in Ryman's baked enamel on copper pieces, or the red, blue, and black tints of the Acrylivin support are in other works. Likewise, the wooden inlays, staining, or epoxy caulking that Ryman uses to edge his fibreglass panel works add important accents to the overall design, as does the shape of a screw's head in other flush-mounted works, or the natural tint of metal used to make them, or the kind of paint with which they have been retouched.

Large canvases of this period were frequently cantilevered off the wall with bent steel plates or segments of boxy aluminium tubing. Usually these were mitre-cut at the end, introducing four diagonal grace notes into otherwise consistently squared-off compositions. By 1982 the industrial look of Ryman's fixtures seem to have infused all other aspects of paintings such as 'Crown' 1982 (no.63), 'Access' (no.64) and 'Range' (no.65), both 1983. The bulk of these paintings, which may seem hard and overbuilt at first glance, is relieved by the shimmer of light on the brushed metal, the glaucous glow of the fibreglass and the waivering Enamelac ribbon that meanders along the squares' outer edges, occasionally turning unexpected corners inward or doubling back over itself. In these paintings, as throughout Ryman's work, extremes of strength and delicacy meet and are miraculously confounded. The thinnest of synthetic supports or most dilute of commercial paints may possess the greatest durability, and the heaviest of armatures scintillate with an evanescent light. Recognition of these latent properties contributes not only to our fascination with these paintings as formal inventions; it is also essential to their emotional aura, as is the unexpected and unifying discovery of any quality in its apparent opposite.

At the other extreme, Ryman's metal and fibreglass plate paintings of 1985–6 are mounted with ordinary screws. Among the most elegant of these is 'Administrator', 1985 (no.71), with its blank white interior, thin black border, and asymmetrically spaced screw heads and perforations. As in many other works, the pairing and spacing of these points suggest lines that might but do not actually run between them. The accumulation of those imaginary lines creates a template, or grid. In the mind's eye one can trace armatures over the blank interior of 'Administrator' and, by dropping this or that potential coordinate out of one's mental picture, endlessly restructure the painting. 'Administrator' and similar paintings are like a Mondrian whose internal spatial divisions have been erased leaving only a series of marginal ellipses marking opposite ends of the bars which formed that structure.

Sparest of all the group is 'Expander', 1985 (no.70). Brushed with a suave milky white, this comparatively small work is bolted down at four points about halfway between the middle of the plate and its quadrilateral rim. Previously peripheral or subordinate to the field of Ryman's paintings, in this case the fasteners have become the work's focal point. Despite initial appearances, however, the screws are not in line with the square's major coordinates, and the slight asymmetry of their positioning gently destabilizes this most stable of shapes. Pinioned and framed by the crisp black dots, the blank centre of 'Expander' holds, but also shifts its axis as it hovers in front of the contrasting white of the wall.

Around the same year as he made 'Expander', Ryman went back to vertical formats for virtually the first time since 1958. A group of these works were painted

on aluminium sheets screwed flush to the wall at top and bottom but folded at eye-level, or just above, in such a way as to project a plane several inches out toward the spectator. Like the thoroughly flat fibreglass variants such as 'Express', 1985 (no.74), these aluminium paintings were then horizontally divided into painted and unpainted zones of unequal proportion. Hans Hofmann's famous concept of 'push-pull' acquires literal dimension in these works. Tension between the various sections in works such as 'Credential', 1985 (no.73), does not result from the advancing and retreating of saturated hues, as it does in Hofmann's work, but from the optical competition between polished metal surfaces that 'whiten' and come forward under glancing electric light, and painted white surfaces that jut out, only to tuck back in, throwing a shadow that becomes integrated into the composition. If the dynamics of Ryman's pulsing blocks recall Hofmann, their aura inevitably conjures up Rothko as well, although Ryman has seemingly bleached, trimmed, and tacked down Rothko's amorphous clouds of colour. 'Charter', 1985 (Art Institute of Chicago), another of the cantilevered aluminium paintings, subsequently became the key unit in a series that collectively bears its name. Unique in Ryman's production, the 'Charters' were commissioned to be installed together in a single room. Even so they are not site-specific, nor, in the tradition of Mondrian's utopian 'Salon de Madame B ... Dresden', 1926 (Staatliche Kunstammlungen Dresden, Gemäldegalerie Neue Meister) were they conceived as elements for a holistic architectural environment. They are much closer to the suite of paintings Rothko made for the Seagram Building, now in the Tate Gallery, or the group housed in the Rothko Chapel in Houston. In both cases Rothko attempted a symphonic grandeur; Ryman's cycle is pure chamber music.

Not only has Ryman painted for and on walls, his paintings have on occasion simulated them. Commissioned in 1975 to make a work for a villa in Italy, Ryman discovered on arriving at the site, that moisture made it impossible to work with the existing plaster surface. The solution in 'Varese Wall' was to create a freestanding wooden partition safely removed from the seepage. In 1984, Ryman returned to the problem with 'Factor', a strutted rectangle floating parallel to and out from the gallery wall like a display panel. Two other works conceived along the same structural lines were attached at right angles to the wall like buttressed ledges. Hovering above the floor and supported at the front edge by two slender rods, 'Pace', 1984 (no.66) may strike one as an eccentric modern table. As always, the source of its unusual orientation is forthright speculation – 'I was thinking about how it would be if a painting was horizontal to the wall rather than being hung vertically, like most painting.'[69] Regardless of how closely his work may approach the status or appearance of another order of physical or aesthetic objects, it remains painting by virtue of the emphasis placed on the receptivity to light of the painted surface, which in this case is a cool glossy white that looks up at the viewer instead of the viewer looking ahead to it. The improbable rightness of this deft flipping of the paradigms of easel-painting is altogether typical of Ryman's work: the enjoyment it brings is that of something obvious in its strangeness and strange in its revealed obviousness.

Recently, Ryman's flat supports have given way to experiments with bowed surfaces. 'Journal', 1988 (no.76), for example, is composed of two sheets of pliant Lumasite joined in the middle by moulding and pushed away from the wall at the top and bottom by large steel clamps. The central plastic seam running between the two halves bears his signature with the letters widely spaced, so that at a distance they almost look like the separations between the knuckles of a hinge. In keeping

with Ryman's basic aesthetic, that seam is simultaneously a functional and a formal element, a point of contact with the wall and a line covered with lines. As one advances toward the painting and the inscription on it becomes legible, one is made aware of the pronounced concavity of the whole structure. Once again, though, the particular form of this relief is dictated not by an interest in novel constructs or materials but by the play of light and shade over its gently enfolding arcs. Like many of his other paintings, 'Journal' reminds one of Ryman's partial affinity with the 'light and space' aesthetic of Robert Irwin, but while Irwin's glimmering saucers flirt with optical illusion, Ryman's squares and rectangles stick to the readily verifiable facts of their making and presentation.

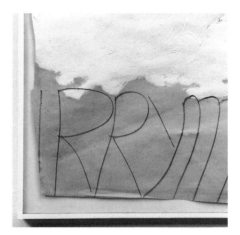

Periodically, Ryman will return to previous ways of doing things to explore the ramifications of a change in procedure. As is normal for a painter of his age and long experience, the reciprocal influence of old ideas on new, and new practices on old has increasingly developed as the crucial dialectic of his work. In Ryman's early work richly hued underpaintings were almost the rule, but they disappeared by the early 1960s and were only partially reintroduced later in the decade, for example in the 'Prototypes' (1969–70), where Ryman used a red primer on his support but then buried it beneath the white topcoat. After the mid-1970s, painted grounds became common again – and visible – but sombre colours replaced the deciduous greens, clay browns and mint blues of the past. Umber and earth-red primers were applied to stretched canvas works such as 'Monitor', 1978 (no.59) and to steel-plate paintings such as 'Archive', 1980 (no.61). In both cases, they accentuated the coolness of his whites, the tightness of their overall weave, and the graphic flare of individual strokes that strayed into corners or otherwise untouched areas.

Earlier compositional problems are also revisited in Ryman's recent work. 'Context', 1989 (Claude Berri, Paris) is to some extent a reinvestigation of the planar divisions found in the first 'Surface Veils', but the fault lines that separate painted areas in the latter have widened greatly in the former, as if the brushed sections were tectonic plates moving further and further apart. This sense of internal realignments is heightened by the asymmetrical placement of the painting's quite conspicuous wall mounts which gravitate to the left, while the painted areas open to the right. Poised on two wooden rectangles, 'Initial', 1989 (no.77) has the same off-side support as 'Context', but only at the bottom. At the top, the Gator board square is flattened against the wall without visible attachments, placing further emphasis on paired blocks, and the precarious imbalance of the whole. 'Locate', 1989 (no.78) meanwhile reincorporates the stacked bar strokes of Ryman's small unstretched painting of 1961 (no.21) into a larger, more heavily impasted, and now rigid ground.

Like the recent works such as 'Context', Ryman's 'Versions' series of sixteen works involves spaces that seem to be at once opening up and filling in. Unlike so much of the work of the mid-1980s, however, the 'Versions' are suffused by an overall softness that derives from their pliant fibreglass support, the putty and tin casts of their underpainting, the fineness of the brads that affix them, and the curled, translucent border of wax paper than runs along their upper edge. Big or small – they measure from ninety-one by eighty-four inches to thirteen by thirteen inches – Ryman has treated their painted surface the same way, applying a few cottony tufts of white in several places and then adding to them without any predetermined plan until they swell into shapeless masses that gather and meld as they grow out from their scattered nuclei (nos.79–81). Subtly modulated internally, and mounted with eye-teasing attentiveness to the transition between paint-

ing and wall, 'Versions VII', 1991 (no.79) revises long-familiar aspects of Ryman's work. Yet a new element, the undercoat of pearlescent paint called Interference, contributes not only to their softness but also to their spatial unpredictability. Under direct light, Interference takes on a metallic sheen: under indirect light it turns a pinkish tan. 'Versions XVI', 1992 (no.81), one of the small paintings prepared in this manner, shows the reasons for Ryman's interest, for as the light rakes it and the surface gradually undergoes this tonal change, the fibreglass sheet, although flat, appears to curve inward like 'Journal' (no.76) and the woolly whites spread over it start to lift from their optically warping ground. One of several paintings made this way, and one of a great many more paintings made over the nearly forty years of Ryman's artistic life to date, this work cannot be said to summarize his career. As punctuation to this exhibition and essay, it should therefore be read as a comma or ellipsis rather than a full stop. Still, it embodies the inherent characteristics of every other Ryman painting: no-nonsense intelligence, an appreciation of useful tradition, and a self-refreshing spirit of 'what if'. These essential qualities along with a rare and diffident integrity inform one of the most sustained bodies of work in modern painting – and, for the viewer, one of the most sustaining as well.

III

Writing about Ryman is notoriously difficult. While words may point out formal and painterly subtleties, they can never fully render them. Transcription is not translation. Yet, making such distinctions is of paramount importance in discussing Ryman, given that generalizations about his painting – including those that are truly apt – tend to blur the details that express its life-force, making his work sound like an aesthetic exercise rather than the imaginative pursuit that it is. The first step toward appreciating Ryman, then, is to acknowledge the limits of the language at our disposal and so recognize painting's essential independence from what can be said about it.

The second is to listen carefully to the artist. For that reason Ryman's statements have played a large part in this account of his work. If I have taken him at his word, it is because his word is good, and, in its modest but insistent way, cautionary. In this, I am not unmindful of the dangers of the intentional fallacy; that is, the misleading identification of an artist's conscious aim with his actual accomplishment. I am more wary, however, of a series of assumptions basic to much discourse on modern painting, assumptions that, when applied to Ryman, may inhibit the viewer's first-hand experience of the work and direct their thinking into a maze of theoretical conundrums. Ryman's art is especially vulnerable to these digressive intellectual habits which derive in part from criticism's general incapacity to deal simply with simple things. At the extreme, one might even say that modern criticism hates the very clarity that so much modern art aspires to. Otherwise, those problematic assumptions originate in the crisis of formalist criticism in the 1970s.

Symptomatic of that crisis is the abiding obsession such critics have had with the idea of painting's auto-extinction. The apocalyptic tendency to which they collectively belong has several sects; all of which seek to give positive meaning to the present by forecasting negative scenarios for the future. Justification for this practice has been found in the earliest phases of abstraction's development. Emblematic

of the beginnings in which some have divined modernism's end, is Kasimir Male-vich's 'Suprematist Composition: White on White', 1918 (The Museum of Modern Art, New York). To the majority of the lay public, this is painting at its lowest common denominator and lowest ebb, a *reductio ad absurdum* of vanguard pretensions, and a bad joke. To the more informed viewer, Malevich's work is an artistic *ne plus ultra* – or *ne minus ultra* – only sublime rather than ridiculous in its economy. For some of its admirers schooled in the ideology of the period, more-over, 'Suprematist Composition: White on White' predicts the demise of easel painting and heralds a new postaesthetic age. Within this community of opinion, the fact that Malevich went back to figuration and so turned away from the glorious future his Suprematist paintings indicated lends the story of Soviet modernism a tragic dimension but does not alter its deterministic message. Meanwhile, all artists who have followed in his footsteps or broken a parallel path have been dogged by the expectation that sooner or later they will reach the end of the line implicit in his work – and stop. Paintings done since then are regarded by those convinced of this inevitable eventuality as poignant symbols of a momentarily cheated fate.

'Suprematist Composition: White on White' is cited as an influence on Ryman in virtually all the literature. In actuality, though, Ryman paid little attention to this particular work which hung at The Museum of Modern Art under his guard-ianship, and even less to the aesthetic doctrine of which it was a talisman. The problem from his point of view was precisely the ingrained symbolism of the piece. 'I had seen Malevich's paintings at the Museum of Modern Art,' he once recalled, 'but really he had no bearing on what I was doing, either in the '50s or the '60s. In fact he was more like a curiosity to me. I thought of him more in terms of Surrealism.'[70] The substitution of the label 'Surrealism' for 'Suprematism' amounts to a Freudian slip at the expense of Suprematism, since in the way Ryman meant it, Malevich's art was basically pictographic, and involved a *sur*, or beyond, realist representation of ideal form in transcendental space.

Here, as in the case of Rauschenberg or Johns, it is obvious how gross formal comparisons between works can lead to false explanations of their genesis and meaning. The mere existence of a precedent says nothing about its effects, if any, and in this instance it seems that the example Malevich set Ryman concerned what *not* to think about or do. As Lucy Lippard observed, the myth of definitive mono-chrome abstraction has two versions; one white and one black. At one extreme, Malevich's Suprematist paintings mark the birth of the cosmos of pure geometric abstraction. At the other extreme, Reinhardt's late paintings seem like black holes belonging to the devolutionary stage of this process when energy totally implodes. Evacuating form from his gridded formats while dimming the lights to a maddenly low level, Reinhardt worked on canvas after slyly nuanced canvas, all the while proudly declaring 'I'm merely making the last paintings which anyone can make'.[71] For Reinhardt, painting was what was left over after you took everything away. When it came to what that meant in practice, Reinhardt's litany of disallowals was long and absolute:

> No lines or imaginings, no shapes or composing or representings, no
> visions or sensations or impulses, no symbols or signs or impastos, no
> decoratings or colorings or picturings, no pleasures or pains, no accidents
> or readymades, no things, no ideas, no relations, no attributes, no qualities
> – nothing that is not of the essence.[72]

Ryman would concur with some of the items on this list but not the sentiment

behind it. An erudite iconoclast and dialectician, Reinhardt denounced those who refused to sacrifice all to their modernist faith, and so banish all vestiges of abstraction's former compromises with representation. Ryman, on the other hand, approached the matter from an equally strict but affirmative point of view. Instead of concerning himself with an impossible Platonic perfection, he turned his sights on an achievable – and elegant – simplicity. At what point, he asked pratically, did a painter have enough to work with – and nothing superfluous?

The positive emphasis of this formulation is significant to the extent that most other explanations of reductive painting emphasize what has been eliminated from the artist's options. Even the use of adjectives like 'reductive' in this context is problematic, since it presupposes that painting has inherent qualities that painters of our day have removed from it, and that the history of modern art is an accounting of those subtractions. Or, as Thomas McEvilley recently argued in defence of this view, 'No absence is simply absence; absence is already a kind of narration.'[73] Regardless of how that narrative is written, or how these subtractions have been justified in the name of purifying art's spirit or form, so long as abstract painting is explained primarily in relation to its evolution away from its historical origins, its latent content will remain one version or another of loss, denial or heroic abstinance.

Reversing this perspective, Ryman has identified the elements sufficient to the medium in order to reveal the beauty of that sufficiency. What Ryman calls 'Realism' involves more than the actuality of the object, however; it entails jettisoning much of the philosophical and historical freight that modern art accumulated in the formative stages but now carries into maturity at ever greater cost to its vitality. Nevertheless, Ryman has been a favourite 'contemporary' painter among critics of an historicist bent and has been called the 'last modernist' by one of his most dedicated supporters from this camp, Yve-Alain Bois.[74] Despite this, Ryman has explicitly rejected the idea that we are witnessing the finale of modernism. 'Abstraction is a relatively recent approach to painting. I think abstract painting is just beginning. All possibilities are open to it in ways we can't envision. I think painting is moving too slowly, but of course it is the nature of painting to evolve slowly. I feel that the possibilities of painting are so great, and that we've just scratched the surface.'[75] Why, then, should we not believe him when he is providing the proof? Furthermore, why not lend a receptive ear to his corollary admonition that 'a painter is only limited by his degree of perception. Painting is only limited by the known.'[76] The known includes styles of thinking as well as styles of making, the academy of 'whys' as well as the academy of 'whats'. Neither a vanguard artist nor a traditional one, Ryman wants to free painting both from its past and from antiquated visions of its future.[77]

Although he has followed the protocols of essentialist painting, Ryman's polite refusal to subscribe to its dogmas is grounded in his trust of aesthetic instinct. That trust completes his bond with Rothko.

> [Rothko's] work might have a similarity with mine in the sense they may
> both be kind of romantic, if you want it. I mean in the sense that Rothko is
> not a mathematician, his work has very much to do with feeling, with
> sensitivity. The word romantic can be taken in several ways, I guess. I mean
> in the good sense, in opposition to the mathematician, you know the
> theorist, the person who has everything worked out beforehand.[78]

Ryman's identification of himself and Rothko as 'romantic' doesn't tally with the

frequent impression of him as the perfectionist proponent of an impersonal aesthetic. But the discrepancy between his self-image and public perception may be explained by a basic cultural bias rooted in a traditional opposition of mind and body, intellect and feeling, measured articulation and expressive spontaneity.

Such a dichotomous view of human nature results in descriptions of Ryman's painting that treat it as a product of a purely cerebral sensibility, neglecting the richness of paint in one particular work, or its luminosity in another. More incomprehensibly still, some feel compelled to condemn the work's quietness as witholding. But Ryman is not playing hard-to-get. The presumption that he is, coupled with a frustrated insistence on categorical antitheses in art, are signs of puritanism in revolt against itself. The special irony of such frustration being vented on Ryman is that his work dissolves these bedevilling oppositions and offers release from a direction we seldom expect it – not, that is, from an anxious or brooding romanticism but from an utterly serene one.

While the radical spareness of Ryman's work stirs resentment in some viewers, in others it provokes sympathetic but equally inappropriate metaphysical rumination. Typical of this reaction is the following from a recent article by Dan Cameron:

> Suddenly [Ryman's] paintings weren't really paintings anymore; they were like pictures in the magnified sense of representing an ideal about painting which simply cannot be realized in any other way. It may seem simplistic but I have always imagined Ryman chose the format of the white painting in part because he knew that it would draw out the viewer's inclination to project one's desire across its surface. It is almost as if the artist were proferring us a vessel in which signification can be conveyed while asking us to go fill it ourselves.[79]

In his essay, McEvilley said much the same thing, adding a critique of Clement Greenberg's formalist theories:

> Greenberg's doctrine of the purely optical had somehow allowed for concepts such as Newman's 'stretched red,' in which 'what you see' is supposedly nothing less than the sublime. The 'purely optical' then becomes a vehicle for all sorts of metaphysical content to be supplied by the viewer, who would likely know from verbal supplements, however, what the artist intended by a particular abstract field. In this context, to say, 'The painting is exactly what you see' is merely to point to a blank that needs to be filled in. What the statement communicates powerfully, however, is the artist's reluctance to fill it in himself. Indeed, in and of itself the work may suggest many things, sparking a train of associations that go far beyond raw perception. I don't think Ryman can eliminate that aspect of his art merely by denying it.[80]

Both these statements persuade to the extent that they invoke the commonly held belief that art is ultimately validated by the references it makes to meaningful things outside itself – that is by its mimetic or symbolic content. Both convert Ryman's self-sufficient 'Realism' back into an evocative 'Abstraction,' leaving the question of why he is so reticent to identify his works' 'hidden' subject matter open to still more vexing guesswork.

Ryman is well aware that it is beyond his power to prevent people from reading extrinsic things into his work. 'I have no control over what someone sees. You can

fantasy [sic] about things. You can look at clouds and see faces in the clouds, that kind of thing. That's not really there; it's just the imagination of the viewer.'[81] As far as Ryman is concerned, the mystical auras perceived by some in his paintings have the same status as the faces seen hidden in clouds. And they are an impediment to understanding in that they place greater value on looking for something that is not there than on seeing what is.

Far from evading the question of his work's meaning, Ryman has answered it on numerous occasions. 'The poetry of painting has to do with feeling' he declared. 'It should be kind of a revelation, even a reverent experience. If you can tune into the frequency of what you are experiencing, you come away feeling very good, you feel sustained.'[82] The conditions Ryman sets for the viewer are only stated so that such a revelation can be made accessible on its proper terms — and those terms are unequivocally actual. Pictorial or illusionistic art requires a suspension of disbelief; Ryman's 'Realism' requires a suspension of wanting — that is, a letting go of conditioned need and conditioned responses. The reverence he is after is a reverence for things of this world, and it is an exceptional experience to the degree that we are so unaccustomed to the level of concentration it requires. Any considerations of a formal, philosophical, or historical nature are secondary to that goal and contrary to it when they preoccupy and distract the viewer's mind. 'Whether it is abstract or representational, that's what [painting] is, that's what it does. Everything else about it — the why of it, the what and the when — the technical aspect of it is interesting and necessary for deeper understanding. But that's not the purpose, or the goal of painting. The primary experience is that experience you receive of enlightenment.'[83]

Enlightenment, in Ryman's sense, consists of unhurried pleasure taken in the here and now. And, by its nature, pleasure can never be made intellectually respectable. That is why it is so disconcerting when presented in its 'pure' form.[84] Pure in the sense of unalloyed, rather than in the sense of puritanically cleansed, for Ryman is not among modernism's ascetics. Turning the tables on a Protestant culture that subordinates enjoyment to a higher good, Ryman is a gently subversive hedonist, intending nothing more or less than to delight himself and others, with no strings attached. His sympathy for Matisse resides in this above all — and his lack of involvement with most of the geometric abstractionists with whom he has been compared. To be sure, Ryman's gentle craving for Matissean 'luxe, calme et volupté' is satisfied in ways consistent with an American commitment to plainness. Devoid of excess and radiantly balanced, Ryman's paintings put one 'in the place just right', to borrow a phrase from the Shaker hymn from which this essay also takes its title. Nonetheless, his means of thus situating the viewer is as exquisite in its way as Matisse's — and as unapologetic in its direct appeal to the senses.

The idyllic longing Matisse's work embodies is ultimately insatiable. Therein also lies the bittersweet essence of Ryman's work. His art's poignancy doesn't depend on the imminent conclusion of the painterly tradition to which it belongs but instead on the unrelenting impulse to which it responds as a part of that tradition. Among Ryman's early works — and among his favourites — is a casein on paper of 1958 (no.6). Unique in his oeuvre, it is inscribed with a text that reads: 'THE PARADOXICAL ABSOLUTE'. When asked what he intended by that, the artist answered that the idea had just came to him without warning. 'I had been reading some philosophy and I had been thinking about the word absolute and I was trying to get at the meaning of it. It had to do with painting also. I was thinking about painting in general and it just seemed paradoxical.'[85] In the context of what Ryman

has made between then and now, the paradox appears obvious, but the clarity with which he rephrased it in paint is dazzling. Seemingly absolute in the moment of experience, true pleasure demands to be repeated as soon as that moment passes, and just as soon we know that the means of finding it again have already changed. The paradox of pleasure is that the feeling desired is ever the same in its totality, but the source of that feeling can never be the same twice. So it is with painting. Accordingly, Ryman has pursued the pleasures of proportion, light, touch, colour, and space in a completely intuitive manner – since intuition, not reason, is the only faculty capable of measuring its fulfilment. And he has been generous in this endeavour. Painting after painting, Ryman provides us an ecstatic tranquillity that is constant in its intensity because subtly but constantly surprising in its guise. We have only to accept that offer.

ILLUSTRATIONS

NOTES

Material for this essay came from a number of sources cited below, and was enriched by reviewing the writings of numerous critics not directly quoted or otherwise mentioned in my text. Excerpts from the work of some of these critics appear in the Chronology. Other than that, I drew heavily on information gathered by Catherine Kinley at the Tate Gallery, and Lynn Zelevansky, Alina Pellicer and Noriko Fuku at The Museum of Modern Art, New York. Linda Norden, who is currently compiling a catalogue raisonné of Ryman's paintings, was also very generous in offering this project the benefit of her research. And, I should add, like anyone writing on Ryman, I owe a special debt to the detailed formal analysis of the artist's oeuvre by Naomi Spector, published in several instalments during the 1970s. Finally I must thank Robert Ryman for his careful responses to my persistent questioning on several occasions over a period of several years.

1 The little that is known about Ryman has prompted some critics to draw unwarranted inferences about his character from his paintings. The image of the artist as a man driven by a compulsive fastidiousness is one of the more common of such misconceptions.

2 Robert Ryman in taped conversation with Robert Storr, June 1992. (Referred to as Ryman to Storr, 1992.)

3 Ibid.

4 Ibid.

5 Ibid. Given current controversy about public funding of the arts, it is worthwhile noting that prior to the now much embattled National Endowment for the Arts (NEA) two major programmes of the United States Federal Government have played a major part in fostering the arts in America. The first and best known was the variety of relief programmes instituted during the Great Depression and generally referred to by the initials of one, the Works Projects Administration (WPA). The second was the so-called GI Bill which granted veterans financial support toward their post-service education. Just as many of the most important artists of the Abstract Expressionist generation were only able to survive and develop because of the WPA, many of the major figures of the next generation studied and supported themselves with assistance from the GI Bill. Ryman originally intended to use his benefits this way but gave up when he found the schools open to him too limiting, hence the necessity of self-financing his self-education.

6 'Robert Ryman, interview with Robert Storr on October 17, 1986' in Rosemary Schwarzwalder, *Abstract Painting of America and Europe*, Galerie Nächst St Stephan, Vienna (pub. 1988), p. 214. (Referred to as 'Ryman to Storr, 1986'.)

7 Ryman to Storr, 1992.

8 Matisse, 'Letter to Henry Clifford' in Jack D. Flam (ed.), *Matisse on Art*, New York 1978, p.120.

9 Ryman in Grace Glueck, 'The 20th Century Artists Most Admired by Other Artists,' *Art News*, Nov. 1977, p.99.

10 For a more detailed listing of works shown at The Museum of Modern Art and in other New York galleries during this period, see the Chronology.

11 Ryman to Storr, 1992.

12 Ryman to Storr, 1986, p.215, Ryman to Storr, 1992.

13 Ryman in Nancy Grimes, 'White Magic', *Art News*, Summer 1986, p.89.

14 Ibid., p.90.

15 Ibid., p.89.

16 Lucy Lippard, 'The Silent Art', *Art in America*, Jan. – Feb. 1967, p.58.

17 Ryman in Grimes, 'White Magic', 1986, p.90.

18 Ibid.

19 Achille Bonito Oliva, 'Robert Ryman Interviewed', *Domus*, Feb. 1973, p.50. Ad Reinhardt wrote numerous texts on the symbolism of black, but he also relied upon it because of its virtue as a 'non-colour' much as Ryman chose white for its neutrality.

20 Ryman in Christopher Lyons, 'Ryman Retains Subtle Style', *Chicago Sun-Times*, 10 May 1985.

21 Ryman to Storr, 1986, p.215.

22 Phyllis Tuchman, 'An Interview with Robert Ryman', *Artforum*, May 1971, p.46.

23 As the late critic Barbara Reise noted, circles are, like squares, entirely symmetrical. Thus they offered Ryman an alternative to his usual format in a handful of works on paper. Their traditional use as symbols for centredness and the cosmos lends them connotations problematic to an art as strictly non-referential as Ryman's. It might be added that critical treatment of Eva Hesse's contemporaneous use of circles confirms this tendency to read symbolic significance into the shape, although in Hesse's case the meaning of the work was importantly enriched by these associations. Incidentally, Reise's essay also recounts that in his interview with Tuchman, Ryman himself drew attention to the fact that the measurements for his paintings are frequently off-square by a quarter to half an inch on a given side and therefore not mathematically exact in the way of some more scientific or idealistic forms of geometric art. See Barbara Reise, 'Robert Ryman: Senza Titolo III (Posizione)', *Data*, Spring 1974, p.32, and Tuchman, 'An Interview with Robert Ryman', 1971, p.46.

24 Ryman in Grimes, 'White Magic', 1986, p.90. Incidentally, Ryman once took a snapshot of his room and painted around the tilted shape of the two windows so that they floated in the overall red of the otherwise cancelled image (see p.212). This play on the window space of pictures and the actual windows of the painter's studio is a unique Duchampian digression from Ryman's strictly non-pictorial, and unironic production.

25 Ryman to Storr, 1992.

26 Robert Ryman interviewed in Barbaralee Diamonstein, *Inside New York's Art World*, 1979, p.332.

27 Ryman's statement for *Art in Process*, Finch College Museum of Art, New York 1969.

28 For a literal use of this motif in painting see Roy Lichtenstein's 'Entablature' paintings of the early to mid 1970s.

29 In the 1970s, Robert Pincus-Witten's barbed appreciation of Ryman spoke for a certain insecure aestheticism inflected by the then ascendancy of idea-based art. In order to maintain his critical balance between pure taste and pure intellect, Pincus-Witten typecast artists about whom he wrote to fit one or the other extreme. Compounded by his assertion that 'Minimalism is remembered as an heroic architectural ambitious style which made greater sense in sculpture than in paintings', Pincus-Witten thus set up an invidious comparison between Brice Marden, whom he labels a 'sensibility painter' and Ryman, whom he claims 'is interested in painting as theory and one is therefore tempted to say he is not interested in painting at all'. 'Ryman', Pincus-Witten continued his analysis, 'may determine as an act of pre-executive choice the kind of brushstrokes to be employed . . . These decisions remove the brushstroke from esthetic graphicism, from calligraphy, from sensibility. Though liberated from sensibility, however, the strokes still remain within the definition of what might reasonably constitute the act of painting. By contrast Marden's brushstrokes are a function of praxis; they rely on the very experience of painting. Before anything else his strokes are aesthetic gestures, despite the reductive orientation of his work'. Ignoring for now the misrepresentation of Marden's work, suffice it to say that what Pincus-Witten dismissively describes as the 'pre-executive choice' of strokes that he grudgingly acknowledges do 'remain within the definition of what might reasonably constitute the act of painting' are in fact the considered marks of an artist who had devoted years to intuitional 'praxis' of exactly the kind he ascribes to Marden. The paintings of 1955–65 under discussion are proof. Furthermore, the difference then and now between these two artists doesn't hang upon the absolute dominance of 'theoretical' ideas over 'natural' sensibility or vice versa. It has to do with when and how accidents and process-derived discoveries, methodically pursued, transcend or are subordinated to style. In short, it is a matter of differences in studio practice rather than of antithetical types of talent. See Robert Pincus-Witten, 'Robert Ryman', *Artforum*, April 1970, pp.75–6, and 'Ryman, Marden, Manzoni' *Artforum*, June 1972, pp.50–3.

30 Full retrospectives took place at the Stedelijk Museum, Amsterdam in 1974, the Whitechapel Art Gallery, London in 1977, the Centre Georges Pompidou, Paris in 1981, the Espace d'art contemporain, Paris in 1991–2, and a synoptic installation of Ryman's work has been on view at the Hallen für neue Kunst in Schaffhausen since 1983. Except for one or two appearances in annual exhibitions at the 10th Street Brata Gallery and occasional participation exhibitions organized by the American Abstract Artists, Ryman scarcely showed at all during the first ten years of his career. Since then no real notice has been taken in America of his early work, other than a small survey at John Weber Gallery in 1972 that included some examples of his paintings from the 1950s. That same year, the Guggenheim Museum mounted Ryman's first New York retrospective; the exhibition, in an effort to align Ryman with minimalism, ignored everything he had done prior to 1964. His only other major American museum show, at the Dia Art Foundation in 1988, concentrated on paintings of the 1980s and included just two works from before 1965.

31 Although a critical advocate of Ryman's art, Reise lamented the amount of attention paid to Ryman's early work in his Stedelijk exhibition. See Barbara Reise, 'Robert Ryman at the Stedelijk', *Art in America*, July–Aug. 1974, p.91.

32 Ryman in Maurice Poirier and Jane Necol, 'The 60's in Abstract: 13 Statements and an Essay', *Art in America*, Oct. 1983, p.123.

33 Ibid.

34 The assumed influence of Johns and Ruaschenberg is of long-standing. For example, in 1972 Robert Pincus-Witten asserts it categorically: 'It is worth noting that Ryman's earliest mature work dating from 1958–59, also recently exhibited at the John Weber Gallery, obviously derives from the same source [Jasper Johns] (as well as from Rauschenberg 1949) [sic].' Robert Pincus-Witten, 'Ryman, Marden, Manzoni', 1972, p.42.

Twenty years later Thomas McEvilley makes a similar comparison, implicitly suggesting, without actually stating, that Ryman followed Johns's lead. 'But others see a "slow evolution,": elements of the work pass through an unending series of nuanced changes and recombinations, with a variety of paints... being applied through a variety of brushstrokes or styles of touch from Johnsian all-over texturing to house painting brushes.' Thomas McEvilley, 'Absence Made Visible: Robert Ryman', Artforum, Summer 1992, p.92.

35 John Cage's experiments with chance operations and arbitrary formal routines are a much cited parallel to John's work. An insouciantly diaristic version of the 'I do this, I do that' mode also guided poet and MoMA curator Frank O'Hara, who originated that phrase. All of which is to say that, in the aftermath of the much pondered Abstract Exporessionist aesthetic, a spirit of disinterested activity began to express itself in many ways and tones, defining the shape and content of much new art in this period.

36 The issue of serial production was very much in the air in the early 1960s, but the practice dates back to early modernism and occurs throughout its history in forms that are sometimes far from systematic or austere. In 1968 artist/curator John Coplans put together a survey exhibition called Serial Imagery for the Pasadena Art Museum. It included work by Monet, Jawlensky, Duchamp, Mondrian, Albers, Reinhardt, Kelly, Bell, Klein, Louis, Noland, Warhol and Stella. The show documented the shift in emphasis away from image toward process and away from 'opticality', as represented by the Monet, Albers, Louis, Noland strain, toward materiality as represented by Stella, but stopped just short of the full turn in that direction taken by Ryman and others. It should also be noted that to the extent that non-objective art in the post-Abstract Expressionist years has often divided between painterly or hard-edged tendencies – following a more or less Wofflin-like definition of styles – Ryman has fallen into the gap separating them and hence has often been absent from survey shows of abstraction that might otherwise have included him. A recent example is Abstraction – Geometry – Painting, organized by the Albright-Knox Gallery in 1989, which applied the idea of geometry in a schematic way. Ryman did not appear but virtually all the other 'minimal' painters did; Jo Baer, David Lovros, Robert Mangold, Brice Marden, Agnes Martin, Larry Poons (early dot dictures), and Dorothea Rockburne.

37 Donald Judd, 'Specific Objects', Donald Judd: Complete Writings 1959–1975, Halifax and New York 1975, p.181.

38 See the Chronology for the employment histories of other members of Ryman's circle that he met while working at The Museum of Modern Art.

39 Ryman recalls arguing with LeWitt over a piece LeWitt was doing in which two boxes, one open, one covered, were to have something placed inside. Ryman thought it pointless to actually put anything in the closed box since it couldn't be seen. LeWitt maintained that the idea – in which the 'art' ultimately resided – demanded that the piece be completed as conceived. Ryman to Storr, 1992.

40 In this light, the 1972 Guggenheim catalogue's assessment, 'In painting minimalism has been less significant [than in sculpture] producing few artists of note, with the exception of Robert Ryman and Robert Mangold' is wrong. Painting

wasn't ancillary to minimalism, it was outside its scope. Moreover minimalism couldn't have 'produced' an artist who, years before the term was coined or the tendency known, was producing paintings.

41 Ryman to Storr, 1992.

42 Stella's original remark was: 'I tried to keep the paint as good as it was in the can.' See 'Questions to Stella and Judd', interview by Bruce Glazer, edited by Lucy Lippard, Gregory Battock, in Minimal Art: A Critical Anthology, New York 1968, p.157.

43 Ibid., p.158.

44 Stella's paintings of this period are entirely frontal in conception: when unframed and visible, the sides have no relation to the treatment of the picture plane except when they have been 'shaped'. Even then they matter only insofar as they outline the canvas form. Generally speaking, Stella's work has continued to concern itself only with what can be seen from the face. Where he has projected planes forward or at odd angles, the edges of these planes have been ignored, as have their support structure behind. In sum, Stella's work conforms to what Ryman calls an 'inward' conception of painting. Even when his polychromed constructions seem to emulate Baroque models and swallow space in great gulps, they do not really interact with their setting so much as try to dominnate them. To that extent they constitute illusionistic depictions of spatial dynamic rather than their 'outward' and actual physical embodiment.

45 Due to spatial constraints, and the recent New York exhibition of the series, the 'Standards' have regrettably not been included in this exhibition despite their importance.

46 Ryman was brought to Bianchini's attention by Dorothy Lichtenstein who worked for the 57th Street Gallery, which until then had generally promoted Pop Art. Ryman's show opened the night of a blizzard and few people came. After celebrating at Max's Kansas City with Bianchini, the Lichtensteins and some other friends, Ryman answered a Sanitation Department radio appeal for emergency volunteers to help clear the streets. In part for the money and in part for the sport of driving a rig – which to his dismay he was not permitted to do – Ryman spent the rest of the night with a crew trucking snow to the East River. Such was the ironic and less than auspicious beginning of his public career. Ryman to Storr, 1992.

47 Robert Ryman in a taped conservation with Lynn Zelevansky, July 1992.

48 Tuchman, 'An Interview with Robert Ryman', 1971, p.52.

49 Although he has made a few temporary pieces that were destroyed and many that appear to have been made out of ephemeral media, in fact Ryman is very careful to ensure that his paintings will hold up over time or involve ingredients, such as wax paper, that can be easily replaced. Thus, when Ryman has adopted new materials, he has generally tested their long-term integrity and strength. For example, before making the Enamelac on corrugated paper paintings, he asked the late conservation expert Orrin Riley to artificially age the cardboard and discovered that despite its bad reputation it was a very stable surface. Riley was also the source for some of the unusual materials Ryman has employed – Elvacite for instance. An unstretched canvas and chalk work of 1967 bears the name 'Orrin' (private collection, The Netherlands).

50 Gary Garrels, 'Interview with Robert Ryman at the Artist's Studio,' Robert Ryman, Dia Art Founda-

tion, New York 1988, p.36.

51 Ibid. p.15.

52 In his interview with Diamonstein, Ryman explains this habit of naming works after companies that supply his materials, but the examples he offers do not always correspond to the actual materials in the works mentioned. See Inside New York's Art World, p.335–6. The explanation of Ryman's close friend Naomi Spector confirms the deadpan wit involved in this practice. 'When he bothers to title his paintings at all he just seems to hit on those with a special sort of ambiguity. They are almost all one word titles, spare, dry and condensed... He says "I just get most of the names from the yellow pages... you know, brand names. They don't mean anything. I just want something that won't interfere with the painting." Naturally, he is not unaware of the humor in all of this. His taste is for the ironic twist in American usage, and he handles it with great style. Thus for example, there are the titles, "Delta", "Adelphi", "Essex," "Impex". These names cling to their traces of "class"... but none of them really convinces anybody.' Naomi Spector, 'Ryman Brand Paintings', Munich 1973.

53 Ad Reinhardt titled his late paintings in a literally descriptive manner comparable to that used by Ryman, for example inscribing the back of one, 'Abstract Painting 60 × 60", 1964.' LeWitt and Carl Andre, among others of their generation, followed the same practice, and for the same reason: to emphasize the work's basic 'objectivity'. See Lynn Zelevansky, 'Ad Reinhardt and the Younger Artists of the 1960s', Studies in Modern Art: American Art of the 1960s, The Museum of Modern Art, New York 1991, p.26.

54 Robert Ryman from the transcript of a speech delivered at the Dannheiser Foundation, New York, Jan. 1991. Edited version published as 'On Painting' in Robert Ryman, exh.cat., Espace d'art contemporain, Paris 1991, pp.57–67.

55 Robert Ryman, Statement, Art Now: New York, Sept. 1971.

56 Ryman is an artist other artists think about a great deal. Sylvia Mangold, a painter and close friend, once dreamed a conversation with him, during which Ryman said, 'You have to learn to paint a surface before you can paint a space'. That oneirocritical admonition is about as concise a statement of his aesthetic as we are ever likely to hear, and even though he never actually said it, he could well have. (As told to R. Storr by S. Mangold.)

57 Ryman to Storr, 1986, p.217.

58 Ryman in Diamonstein, Inside New York's Art World, 1979, p.334.

59 Ryman to Storr, 1986, p.217.

60 See Bryan O'Doherty, Inside the White Cube: The Ideology of the Gallery Space, Santa Monica and San Francisco 1976, 1986, and Thomas McEvilley, 'Absence Made Visible', Artforum, Summer 1992, pp.92–6.

61 In recent years, Ryman's survey installations in Schaffhausen, Paris and New York have ignored chronology and followed a purely visual logic based on the similarity and contrasting dissimilarity of individual works hung in sequence or by gallery grouping.

62 I myself have written such critiques and do not recant them. See Dislocations, The Museum of Modern Art, New York 1991. Nevertheless, it strikes me as arbitrary and absurd to load all of the White Cube's ideological baggage onto each and every kind of work that appears there, as it does to treat the same work as miraculously exempt from contextual questioning. In truth it seems hard to imagine a body of work that

belongs there more naturally than Ryman's; the objection that the space is 'unnaturally' empty is valid, but merely raising it as a rhetorical challenge begs all the interesting questions.

63 In 1968 E.C. Goosens curated an exhibition for The Museum of Modern Art, New York, entitled *The Art of the Real*, which included works ranging from Georgia O'Keefe through Rothko and Pollock to Johns, Kelly, Judd and Mangold. Surveying the artistic horizon in this way Goosens sought to identify an emerging sensibility in American art that took art out of the realm of transcendent expressionist feeling and relocated it in the 'real' world. 'American artists', Goosens wrote in the catalogue, 'have taken a stance that leaves little doubt about their desire to confront experiences and objects we encounter every day with an exact equivalence in art . . . Today's "real" makes no appeal to the emotions, nor is it involved in uplift. Indeed, it seems to have no desire at all to justify itself, but instead offers itself for whatever uniqueness it is worth – in the form of the simple, irreducible, irrefutable object.' Goosens's use of the omnibus category 'Art of the Real' in this context constitutes another tentative definition of what has since generally come to be known as minimalism. To that extent, it counts as an incidental precursor to Ryman's use of the term 'Realist' except insofar as Ryman believes that such 'simple, irreducible, irrefutable, object[s]' are indeed capable of expressing elevated emotion. See E.C. Goosens, *Art of the Real: USA 1948–1968*, The Museum of Modern Art, New York 1968. 'Aniconic' is the term used by Marcia Hafif, who has been a cogent advocate of such painting and sometime defender of Ryman's work. See Marcia Hafif, 'Robert Ryman: Another View', *Art in America*, Sept. 1979, pp.88–9; and 'Getting on With Painting', *Art in America*, April 1981, pp.132–9. Finally, let it be said that both Malevich and Klein referred to their work as 'Color Realism'.

64 Ryman, original transcript of 'On Painting' (see n.54 above).

65 Ibid.

66 Ibid.

67 Michael Fried, 'Art and Objecthood' in *Minimal Art: A Critical Anthology*, pp.116–147.

68 Mel Bochner, 'Excerpts from Speculation (1967–70)', *Artforum*, May 1970, p.71. Around this time Lucy Lippard began to describe the diverse formal practices of post-minimalism and conceptualism as the 'dematerialization of art', associating Ryman directly with this tendency. Of his direct wall mounting of the 'Standard' and 'Classico' paintings she wrote, 'Ryman is primarily a painter but these strategies enabled him to concentrate more fully on painting per se and freed him from the bulky, difficult to transport object; as such this work is notable within the "dematerialization" process.' At a moment when much new work did deny its objecthood, Lippard thus confused permanence or 'bulk' with materiality, and so misconstrued Ryman's actual interest in the formal and expressive nuances of his painting media as a desire to escape the onus of their physicality. In fact, Ryman was 'materializing' his art in ever clearer and more varied terms rather than 'dematerializing' it. See Lucy Lippard, *Six Years: The Dematerialization of the Art Object from 1966 to 1972*, New York and Washington 1973, pp.25–6.

69 Garrels, 'Interview with Robert Ryman at the Artist's Studio,' 1988, p.15.

70 Ryman in Poirier and Necol, 'The '60s in Abstract', 1983, p.123.

71 Bruce Glaser, 'An Interview with Ad Reinhardt' in *Art-as-Art: The Selected Writings of Ad Reinhardt*, edited by Barbara Rose, New York 1975, p.13.

72 Ad Reinhardt, 'ART-AS-ART', ibid., p.56.

73 McEvilley, 'Absence Made Visible', 1992, p.95.

74 Yve-Alain Bois, 'Ryman's Tact', *October*, Winter 1981, p.103. Bois writes: '[Ryman] is perhaps the last modern painter, in the sense that his work is the last to be able graciously to maintain its direction by means of modernist discourse, to be able to fortify it if necessary, but above all to undermine it and exhaust it through excess.' Since Bois has previously announced that he is writing his text 'under sign of Karl Kraus' and in his other essay on Ryman, 'Surprise and Equanimity' (Pace Gallery, New York 1990) begins with a long digression on Barthes and Robbe-Grillet, the reader has ample reason to wonder what he means when he says that Ryman has been 'able graciously to maintain [his work] by means of modernist discourse.' The discourse Bois cites is just another literary imposition on a body of work that never expressed a need for such attentions. Nor is there any basis for Bois's saying that Ryman has 'undermin[ed] [that discourse] and exhaust[ed] it through excess' other than his own need to cast an apocalyptic aura around the things he likes in order to legitimize that interest in context of a general dismissal of painting by his post-modernist colleagues. Douglas Crimp accorded Frank Stella and Daniel Buren dual honours as the last abstractionists in his essay, 'The End of Painting', *October*, Spring 1981, pp.69–86. Crimp's essay is a prime example of formalist determinism at its most exaggerated. His concluding remarks reveal the essential difference between the involvement critics of this camp have with painting and that of the painters they chose to support in the interest of their endgame aesthetics. 'But Buren,' Crimp wrote, 'has always insisted specifically on the visibility of his work, the necessity for it is to be seen. For he knows only too well that when his stripes are seen as painting, painting will be understood as the "pure idiocy" that it is. At that moment when Buren's work becomes visible, the code of painting will have been abolished and Buren's repetitions can stop: the end of painting will have finally been acknowledged.' Whether or not this is an accurate reading of Buren's intent, it clearly states Crimp's exclusive interest in revealing and abolishing the 'codes' of painting by means of excessive and exhaustive repetition. In short, where Crimp argues that Buren seeks to make painting's undifferentiated nullity visible, Ryman seeks to the contrary to make visible painting's enduring potential to illuminate difference. Crimp's strangely distorted understanding of Structuralist thought thus led him to believe that the ultimate function of criticism – and of art itself – was to expose the art's rhetoric the quicker to have done with it. It is the classic response of the academic thinker who confuses language's properties and mechanisms with its poetics. Bois is responsive to painting's poetry, but cannot bring himself to deal with it outside the critical paradigms he has adopted. Neither does he explain how one is to view the ongoing work of Kelly, Marden, Stella, and others in light of his designation of Ryman as 'the last modern painter'. In apparent agreement with Crimp that modernist painting is moribund, Bois thus ends up admiring Ryman's painting for the manner of its 'dying'. Meanwhile Ryman is busy making new work – confident, as Yankee baseball player and philosopher Yogi Berra said, that 'It ain't over till it's over'.

75 Grimes, 'White Magic', 1986, pp.87, 92.

76 Ryman in the catalogue for *Documenta 7*, Kassel 1982.

77 Ryman's ambivalence about belonging to the self-conscious theoretical vanguard comes through in this comment to Oliva: 'I don't really consider myself too much of, well, of an avant-garde artist – I am maybe – but what I do, my work, involves just very simple procedures of applying painting and making something happen with it. Oliva, 'Robert Ryman Interviewed', 1973, p.50.

78 Ibid.

79 Dan Cameron, 'Robert Ryman: Ode to a Clean Slate,' *Flash Art*, Summer 1991, p.93.

80 McEvilley, 'Absence Made Visible' 1992, p.95.

81 Ryman in Tuchman, 'An Interview with Robert Ryman' 1971, p.53.

82 Ryman in Poirier and Necol, 'The '60s in Abstract', 1983, p.124.

83 Ryman to Storr, 1986, p.220.

84 Ryman's frequently refers to music in describing his goals in the visual arts. Asked what he wanted to communicate to the viewer, he said, 'An experience of enlightenment. An experience of delight, and well being, and rightness. It's like listening to music. Like going to an opera and coming out of it feeling somehow fulfilled – that what you experienced was extraordinary.' (Ryman to Storr, 1986, p.219). Of course, since Walter Pater declared that 'all art constantly aspires to the condition of music' this kind of analogy has been a regular feature of aesthetic discussion. Particularly, when it comes to abstract art, inasmuch as the evolution away from programme music preceded painting's development away from depiction. Thus music's example could be cited in justification of greater formalism in the visual arts. This noted, Ryman was once a musician and is therefore in the special position of being a practitioner of both the media he is comparing – that is to say his basis of comparison is not just logical, but synaesthetic. In another context, it would interesting to investigate the relation between jazz improvisation and his work, as well as the differences between his approach and that of Cage, which otherwise had such a powerful influence on painting in this period. One last irony: although Ryman has made every effort to eliminate literature from his painting, the counter term he singles out – opera – is music's most literary expression.

85 Ryman to Storr, 1992.

Catalogue Note

Catalogue entries compiled by Catherine Kinley, Assistant Keeper, Modern Collection, Tate Gallery, and Lynn Zelevansky, Curatorial Assistant, The Museum of Modern Art, New York.

These entries could not have been compiled without the help and cooperation of Robert Ryman. Linda Norden's research for a catalogue raisonné formed the basis of the catalogue entries. Janice Vrana of the Pace Gallery was very helpful in allowing us access to the gallery's archive and unearthing from it crucial photographs and dates. Dan Flavin, John Krushenick, Leo Rabkin, Irving Sandler, and Michael Venezia clarified historical questions related to Ryman's life and work. Thanks are also due to Anne Plumb, Julian Pretto, Fiona Robertson, Gundula Schulze of Konrad Fischer Gallery, Düsseldorf, Naomi Spector, and the staff of the Leo Castelli Gallery, New York.

Explanations

Measurements are in centimetres, followed by inches in brackets; height before width.

Exhibition history ('Exh') is generally confined to the first showing and any subsequent major showing.

Literature ('Lit') lists the main sources only, including where possible the earliest known mention, and specific references the work. Exhibition catalogues are not generally listed under 'Lit' if the exhibitions in question have already been cited under 'Exh'.

Inscriptions are by the artist.

Abbreviations: General

col.	colour
exh.	exhibited
exh. cat.	exhibition catalogue
lit.	literature
repr.	reproduced

Abbreviations: Quotations

RR:	Quotation following is from Robert Ryman.
RR and CK	From an interview between Robert Ryman and Catherine Kinley held in the artist's studio on 11 April 1992.
RR and LZ	From interviews between Robert Ryman and Lynn Zelevansky held in the artist's studio on 1 and 7 July 1992.

Abbreviations: Exhibitions

Amsterdam 1974	Robert Ryman, Stedelijk Museum, Amsterdam, Feb. – March 1974
Basel 1975	Robert Ryman, Kunsthalle Basel, June – Aug. 1975
London 1977	Robert Ryman, Whitechapel Art Gallery, London, Sept. – Oct. 1977
New York 1972	Robert Ryman, Solomon R. Guggenheim Museum, New York, March – May 1972
New York 1988–9	Robert Ryman, Dia Art Foundation, New York, Oct. 1988 – June 1989
Paris 1981	Robert Ryman, Musée national d'art moderne, Centre Georges Pompidou, Paris, Oct. – Nov. 1981
Paris 1991	Robert Ryman, Espace d'art contemporain, Paris, Oct. 1991 – July 1992
Schaffhausen 1983 –	Ryman, Hallen für neue Kunst, Schaffhausen, permanent installation since 1983
Zurich 1980	Robert Ryman, InK, Halle für Internationale neue Kunst, Zurich, June – Aug. 1980

1 **Untitled (Orange Painting)** 1955 and
1959

Oil on canvas 71.4 × 71.4 (28⅛ × 28⅛)
Lit: Naomi Spector, Amsterdam 1974, p.1;
Christel Sauer, Zurich 1980, p.16, repr. p.25;
Paris 1981, repr. p.23; 'Robert Ryman:
Interview with Robert Storr, October 17
1986', *Abstract Painting of America and Europe*,
Vienna 1988, p.215
John E. Ryman

This painting has not previously been exhi-
bited. Ryman has always referred to this work
as his first 'professional' painting or earliest
'exhibitable' work. It is inscribed '55' on the
canvas overlap on the left edge, possibly in felt
pen. Ryman remembers making this inscrip-
tion in the early 1970s following the paint-
ing's return to him from conservation
treatment. Until now he has dated the work
1955, because he remembers having worked
on it in his studio in Spring Street, New York,
where he lived early on. All previous literary
references have given 1955 as the date of the
work. When the painting was seen recently
under a raking light, a signature and the date
'1959' were discovered in the lower left-hand
section.

Paint losses in the upper area of the painting
appear to have been worked over in darker
orange. An 'X' shaped crack on the upper right
side of the canvas has been partially covered
with a paint stroke of the same darker colour.
These additions suggest that the canvas may
have been executed during two or more dis-
tinct periods, with some time elapsing
between them. Ryman's often brightly
coloured underpainting can be as complex as
his finished paint layers. In consequence, it has
been suggested that this work was originally
intended as the undercoat for another painting.
Its colour could also indicate that it was begun
before Ryman began to work predominantly
in white, that is before 1959. However, the
partly obscured signature and later date on the
front of the canvas suggest that it was worked
on in 1959. The artist does not believe that he
worked on the painting after 1959.

About a year after he made this painting,
having no plans to exhibit work, Ryman
decided to give it to his brother.

RR: I liked this painting a lot, and my brother
visited me about a year later and I didn't
know what to do with it. No-one was going
to show anything … and so I gave him this
painting and he took it back to Nashville and
it stayed there for many years. In fact he
unfortunately hung it over a radiator or
something. The heat was not good for it and
… it became a little warped. And some years
later when I was visiting him I saw the
painting there, and I said that we should do
something about this. So I brought it back to
New York [in May 1972] and had it taken to
Orrin Riley the conservator, and we discussed
what to do about it, and it was mounted then
on a solid wood backing to give it strength. I
liked the painting but I never put it in an
exhibition because it was such an odd
painting. Being orange, it's such a shocking
color, it didn't really fit with most of the
exhibitions. But I thought there would be a
time to show it sometime and this is the time.
Of course it's not all the same hue. There are
many oranges in here, there are reds, light
oranges and dark yellows … There is a
composition on the edge …

I've always thought that if I ever wanted to
paint a white painting it would be in the
order of the way this painting was done,
because this is definitely an orange painting
but there are many nuances and many
oranges (and black and green). And if I were
doing a white painting I would approach it
the same way, and there would be whites
and warm-whites and cold areas and then
you would have a white painting. As it is, the
way I use white it's more as a neutral paint,
in order to make other things in the painting
visible, color for instance.
(RR and CK)

The earliest painting I know is at the same
time the only one in which there is no white
paint. It is painted, the sides included, in a
powerful orange with small lighter and
darker rectangles inserted in the upper edge
of the painting. These smaller over or
underlaid colour fields occur repeatedly until
about 1960; then application serves a
compositional purpose as well as the
subjective satisfaction of an artistic curiosity
concerning the interaction of different
coloured and different sized areas painted in
various ways.'
(Sauer 1980, p.16)

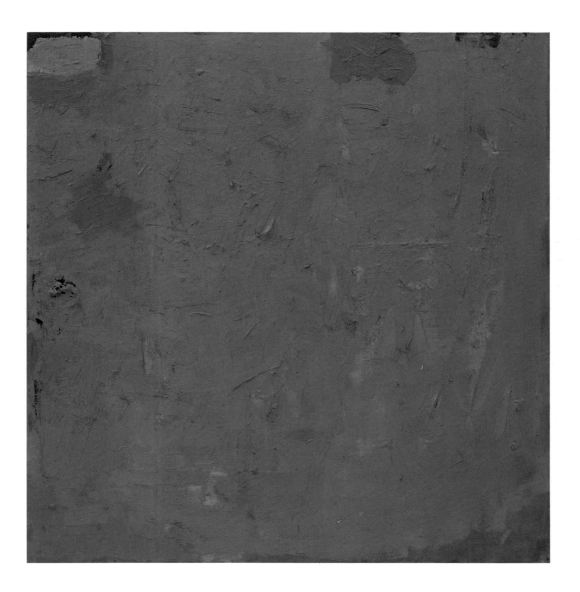

2 Untitled 1957

Casein and graphite pencil on primed cotton
canvas, on board on manila folder, on glass,
on plywood 24.5 × 21.5 ($9\frac{5}{8}$ × $8\frac{1}{2}$)
Signed on glass backing in black magic-
marker 'RRYMAN 1957'
The artist

RR: That's a very early painting. It's casein on
primed cotton. It also has glass. It's an odd
[painting] because the way it's mounted is
really almost part of the aesthetic, the
concept . . . the glass is right to the edge. It's
mounted on glass and the glass is on a quite
thick plywood backing. It has a strainer to
keep the glass off it, but then the glass is just
taped onto it. And it's been like that ever
since 1957; I don't know if it's been shown. I
don't think so. I think I just didn't know what
to do with it. I was trying to devise some way
to hang it, and I had it pinned to the wall.
Then I thought, because it was casein, it
might not be good to have it that way. I felt it
should be under glass to protect it, so I did it
myself: I mounted it, put it on this board,
and stapled a wire on the back. The matt
board was attached to a plywood backing,
where I could staple a wire.
(RR and LZ)

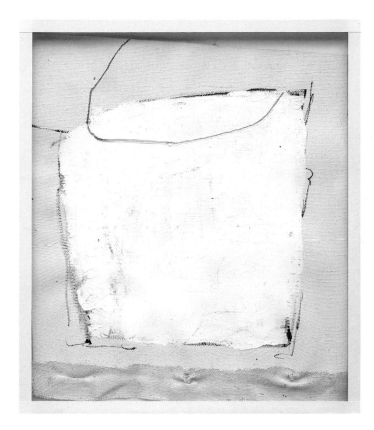

3 Untitled 1957

Gouache on paper mounted on board and plywood 19.9 × 20.6 ($7\frac{7}{8}$ × $8\frac{1}{8}$)
Exh: Brata Gallery Group Show, New York, December 1958; Amsterdam 1974 (1, repr.); London 1977 (1); Zurich 1980 (repr. 5); Schaffhausen 1983– (no number)
Lit: Naomi Spector, Amsterdam 1974, pp.2–4; Jeremy Gilbert-Rolfe, 'Appreciating Ryman' *ArtsMagazine*, vol.50, no.4, Dec. 1975, p.70; Naomi Spector, 'Robert Ryman: une chronologie', in 'Dossier Robert Ryman', *Macula* (Paris), no.3/4, Sept. 1978, pp.115–6, repr. no.1; Paris 1981, repr. p.25; Paris 1991, repr. p.71 in col.
The artist

At this time (1957–8), Ryman began to use his signature and the date of the work as an important element in the composition (see also no.4). In this small painting, inscribed 'R RYMAN 57' vertically in white paint along right edge, the inscription is integral to the painted field.

There is a gouache on paper painting from 1957 which shows a mastery of the elements which continued to be of major importance in paintings to the present time. The first of these is the great variety of white brushstrokes which activate practically the entire surface leaving an irregular band of manila colored paper exposed at the bottom edge. There are strokes of different widths, lengths, speeds, directions, shapes and shades. Some look like gestures, some like a means of covering the area, some are sharply angled, some circular, some rough, some smooth. Some have been applied gently and relatively evenly, others with enough force to leave behind ridges in relief, and there are . . . dollops of paint which look splashed on. The deliberateness with which these quickly changing strokes are painted gives the work power which belies its modest dimensions . . . All these elements are related and all are important.
(Spector 1974, p.3)

RR: I just taped it all together and stapled a wire on the back and that was how it was shown. Many of the small ones I did that way, and I still have that same framing device on some of the early ones. I didn't want any kind of a heavy frame on them because it distracted from the openness of the painting. On the other hand it needed to be protected because of the gouache paint, and some of the casein also.

I don't know if it is the first time I used the signature [incorporated into the painted field]. It is the first time I used it turned on its edge because I felt that I could use the signature as an element in the composition, that it was a traditional device that painters always used; not necessarily as a compositional element, but they generally signed their paintings on the front. And I felt if I turned the signature on its edge it would become more abstract as line in itself, because I rarely use line in my painting. So I could use my signature as line, and that's why I used it on the front and sometimes prominently in white, and on the edge because it was more abstract that way and could be read more as line, as curves, rather than simply as a signature. At that time [c.1957–8] I signed 'R Ryman', later on I just put 'Ryman'.
(RR and CK)

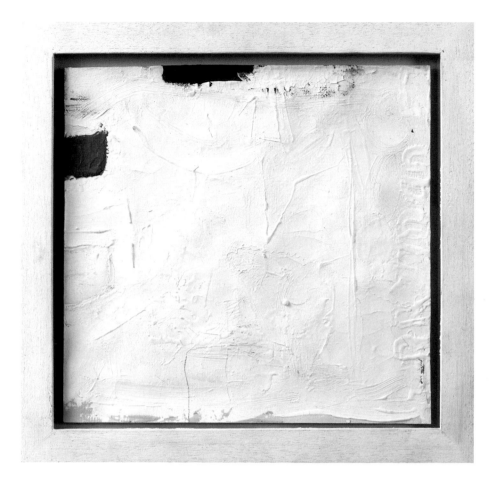

4 Untitled 1958

Oil on cotton canvas 1 3 5.4 × 8 3.2 $(53\frac{1}{4} × 32\frac{3}{4})$
Exh: *Robert Ryman, Early Paintings*, John Weber
Gallery, New York, April 1972; Paris 1991
(repr. p.73 in col.)
Lit: Jeremy Gilbert-Rolfe, 'Appreciating
Ryman', *ArtsMagazine*, vol.50, no.4, Dec. 1975,
p.71; *Artforum International*, Summer 1992,
vol.30, no.10, repr. p.92. Also repr.: as
postcard in col., Schaffhausen
The artist

This painting is inscribed 'RRyman58' bottom
centre in white paint, and is an early example
of his use of signature and date in composition
(see also no.3).

RR: In 'Untitled', 1958 the signature is very
much a compositional device pushed all the
way to the bottom, quite prominent but very
much line and movement and opposing the
square paint plane. Of course this is a
rectangular painting which was unusual for
me ... Generally there is the square paint
plane area. Even in my recent paintings,
when the paintings are rectangular, the paint
plane is square. I knew I was going to paint at
the top, so the canvas was sized. Later, I
decided to use the signature as line at the
very bottom. I sized that part of the canvas so
that the oil would be sitting on the size rather
than on the cotton, and the size became a
visible element, a very subtle band at the
bottom. There are three [main] areas and
then of course, what we don't see, is the left
edge which has a considerable amount of
activity going on which is seen when the
painting is viewed from the side. The left-
hand side is very similar to the orange
painting ['Untitled', no.1] which has all the
same kind of activity – except in the orange
painting it's on the right.
 [The importance given to the sides of the
paintings] had to do with the feeling that
always in painting you're confined to the

space of the canvas, and of course in
traditional picture painting you're confined
to the very front space because of it being a
picture. I felt that, this not being a picture,
the painting did not necessarily have to be
confined to the front plane. It could go
around the edge, and the painting could
open up in that way. And that gives you a
slightly different dimension. When you look
around, when you move around the
painting, the painting changes. And I think it
had to do, in later years, with the way the
wall was used and working with the wall-
plane. It was just a matter of opening up and
expanding the painting away from the frontal
paint plane. This relates to many of the
paintings I was doing at that time in '57, '58,
'59, when I used black shapes, usually
coming in from the side.
(RR and CK)

'Untitled', 1958, carries the dark marks
around the side, identifying the top left of
the object with the top left of the rectangle,
while at the same time distinguishing the
two by not making the marks continuous
with one another. 'Untitled' is also
interesting in that, while it accommodates
the edge of the object into the conventional
grammar traditionally seen as the province of
the surface alone, it nonetheless reserves for
the latter a degree of material intensity
denied to the sides. The sides retain, in other
words, their function as areas of transition.
[This] is atypical of Ryman. His paintings
aren't usually vertically oriented; most often
they're square ... Ryman's use of his signature
at this time [1957–61] [is] used to introduce
a linear element into the work. [Here] the
signature is large, centred at the bottom of
the piece. Its thickness makes it read as a re-
emergence, and perhaps also as a definitive
re-ordering of the thick surface of the top
part of the work.
(Gilbert-Rolfe 1975, p.71)

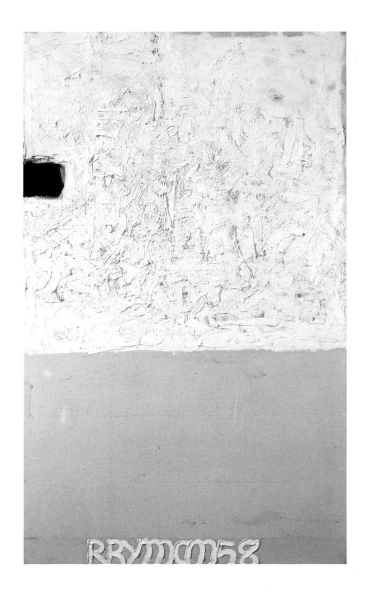

5 Untitled 1958

Oil on cotton canvas 109.3 × 109.3 (43 × 43)
Exh: *Robert Ryman, Early Paintings*, John Weber
Gallery, New York, April 1972; Amsterdam
1974 (2); London 1977 (2); *The Reductive
Object: A Survey of the Minimalist Aesthetic in the
1960s*, Institute of Contemporary Art, Boston,
March–April 1979; Zurich 1980 (1, repr.
p.27); Paris 1981 (1, repr. p.24);
Schaffhausen 1983–
Lit: *In the Realm of the Monochromatic*, exh. cat,
Anderson Gallery, Virginia Commonwealth
University, Richmond, 1979; Jeremy Gilbert-
Rolfe, 'Appreciating Ryman', *ArtsMagazine*,
vol.50, no.4, Dec. 1975, pp.70–3; Paris 1991,
repr. p.75; *Du*, no.12, Dec. 1989, p.25, repr.
pl.3 in col.
The artist

Inscribed '58' bottom right.

In this painting, the date, '58' is incorpor-
ated into the paint plane. This was one of a
group of works from the period 1958–63,
including nos.4, 12, that Ryman exhibited at
the John Weber Gallery in New York in 1972,
at the time of his exhibition at the Gug-
genheim Museum. Between 1958–61 he
worked on a number of larger canvases, filling
the surfaces with thick white strokes of paint,
in all-over patterns, sometimes broken by date
and signature. As in this painting, different
grounds are allowed to show through. Before
1960, these grounds often revealed traces of
red, yellow or black; after 1960, blues and
greens predominated.

RR: Here are traces also of those shapes that
were on the edge that came into the paint
plane, into the front plane, but which in this
case were pretty much taken out [see also
nos.3,4]. This [top left edge] was a black area
which I reduced: I took it out. You can see
that there was something there.
(RR and CK)

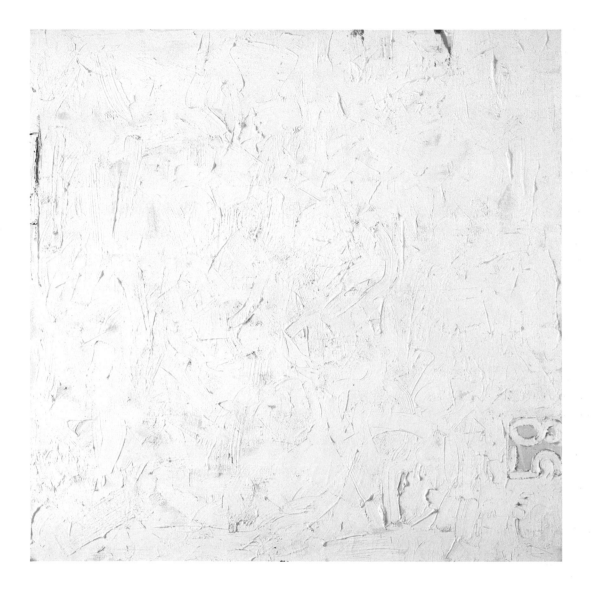

6 The Paradoxical Absolute 1958

Casein on printed paper 18.2 × 18.5 ($7\frac{1}{8}$ × $7\frac{1}{4}$)
Exh: Zurich 1980 (6, repr. p.29); New York
1988–9 (no number); Paris 1991 (no
number)
Lit: Naomi Spector, 'Ryman Brand Paintings'
in *Bilder, Objekte, Filme, Konzepte*, exh. cat.,
Staadtische Galerie im Lembachhaus,
Munich, April–May 1973, p.156; Paris 1981,
repr. p.25. Also repr: *Abstract Painting of America
and Europe*, Vienna 1988, p.221; Yve-Alain
Bois, 'Surprise and Equanimity' in *Robert
Ryman, New Paintings*, exh. cat., New York 1990,
p.9; Jean Frémon, *Robert Ryman, le paradoxe absolu*,
Caen 1991
The artist

Inscribed upside down twice, upper left and
upper centre, dated '58'.

At around this time, Ryman made a number
of small works on printed paper, using, for
example, announcements sent to him from
various galleries, because he liked the different
paper qualities and textures provided by such
found materials. For this work, Ryman used a
printed gallery announcement as his ground.
The words 'paintings and sculpture' are
printed near the bottom edge to the left of
centre. Ryman painted the words 'THE PARA-
DOXICAL ABSOLUTE' in white on black along the
bottom of the painting, starting at the left edge.
Compare with contemporary small works
illustrated Zurich 1980, p.29 and Paris 1981,
p.25.

This is probably the first example of Ryman
inscribing anything other than his signature
and the date on the front of a painting. (He has
not done this often, but in 1986 he made a
series of five paintings each with the word
'TEST' inscribed on it. According to Ryman, this
was to indicate that they were not works but
experiments, although he afterwards decided
that they were finished paintings.)

RR: I didn't have any money at that time.
These mailings were something to paint on. I
must have liked the color and texture too.
(RR and LZ)

RR: 'The Paradoxical Absolute' was painted
in casein on a gallery announcement … It was
a printed piece of paper. I don't remember
what it was, but it was a nice paper so I used
it to paint on … 'The Paradoxical Absolute'
didn't come from the announcement. That
just came from my head. I just liked it. I think
I was thinking at the time about philosophy.
And I didn't read so much about art, I didn't
read the art magazines but I read other things.
I was interested in the word 'absolute' and its
meaning and how things were not exactly
that way. Somehow I came up with that
phrase and I thought it interesting and I
wrote it on this painting. It was a matter of
putting the title on the front of the painting
… it was just something I did … mostly I
didn't title [the paintings]. I think mainly
because they weren't going anywhere. I mean
they weren't being shown and I thought that
if they were ever shown then I would think
of something to call them … Since I wasn't
exhibiting, the titles were not of importance
at all because it was just the painting I was
interested in, in doing the painting, and it
wasn't a picture of anything. The titles were
totally unimportant.
(RR and CK)

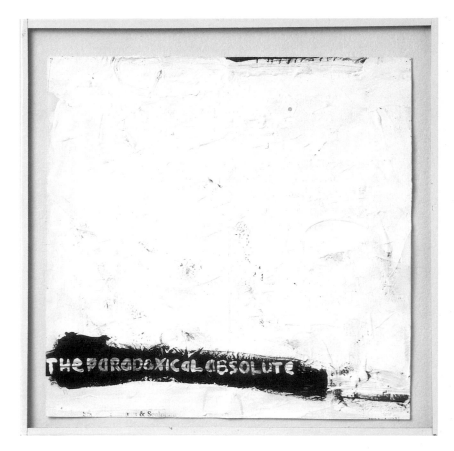

7 **Untitled** 1958

Oil, casein and graphite pencil on wallpaper, 22.8 × 23 (9 × 9$\frac{1}{16}$) including frame
The artist

Inscribed 'R. Ryman 58' vertically, upper left edge, this is mounted between glass sheets, held together with white tape.

This is one of a number of small works made in 1957–8, generally casein or gouache on newsprint or plain paper, but here, wallpaper (see nos.8, 9). Other examples are illustrated in Zurich 1980, pp.28–9 (nos.1–6).

RR: There was green underneath the central section as I remember, a very deep green, but it's predominantly black, a kind of greenish black. I don't remember what color the signature is . . . it was just a compositional device there, this shape was coming in and then the signature was the line with the curves, and the movement going opposite to the shape . . . I don't think that it has been shown anywhere . . . most [works made c.1958] were not shown (although a few have been), simply because there wasn't the right opportunity. I didn't show until 1967, so by then I had new paintings to show. I didn't want to show the 1958 paintings.
(RR and CK)

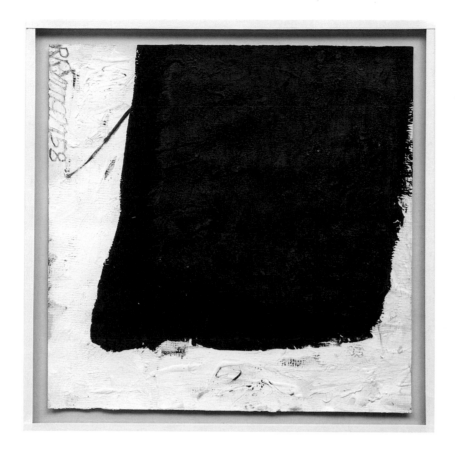

8 Untitled 1958

Casein and graphite pencil on tan paper on
grey-white matt board 35.5 × 34.5
($14 \times 13\frac{5}{8}$)
Exh: London 1977 (4, repr. p.10)
Lit: Naomi Spector, 'Robert Ryman at the
Whitechapel', London 1977, p.10; Jean
Frémon, 'Ceci n'est pas un carré blanc',
Ryman, peintures recentes, exh. cat., Galerie Maeght
Lelong, Paris 1984, p.4, repr. p.18 in col.
The artist

In this work the date '58' appears on the right
side of the composition. The artist's signature,
'RRYMAN', written in pencil, runs along the
bottom of the paper occupying about one-
third of the image. Like no.7 it is mounted
behind non-reflective glass.

As in a number of Ryman's small collages
and unstretched canvas works of 1958 and
1959, this painting incorporates his signature
and the date as an element in the composition.

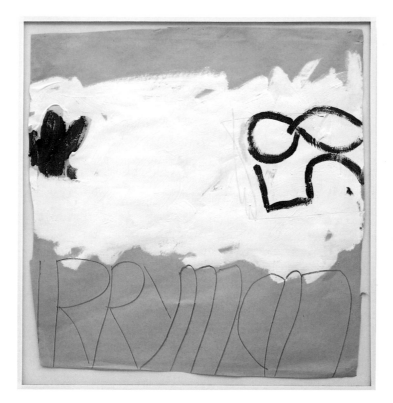

9 To Gertrud Mellon 1958

Casein and graphite pencil on wallpaper
29.9 × 30.5 ($11\frac{3}{4} × 12$)
Exh: Staff exhibition, The Museum of Modern
Art, New York 1958
The artist

Inscribed 'To Gertrud Mellon' on the back, and
'RRYMAN58' bottom left, this is framed behind
non-reflective glass.

This work was first exhibited at a Museum
of Modern Art staff exhibition in 1958, while
Ryman was employed as a guard at the
museum. It was bought by Gertrud Mellon
who recently sold it back to the artist. The title
of the work, added by Ryman when he
bought back the painting, is inscribed by him
on the back of the work. The purchase price
paid by Gertrud Mellon in 1958 ($70) is also
inscribed on the backing board.

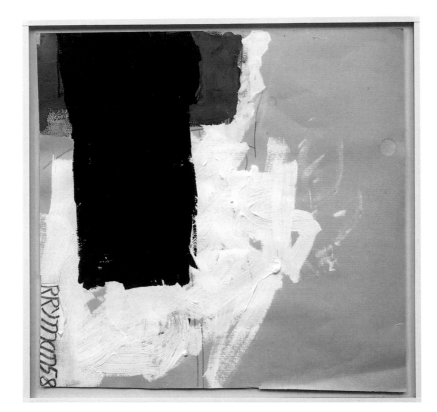

10 Untitled 1959

Pencil, casein and tracing paper on tracing
paper 26 × 26.3 ($10\frac{1}{4}$ × $10\frac{3}{8}$)
Exh: *Early Works by Gallery Artists*, Dwan Gallery,
New York, Nov. 1970; Amsterdam 1974 (6,
repr.); London 1977 (9); Zurich 1980 (5,
repr. p.37); Paris 1981 (5, repr. p.27);
Schaffhausen 1983–
Lit: Naomi Spector, Amsterdam 1974,
pp.4–5; Jeremy Gilbert-Rolfe, 'Appreciating
Ryman', *ArtsMagazine*, vol.50, no.4, Dec. 1975,
p.71; 'Dossier Robert Ryman', *Macula* (Paris),
no.3/4, Sept. 1978, repr. p.116 (2). Also repr:
Fischbach Gallery announcement 1970
The artist

Inscribed 'RRYMAN 59' twice on tracing paper
collage, bottom right.

This fragile work on translucent paper, about
10 inches square, is important for it is among
the earliest examples of work which relates to
the wall. Here it practically incorporates it
into its semi-translucent self. This collage is
notable also for its delicate lines, which occur
singly, in a series of three, as a rectangular
frame around an area of white paint, and in a
larger curving angle on the right which
suggests a rectangle in the lower right corner
of the work.
(Spector 1974, pp.4–5)

RR: This was one of the paintings with the
double signature [see also no.18]. It has some
collage elements also, the signatures are
pasted on. But this has so many nuances in it.
There is this little red line, which was just in
pencil, and then the black shape in the corner
which I seem to have used a number of
times, and then the opposite line. It just
consists of a few simple devices that I felt
seemed to work, seemed not to need
anything more, and then this paint stroke,
and then a curved line. So I had a curve and a
straight line and shape and color in it. It had
all of the compositional elements that any
painting has. And then of course, it being on
tracing paper the tracing paper becomes very
translucent and soft ... and very naked too, as
the elements stand out because of the tracing
paper.
(RR and CK)

11 **Untitled** 1959

Casein, graphite pencil, red crayon, red
ballpoint pen and tracing paper on tracing
paper on board, on wood 25.5 × 21.5
(10 × 8½)
Exh: ?*Robert Ryman, Early Paintings*, John Weber
Gallery, New York, April 1972; London 1977
(10); Zurich 1981 (5, repr. p.47, fig.3,
wrong dimensions facing); *Three Generations:
Studies in Collage*, Margo Leavin Gallery,
Chicago, Jan–March 1978
The artist

Inscribed and dated 'RRYMAN59' in red
ballpoint, lower right centre, and framed with
Plexiglas. The work consists of a rectangular
collage with tracing paper at top centre,
slightly overlapping the top edge; a horizontal
white paint stroke beneath the collaged tracing
paper, and three short pencil lines near the
lower right corner of the collage, on the main
sheet of paper. There are occasional pencil lines
at various places throughout.

This work may have been included in
Ryman's 1972 exhibition at the John Weber
Gallery in New York but the artist is unable to
confirm this.

12 Untitled 1959

Oil on cotton canvas 110.6 × 110.6
($43\frac{1}{2}$ × $43\frac{1}{2}$)
Exh: *Robert Ryman, Early Paintings*, John Weber
Gallery, New York, April 1972; Amsterdam
1974 (4); London 1977 (6); Zurich 1980
(4, repr. p.31); Paris 1981 (4, repr. p.26);
Schaffhausen 1983–
Lit: Paris 1991, repr. p.79. Also repr.: 'Dossier
Robert Ryman', *Macula* (Paris), no.3/4, Sept.
1978, p.118, repr. no.9 (dated 1961);
Documenta 7, exh. cat., Kassel 1982, vol.1, repr.
p.67
The artist

Dated '59' on side of stretcher, top left.
Inscribed vertically 'RRYMAN' bottom left, in
ochre on raw area of cotton support.

RR: I used the signature as a line, and I
generally put it up the side or on the end . . .
just to make it more abstract so that it would
read more as a line and not so much as my
name, necessarily. I used my name because
that was an accepted element of all painting
. . . If I just used line . . . it would have been a
kind of symbol . . . It would have been as if I
was painting something or trying to say
something.
(RR, unpublished interview with Robert
Storr, June 1992)

According to Ryman, his use of cotton as a
support in 1958–9 was governed by his
interest in the colour of the cotton fabric,
rather than cost:

RR: It wasn't economics because there wasn't
much of a difference. It had to do with the
color actually, because the cotton was always
this kind of Naples Yellow color, and of
course the linen was always dark brown and
could be prepared or gessoed in a traditional
manner so that they [the paintings] all looked
the same. But in certain ways I think cotton
was easier to work on at that time, because it
didn't take quite the stretching and the
preparation that linen needed. With cotton
you could stretch it and wet it down to take
the wrinkles out and then coat it with rabbit
skin glue . . . but with linen it took a little
more stretching, you had to restretch it
because linen was more difficult to work
with. This was a time when the
predominantly black shapes were being
eliminated. Sometimes only the traces on the
edge would remain. I would see how it was
working for a while and, if I didn't like it,
take it out.
(RR and CK)

13 Untitled 1959

Oil on jute sacking 84 × 84 (33 × 33)
Exh: Paris 1991
The artist

Ryman used jute sacking as a support for this
painting, and the seam became part of the
image:

RR: I cut it open. That's why there's stitching
here, because it was part of the way it was
sewn together, and I thought it was a nice
piece of material. It was very strong and
similar to linen, maybe even stronger in
certain ways, so I stretched it on a stretcher
and it came out with those edges, with the
stitching.

So when I was painting it, I used the seam
as part of the structure of the composition
and that is why it looks the way it does, with
that edge open, and it's curved a little bit on
the side.
(RR and CK)

14 Untitled 1959

Oil on pre-primed canvas 20.5 × 21 $(8\frac{1}{8} \times 8\frac{1}{4})$
Lucy R. Lippard

Inscribed on top of stretcher verso in red
ballpoint 'RRYMAN'.

A painting given by the artist to the critic
Lucy Lippard. The artist does not think it has
previously been exhibited.

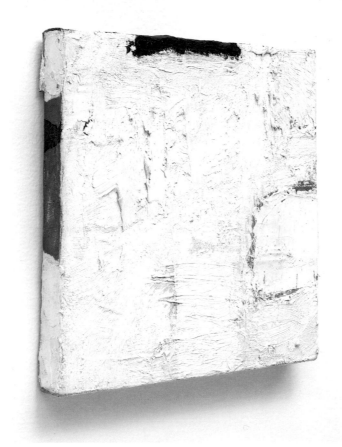

15 Untitled 1960

Oil on two cotton canvas panels, left-hand panel 165.5 × 109 (65¼ × 43), right-hand panel 165.5 × 56 (65¼ × 22), overall size 165.5 × 164 (65½ × 65)

Exh: Robert Ryman, Early Paintings, John Weber Gallery, New York, April 1972; Amsterdam 1974 (8, repr. in col.); *Fundamental Painting*, Stedelijk Museum, Amsterdam, April–June 1975 (1)

*Lit: Naomi Spector, Amsterdam 1974, pp.7–8; Jeremy Gilbert-Rolfe, 'Appreciating Ryman', *ArtsMagazine*, vol.50, no.4, Dec. 1975, pp.70–3; 'Dossier Robert Ryman', *Macula* (Paris), no.3/4, Sept. 1978, repr. p.11*

Stedelijk Museum, Amsterdam

Inscribed 'RRYMAN60' at top centre left of panel.

One of a group of paintings from 1960–1 of roughly the same dimensions, with all-over patterns of white brushstrokes often concentrated away from the centre of the support. In the left panel of this two-part painting, densely applied white paint almost obscures yellow, green and blue underpainting. There is a narrow band of exposed canvas running the length of the right edge. In the right-hand panel, the surface is smoothly applied to cover the whole surface. This is an early example of a painting by Ryman made from more than one part.

RR: I did this painting in '59. It says '60 and it's dated '60 because that's really when I finished it. I did most of it in '59 and the reason I remember this is because I was living in a very little place at the time off Avenue A and Eleventh Street in New York, and this would not go out the door. So that's one reason why it was in two sections, so that I could get it out.

And of course one panel is a very smooth soft surface and the other is very articulated with a lot of movement. The paint is just the opposite. [The support] is cotton and it's left raw there, and so you see the soft yellow of the cotton itself and then this thing I am always using, the straight line and the curved line next to each other. I think also in this case there is a lot of color underneath ... the color which was there was not considered that much. It was more whatever colors I had underneath the white, because I was aware I was going to cover it so it was just a matter of having some kind of a difference in light intensity that would be caused by the color underneath the paint. I wasn't that involved with the color itself. It was just part of the process of building up that surface.
(RR and CK)

16 Untitled 1960

Oil on linen canvas 133 × 133 ($52\frac{3}{8}$ × $52\frac{3}{8}$)
Exh: Robert Ryman, Early Paintings, John Weber
Gallery, New York, April 1972; Zurich 1980
(10, repr. p.45); Paris 1981 (10, repr. p.31);
Schaffhausen 1983–
Lit: Paris 1991, repr. p.87 in col.
Crex Collection, Hallen für neue Kunst, Schaffhausen

Inscribed 'R RYMAN' bottom left.

 In addition to small paintings on canvas and
paper, in 1960 Ryman was also working on
larger canvases with accumulated all-over text-
ures produced by a build-up of brush marks,
the greater concentration of marks generally
being off-centre (see also Paris 1991, repr.
pp.83, 85, 89).

17 Untitled 1960

Oil, gouache, casein, graphite pencil and red crayon on tracing paper on plain paper
33 × 33 (13 × 13)
Lit: Zurich 1980, p.47, repr. no.4
The artist

Inscribed 'RRYMAN60' centre right in pencil, mounted on cream matt board, on wood, covered with non-reflective glass.

Plain paper forms a quarter inch border around the tracing paper. A black square in the upper left corner is painted in casein and a white square area at top centre over the main white painted area is gouache. Under it, the remaining white and orange undercoat is oil. Near the centre at the bottom of the work are six red small vertical crayon marks. Pencil lines appear at intervals around the central form. Compare with nos.10, 11.

18 Untitled 1960

Pencil, oil, casein and tracing paper on
tracing paper laid on opaque paper
25.4 × 26.6 (10 × 10$\frac{1}{16}$)
Exh: Amsterdam 1974 (14); London 1977
(16); Zurich 1980 (14, repr. p.37); Paris
1981 (14, repr. p.35, b.r.)
Lit: Phyllis Tuchman, 'An interview with
Robert Ryman', *Artforum*, vol.9, no.9, May
1971, p.46, repr. p.51; Naomi Spector,
Amsterdam 1974, p.5; Barbara Reise, 'Robert
Ryman: Unfinished I (Materials)', *Studio
International*, vol.187, no.963, Feb. 1974, p.78,
repr.; Barbara Reise, 'Senza Titolo III
(Posizione)', *Data*, vol.4, no.11, Spring 1974,
p.33
The artist

This collage with its double signature at
bottom right is closely related in technique and
image to the earlier 'Untitled', no.10.

19 Untitled 1961

Oil on linen canvas 96.6 × 96.6 (38 × 38)
Exh: Amsterdam 1974 (17); London 1977
(19); Zurich 1980 (18, repr. p.55); Paris
1981 (20, repr. p.40); Schaffhausen 1983–
Lit: Naomi Spector, Amsterdam 1974, p.8
The artist

Inscribed 'RRYMAN 61' twice, bottom left.

As in the slightly earlier 'Untitled', 1960,
not in this exhibition (repr. Paris 1991, p.81 in
col.), here Ryman has introduced a flat rec-
tangle against the edge of the canvas, in con-
trast to the remaining vigorously painted
surface.

RR: It has the double signature . . . and this
corner [top right] is actually the gesso, it
wasn't over-painted and it was in a sense
showing the individual elements of the
painting so you saw the linen with the size
and then you saw the gesso priming, which I
simply made into this rectangular shape in
the corner of the painting; there again [as in
no.15] with the straighter line against the
curve and the different paint surface.
(RR and CK)

20 Untitled 1961

Oil on sized Bristol board 22.8 × 22.8 (9 × 9)
Exh: Amsterdam 1974 (26, repr.); London
1977 (28); Zurich 1980 (19, repr. p.51);
Paris 1981 (21, repr.); Schaffhausen 1983–
Lit: Naomi Spector, Amsterdam 1974, p.5;
'Dossier Robert Ryman', *Macula* (Paris),
no.3/4, Sept. 1978, pp.113–85, repr. 5
The artist

Inscribed 'RRYMAN' top left ('1961' near
centre).

One of a number of paintings on Bristol
board made between 1959–61. Ryman found
this heavy paper a good surface to work on.
The paintings are characterized by complex
brushstrokes:

Along its bottom edge and up the otherwise
unpainted right side is a row of round tufts
made by pressing the mouth of the tube of
paint to the paper and lifting it directly up,
leaving little raised peaks in each of the white
circles.
(Spector 1974, p.5)

**21 A painting of twelve strokes measuring
1 1¼″ × 1 1¼″ signed at the bottom right-
hand corner** 1961

Oil and gesso on linen canvas 28.5 × 28.5
(1 1¼ × 1 1¼)
Exh: Amsterdam 1974 (23); Basel 1975 (2,
repr.); London 1977 (25); Zurich 1980 (23,
repr. p.37); Schaffhausen 1983–
Lit: Naomi Spector, Amsterdam 1974, pp.5–6.
Also repr: Paris 1981, p.35
The artist

Inscribed 'RRYMAN 61' bottom right.

This is one of several small unstretched linen
canvases, most measuring about twelve inches
square, where Ryman arranged small dabs or
bars of paint in vertical stacks, sometimes
extending these by blocking in his signature.
Here the signature appears once, but in
another closely related and slightly larger
painting, 'Untitled', 1961 (Amsterdam 1974,
20, repr.) he incorporates it three times, below
eleven strokes and, as Naomi Spector points
out, lengthens the last two inscriptions to
'RRYMAN 611' to match the proportions of the
bars of paint above it. In another example, ten
signatures replacing the painted bars are
stacked vertically, one above the other, run-
ning the length of the canvas (repr. London
1977, p.9, fig.23). Other multiple signature
works are illustrated in Paris 1981, p.35.

The significance of this group of paintings
can hardly be overemphasised, for this is the
first time the modular idea dominates the
painting. Repetitions of similar strokes occur
again and again in various ways ... up to the
present time. Even the idea of whole panels
being repeated as modular units in many-part
paintings may be said to have originated
here, with these firm elements rhythmically
accumulating themselves.
(Spector 1974, p.6)

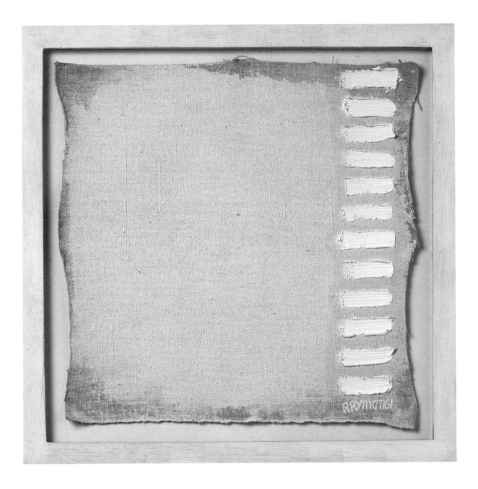

22 **Wedding Picture** 1961

Oil on Bristol board 30.5 × 30.5 (12 × 12)
Exh: Amsterdam 1974 (22); Basel 1975 (6,
repr.); London 1977 (24); Zurich 1980 (24,
repr. p.63); Paris 1981 (26, repr. p.43);
Schaffhausen 1983–
The artist

Inscribed 'RRYMAN 61' near centre.
 In 1961 Ryman married the American critic,
Lucy Lippard.

RR: This is an unusual painting. It's titled
'Wedding Picture' and it is the only painting
I ever did in Maine. I could never paint there
you know, there was too much fog and too
many trees . . . But I did do this there and it's
in a sense more picture-like than most of the
paintings I was doing at that time, simply
because it had very defined elements within
the space. It is a very open painting and it's
one of my favourites. I was married there [in
Maine] but I don't think it was made at that
time. There was a little house there and we
went up and stayed for a month or so in the
summer, and that's why it's called 'Wedding
Picture'. I had no studio, not literally, because
I was up there so little – a month maybe at
the most . . . I would do a few small things at
times, at least at the beginning I tried. Then
later on I didn't even attempt to because
there was just not the right situation there. I
remember because of the fog it took forever
for the painting to dry. It is oil and it never
seemed dry enough.
(RR and CK)

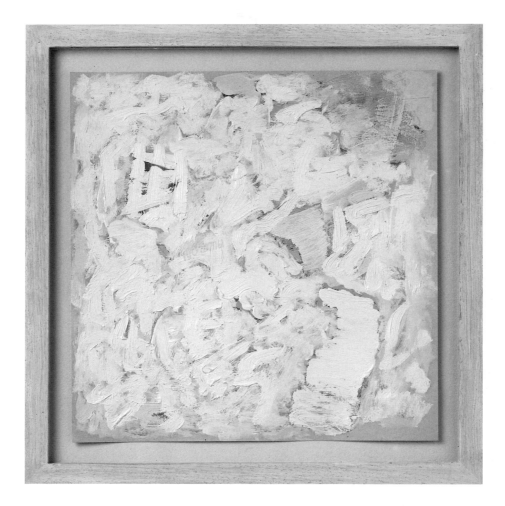

23 Untitled 1961

Oil and gesso on unstretched linen canvas
41.9 × 41.9 (16½ × 16½)
Exh: Amsterdam 1974 (19); London 1977
(21); Zurich 1980 (21, repr. p.61); Paris
1981 (23, repr. p.42); Schaffhausen 1983–
Lit: Naomi Spector, Amsterdam 1974, p.8.
Also repr: *Ryman, peintures recentes*, Galerie
Maeght Lelong, Paris, April–June 1984, p.10
The artist

Inscribed 'RYMAN' top right in green.

RR: I've used this corner a number of times
[see the much later 'Context', 1989, repr.
Paris 1991, p.161], and I do not know why
exactly. It's an unconscious thing. It gives me
an angle which I have used very seldom in
my painting. Here, I felt it gave the painting
an interesting, slightly different feeling than
some of the others, because many times I was
using a rectangle and a corner, or a square
and a corner, but almost never a triangle.
What happened was not planned. It was not
planned to leave the corner but I was
painting this area and I stopped and came
back the next morning and there was
definitely an area where the corner had been
left. I thought, maybe I will not go any
further with the main paint plane area. So I
straightened it up a bit and then continued
and added paint … It didn't begin with
leaving that corner like that.
(RR and CK)

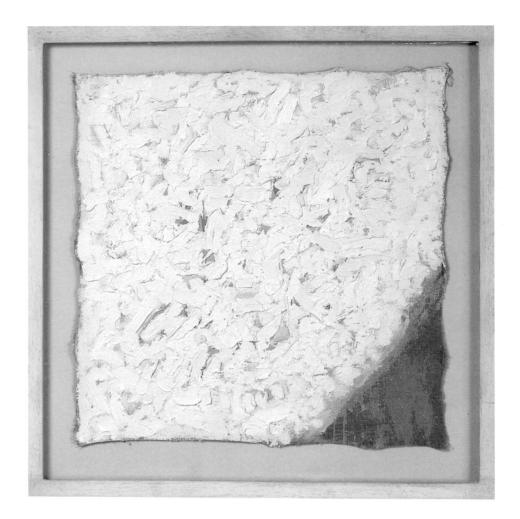

24 Untitled 1961

Oil and graphite on brown paper, mounted
on board 23 × 23 (8 × 8)
Exh: *American Painting in the Watershed Year* 1961,
Alan Frumkin Gallery, New York 1974 (17,
repr.)
The artist

Inscribed 'RRYMAN61' in pencil at lower left
edge of large white rectangle.

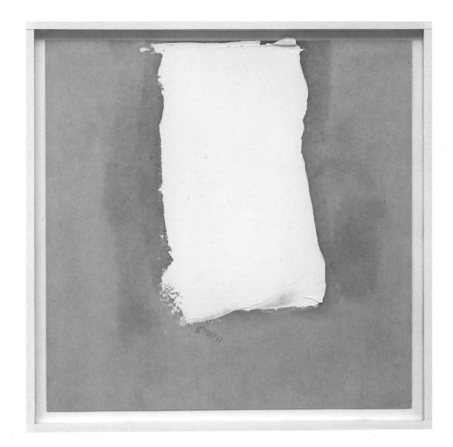

**25 An all white painting measuring
 9½″ × 10″ and signed twice on the left
 side in umber 1961**

Oil on linen canvas 24.1 × 25.4 (9½ × 10)
Exh: *Robert Ryman, Early Paintings*, John Weber
Gallery, New York, April 1972; Amsterdam
1974 (24, repr.); London 1977 (26); Zurich
1980 (20); Paris 1981 (16, repr. p.37 upside
down); Schaffhausen 1983–
Lit: Naomi Spector, Amsterdam 1974, p.6;
Zurich 1980, repr. p.53
The artist

Inscribed 'RRYMAN 61' top and bottom left.
 This work relates to 'Untitled', 1961 (repr.
Paris 1981, bottom of p.37).
 Naomi Spector compares this painting with
the group of small works from the same period
using series of units, sometimes with repeated
signatures (see no.21).

From the same period [1961] is another
group of paintings, also smooth in surface
and severe in concept. On unstretched linen
canvases about 10 inches square, oil paint has
been stroked alternately in vertical and
horizontal directions. The consequence is a
rather smooth, hard 'woven' surface which,
in spite of some roughness of paint around
the edges, relates strongly to the 'Unfinished
Painting' of 1965 [see no.32] and many
others.
(Spector 1974, p.6)

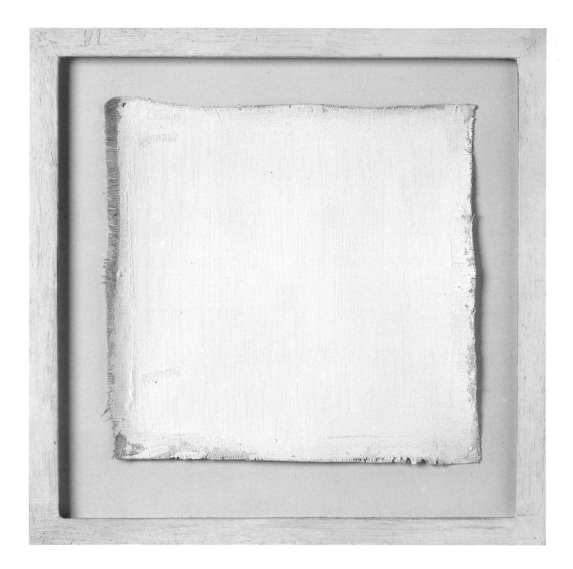

26 Untitled 1961

Oil on Bristol board 25.5 × 25.5 (10 × 10)
Private collection

Inscribed on the reverse, 'a painting of six strokes in the lower right-hand corner, signed left centre in flesh orange and in neutral, measuring 10″ × 10″.' Inscribed on the front, 'RRyman', centre left, and 'RRyman61', top centre. This has similarities with 'Wedding Picture', 1961 (no.22) and the six strokes in the bottom right-hand corner relate to paintings like 'A painting of twelve strokes measuring 11¼″ × 11¼″ signed at the bottom right-hand corner' also made in 1961 (no.21).

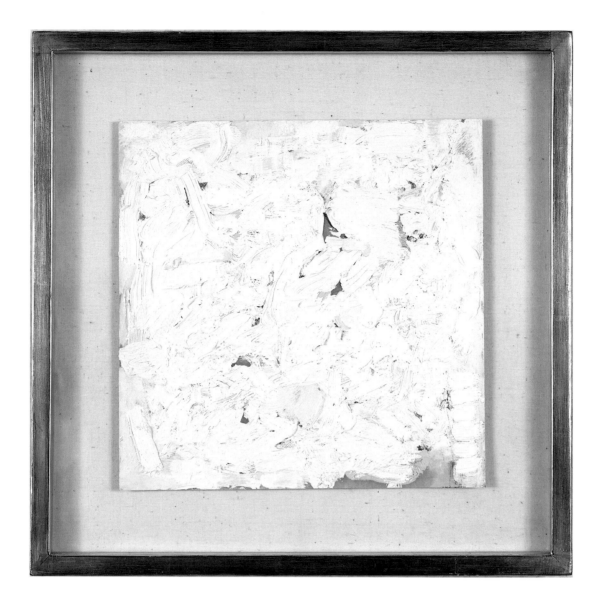

27 Untitled 1961

Oil on unstretched linen canvas 33 × 33
(13 × 13)
Lit: Contemporary Art, Sotheby's New York,
3 Oct. 1991, sale 6213, lot 96, repr. in col.
and on cover of cat.
Private collection, New York

Signed 'RYMAN' bottom right in green paint.

 The composition is a square within a square
and the artist has incorporated his signature in
green at bottom right. Painted on unstretched
canvas, primed in flat white, with the inner
square area of overlapping, short, curving
strokes, this painting relates to other small
works of this time. Areas of primer, as well as
green, blue and black paint are visible beneath
the white. The paint surface is particularly lush.

 This represents a body of work in large and
small formats that culminated in 1962, after
which Ryman's painting was more system-
atically conceived.

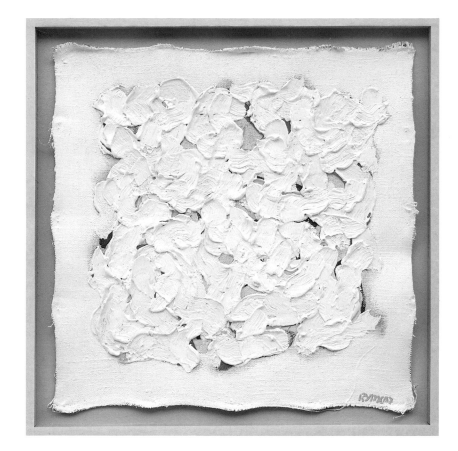

28 Untitled 1962

Oil on unstretched linen canvas 42 × 42
($16\frac{1}{2} \times 16\frac{1}{2}$)
Exh: Amsterdam 1974 (28, repr. in col.);
London 1977 (29); Zurich 1980; Paris 1981
(32, repr. p.48); Paris 1991
Lit: Naomi Spector, Amsterdam 1974, p.8;
London 1977, p.11
The artist

This work compares with 'Untitled', 1960–1
(repr. in col. Paris 1991, p.91), now at Schaff-
hausen.

In 1960, 1961 and 1962 [Ryman] produced
a number of small unstretched paintings on
linen. These . . . are dominated by an area of
dynamic . . . strokes of white oil paint between
which particles of blue-green pigment glow.
The area of paint stops short of some or all of
the edges, revealing the thin gesso and the
raw canvas . . . One of the most representative
of this group . . . [shows] . . . a border of the
raw linen on all four sides, but a considerable
amount of the blue-green underpainting all
around the central area. The left and right
sides of the fabric have been cut but are
ragged. Their irregularity is increased by the
scalloped effect which resulted from
stretching the linen out further at certain
points to staple it flat on a board for sizing.
The bottom edge shows that it too has been
stretched out further at intervals. But this
edge is the selvage and has two narrow
horizontal red stripes woven into it. They are
like an honest part of the material and are like
a found image.
(Spector 1974, pp.8–9)

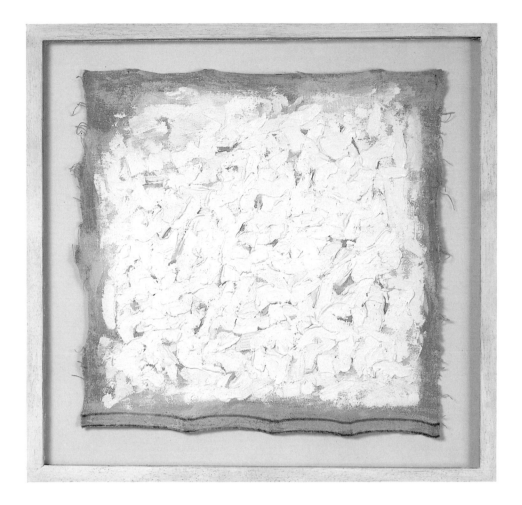

29 Untitled 1962

Oil on linen canvas 176.5 × 176.5 (69½ × 69½)
Exh: Zurich 1980 (25, repr. p.67); Paris 1981
(28, repr. p.44); *Classic Modernism: Six Generations:*
Mondrian, Albers, Newman, Kelly, Ryman, Halley,
Sidney Janis Gallery, New York, Nov.–Dec.
1990; Paris 1991
The artist

This is one of four canvases painted in 1962
where Ryman has partially obscured his linen
support and areas of intensely coloured under-
painting with an all-over surface of wiggling
one inch wide strokes of thick white paint. The
other versions are 'Untitled', 1962, blue and
rust red underpainting (Schaffhausen, repr.
Paris 1991, p.95 in col.) and 'Untitled', 1962
green and red underpainting (see no.30). A
further version with violet, cobalt and red
underpainting is in the artist's collection in
New York.

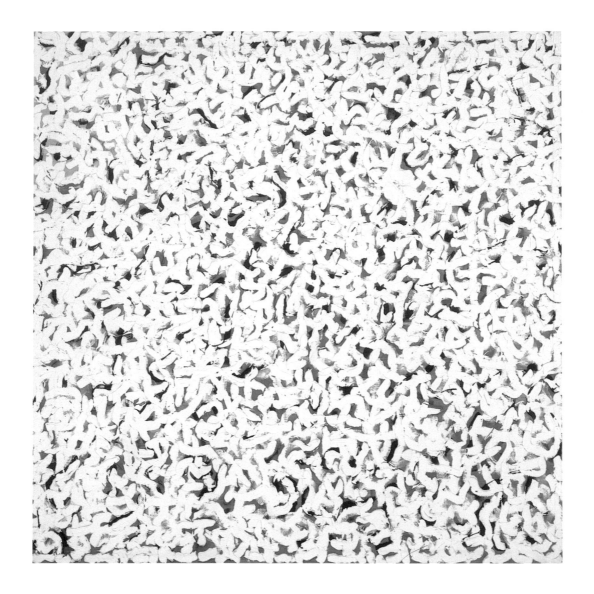

30 Untitled 1962

Oil and vinyl on linen canvas 160.1 × 165.2
(63 × 65)
Exh: Zurich 1980 (27, repr. p.69); Paris 1981
(30, repr. p.46); Schaffhausen 1983–
Lit: Christel Sauer, Paris 1991, p.25, repr. p.93.
Also repr. as postcard in col., Schaffhausen
The artist

As in no.29, here Ryman has used white
strokes over other colours, in this case rust-
red, browns and greens. The right edge of the
canvas has not been attached to the back of the
stretcher but projects out flat against the wall
to the right of the painting.

RR: It was a matter of working with the side
of the painting and making the painting as
naked and as open as possible, which I did on
those earlier paintings with the shapes on the
side [see nos.3, 4, 8]. This one had a great
deal of movement and color even on the
front; then I brought it around on the side.
When I was stapling the canvas onto the
structure there was a strip of canvas that
usually goes round the back and I thought
maybe I'll just leave this unattached. I wasn't
quite sure how it would be. There was a new
paint out at the time . . . it was like an acrylic
but it was made of a vinyl paint. It was almost
like rubber when it dried so it could take a
flex. I used that paint on this edge of the
canvas where it came off of the stretcher,
using the same colors that I had used with oil
on the front and just essentially continued the
front paint plane onto the back of the linen.
And I had three sides of the painting which
were very straight and then I had the one side
which was jagged and it was directly next to
the wall.
(RR and CK)

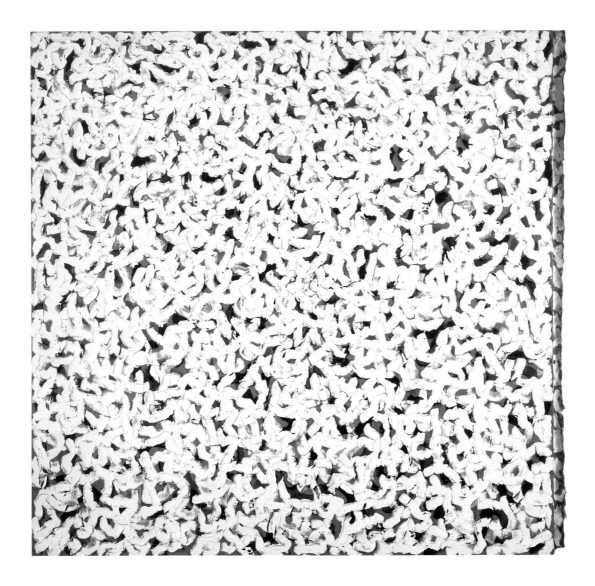

31 Stretched Drawing 1963

Charcoal on unprimed, stretched cotton
canvas, stapled to wood stretcher 36.8 × 36.6
$(14\frac{1}{2} \times 14\frac{7}{16})$
Exh: London 1977 (35, repr. p.10)
Lit: Phyllis Tuchman, 'An Interview with
Robert Ryman', *Artforum*, vol.9, no.9, March
1971, pp.46–53, repr. p.49; Barbara Reise,
'Robert Ryman: Unfinished II (Procedures)',
Studio International, vol.187, no.964, March
1974, p.123 repr.; Barbara Reise, 'Procedures'
in 'Dossier Robert Ryman', *Macula*, (Paris)
no.3/4, Sept. 1978; p.151 repr.; Naomi
Spector, 'Robert Ryman at the Whitechapel',
London 1977, pp.9–10. Also repr: *Drawing
Now*, The Museum of Modern Art, New York,
Jan.–March 1976, p.63
The artist

The canvas is covered with 5 × 5 square grid in
charcoal, and signed on the back 'RYMAN63'.

This is one of two 'Stretched Drawings'
made by Ryman at the time. He drew a grid on
stretched canvas, unstretched it, and then
stretched it again. He also made a series of 'Bent
Line Drawings' in blue ballpoint pen on poly-
ester. For each of these he drew a perfect square
on a piece of unstretched fabric. Because the
polyester was pliant, the squares became dis-
torted when the work was stretched. For
Ryman the interest lay in the contrast between
the straight edge of the support and the curved
drawn line.

This looks like a regular stretched canvas, but
it has no paint. The cotton canvas has been
marked with a charcoal pencil grid which
wraps around the sides of the stretcher along
with the canvas. But the presence of marked
lines and the absence of paint in the drawings
always makes the distinction clear.'
(Spector 1977, pp.9–10)

32 Untitled 1965

Enamelac on linen canvas 158.5 × 158.5
(62½ × 62½)
Exh: New York 1972 (5, repr.); Zurich 1980
(30); Paris 1981 (35, repr. p.49);
Schaffhausen 1983–
Lit: Lucy Lippard, 'The Silent Art', *Art in
America*, vol.55, no.1, Jan.–Feb. 1967, p.58;
Phyllis Tuchman, 'An Interview with Robert
Ryman', *Artforum*, vol.9, no.9, May 1971,
p.53; Naomi Spector, Amsterdam 1974, p.17;
Jeremy Gilbert-Rolfe, 'Appreciating Ryman',
ArtsMagazine, vol.50, no.4, Dec. 1975, p.73.
Also repr: Paris 1991, p.50
Private collection

In 1965, Ryman made a series of totally flat
monochrome white paintings, in oil, acrylic
and enamel. This relates to a similar sized
painting also exhibited at the Guggenheim in
1972, 'Unfinished Painting', 1965 (New York
1972, no.6).

RR: In 1965, I did two paintings. One
became an 'Unfinished Painting' (that was
the title of it). They were two related
paintings. Both were the same size, five by
five feet. One was done in enamel and one
was done in oil because I wanted the
reflection of the light with the enamel and I
wanted the absorption of the light, very matt,
with the oil in the second painting. They
were both on the same linen.
(Tuchman 1971, p.53)

RR: Each paint has different properties, and
you get different results ... and that's why I
use different paints. Enamel is such a fluid
paint, and it dries relatively quickly. Certain
types of enamel tend to give a highly
reflective surface, which in this case is what I
wanted. I wanted that very opposite feeling to
the linen, which was brown, and I left the
linen brown ... it's natural color. And then the
enamel, though it leaves a highly reflective
surface, also has a very soft feeling. So there
was that juxtaposition of the two elements.
The enamel went right up to the edge of the
canvas. The linen was seen obliquely from the
side, and there was a soft edge where the
enamel met the edge of the stretcher. The
stretcher was very straight, with more of a
hard feeling, and then you had the softness
next to it. Before I applied the enamel, the
canvas was sized ... In '65 I probably used
glue. I might have used vinyl acetate. But
there again, it might have been rabbit skin
glue. All the early paintings have rabbit skin
glue as a size and later on I started using vinyl
acetate, because I was told by Orrin Riley that
it was more stable.
(RR and LZ)

33 Untitled 1965

White enamel on linen canvas, stretched and
stapled onto wooden stretcher 25.8 × 25.8
($10\frac{1}{8} \times 10\frac{1}{8}$)
Exh: New York 1972 (7, repr.)
The artist

Inscribed along right edge in grey paint,
'Ryman 65'.

The paint surface of this work is uninflected
and Ryman's brushstrokes are hardly visible. A
single sheet of white enamel covers the surface
but the edges of the canvas are just visible in an
uneven line around the edge of the painted
field.

This is one of a group of small canvases
of 1965 that were exhibited in Ryman's
one-person exhibition at the Guggenheim
Museum in 1972. Several were reproduced in
the catalogue for that exhibition (see New
York 1972, cat.nos.1–8).

34 Untitled 1965

Enamel on Bristol board 19.7 × 20.6 ($7\frac{3}{4} \times 8\frac{1}{8}$)
The artist

Inscribed in pencil bottom left 'Ryman 65'.

 One of the small paintings related to the 'Winsor' series (see no.36), in that it has horizontal bands running across it. However, the artist has pointed out that the association is not a formal one. This is close in scale and composition to a number of small works on canvas exhibited by Ryman at the Guggenheim in 1972 (see New York 1972, cat.nos.1–8). The relationship between the viscous enamel paint and the smooth Bristol board is particularly sensual.

RR: They were small paintings, and they were done with a small brush. They are not really titled 'Winsor'; the only 'Winsor' paintings are the bigger ones. The little ones are . . . untitled.
(RR and LZ)

35 **Untitled 1** 1965

Oil on stretched linen canvas 27.9 × 27.9
(11 × 11)
The artist

Signed 'Ryman 65'.

This work is related to 'Untitled No.2', in the artist's collection. It bears a resemblance to 'Mayco' (no.37) in that it is composed of a few broad horizontal bands of paint, although it is very much smaller. Using a narrower brush, Ryman achieves approximately the same proportional relationship between the individual bands and the surface as a whole as exists in the larger painting. The paint application is related to that of 'Twin' (no.38).

36 Winsor 34 1966

Oil on linen canvas 159.1 × 159.1 (63 × 63)
Exh: Paris 1991 (listed) *from Collections of Friends
of the Museum of Fine Arts*
Lit: Richard Channin, 'The Rise of Factural
Autonomy', *ArtsMagazine*, vol.47, Nov. 1972,
pp.30–7; Barbara Reise, 'Robert Ryman:
Unfinished II (Procedures)', *Studio International*,
vol.198, no.964, March 1974, pp.122–8;
Joseph Masheck, 'Iconicity', *Artforum*, vol.17,
no.5, Jan. 1979, pp.36–7; Christel Sauer,
Zurich 1980, p.[19]
The Greenwich Collection Ltd
[Not illustrated]

In 1965 Ryman's paintings began to develop
in recognizable systematic groupings and to
bear specific titles, both individually and as
series. Also at this time, according to Naomi
Spector, Ryman ceased to use paint to make

. . . something that could be seen at all apart
from the paint itself. Now the work was
about the nature of paint: the paint was the
content of the paintings, as well as the form.
They had no meaning outside the paint and
the supporting material and the history of the
process of the application.
(Spector 1974, p.9)

Ryman titled his first series for the year 1965,
comprising four paintings, 'Winsor', taken
from Winsor & Newton, the British paint
manufacturers whose products he uses.
'Winsor 34' consists of horizontal painted
strips, each approximately two inches wide.
Made at around the same time, although not
technically 'Winsors', were a series of smaller
untitled canvases, described by Naomi Spector
as 'prophetic', in that Ryman used the same
painting procedure as for the 'Winsors' (see
'Untitled', 1965, repr. Amsterdam, p.35):

The brush was laden with paint, placed at the
upper left corner and pulled to the right until
the paint was used up. Then it was laden
again with paint and pulled again to the right
until there was no more paint on it. This was
repeated until the strokes reached the right
edge of the canvas. Then a second row of
strokes was made directly beneath the first,
and then another row beneath that, until the
rows filled the surface. The left edge of the
painting would emerge with a more uniform
look than the right, where the brush would
run out of paint . . . A great number of works
like this were made in different combinations
of materials.
(Spector 1974, p.13)

Ryman's recollection is that he numbered the
'Winsors' arbitrarily, to aid the identification
of each work, without setting up a chronologi-
cal sequence. (In the case of 'Signet 20', a
'Winsor'-like painting of 1965–6 which is
over five feet square, the title refers to the
brand and size of the brush Ryman used to
make it. The artist remembers receiving a tele-
phone call from Christie's when 'Signet 20'
was to be auctioned. They were at a loss for
information regarding what they assumed
were nineteen other 'Signet' paintings, and
were relieved to learn that no others existed.)

RR: The 'Winsor' paintings were actually just
a group of paintings that I did at that time,
1965–6. And, technically, they were done
pretty much with the same size brush and the
same paint. The sizes varied and the canvas
varied. Some were on cotton, most were on
linen. And of course, when I approach
paintings in that way, as a group, the feeling
is very similar. But, even though the approach
is similar, the result tends to be a little
different. And that was the interest. I wanted
to see how the scale would change the
painting, and how different linen or maybe a
slightly different paint consistency would
affect it.

There were certain paintings from 1964–5
some on aluminium, all relatively small, that
formed a series in a similar way that the
'Winsors' did. There is one in Paris and there
might be one in Schaffhausen. [See 'Untitled',
1965, repr. Paris 1991.] But, as I say, I wasn't
thinking of them that way.

I never titled a painting unless it went out
to a show. Since the early works were never
shown, most of them don't have titles . . .
Later I started using titles because my work
was being shown more. I thought it would
be a good thing for identification . . . And I
tried to pick titles that one didn't associate
with objects, things, people, places . . . it was
just for identification. But I wanted to use
words that were simple, words that
everybody knew, but that did not carry too
many associations. The 'Winsor' paintings
were all done with the same brush . . . the
paint as it appears, is the same width the
brush was.
(RR and LZ)

Compare also 'Winsor 5' and 'Winsor 20'
(repr. Paris 1991, p.99 and Zurich 1980, p.79)
and 'Winsor 6' (repr. opposite)

37 Mayco 1966

Oil on linen canvas 192 × 192 (75½ × 75½)
Exh: Fischbach Gallery, New York; New York
1972 (14, repr.)
Lit: Barbara Reise, Spring 1974, p.36; Christel
Sauer, 'Robert Ryman, An Introduction' in
Zurich 1980 [n.p.], repr. p.81. Also repr: *Art of
Our Time*, The Saatchi Collection, London/
New York 1984, 105 in col.
Thomas Ammann Fine Art, Zurich

According to the artist, 'Mayco', which he has
said is one of his favourite paintings, is closely
related to 'Twin' (no.38), which it itself the
twin of 'Allied', in the collection of the
Wadsworth Atheneum in Hartford, Connec-
ticut. The three paintings, all from 1966, were
made with the same broad brush (approxi-
mately twelve inches wide). This was the first
time Ryman had used a very wide brush,
although he had used a similar approach to
painting in the 'Winsor' series (see no.36),
pulling the paint across in horizontal rows; the
difference here being that, unlike the 'Win-
sors', 'Mayco' does not obviously indicate, in
each horizontal band, where the artist
reloaded his brush.

RR: I guess you could say [Mayco] was
related to 'Twin' and 'Allied'. They were all
on canvas, some linen and some cotton, and
done with broad brushes. You see, when
you're working with oil paint particularly,
and you use it with a certain heavy
consistency, it leaves brush marks. And those
marks reflect the light. And how the paint is
brushed on will determine how the light
works on the surface. With a big brush, I
could make a large surface interact with light
in a very similar way, overall. Of course, the
size of the brush changes the scale of the
painting, and the feeling, because if you're
using a small brush, you have to make more
strokes to cover a certain area, which gives
you a different surface. Using the big brush
was just a way to pull paint over a large area,
while keeping the brushstroke. I wanted all
the brush marks to go in the same direction,
because that would allow the light to be
absorbed evenly, and you wouldn't get
certain areas that were reflecting, and certain
areas not. And also, there was a matter of
immediacy involved. I didn't want to – and I
called it fussing before – I didn't want to
work the paint too much. I wanted it to have
the feeling of having gone on at one time, as
if it were a single gesture. So there could be
no covering of mistakes – it goes on and
that's the way it is. I like that feeling, and I
like that approach. I did that with my small
brushes too. I never wanted to scrape the
paint off . . . that kind of thing. I hated that
because it looked as if there was some kind of
struggle involved, as is you weren't sure
what you were doing. And I didn't like that
feeling.
(RR and LZ)

38 Twin 1966

Oil on linen canvas 193.1 × 193.1 (76 × 76)
Exh: *Recent Acquisitions*, The Museum of Modern
Art, New York, Jan.–March 1972 (?); New
York 1972 (16, repr.); *American Art since 1945*,
Philadelphia Museum of Art, Sept.–Oct. 1972
(listed, no number); *Reinstallation of the
Collection*, The Museum of Modern Art, New
York, May 1984–Feb. 1985 (no catalogue, no
number); *Contrasts of Form: Geometric Abstract Art
1920–1980*, The Museum of Modern Art,
New York, Oct. 1985–Jan. 1986 (239, repr.
in col.); *Contemporary Works from the Collection*,
The Museum of Modern Art, New York,
April–Oct. 1986 (no catalogue, no number)
Lit: Diane Waldman, 'Introduction' in New
York 1972, p.[14]. Also repr: Zurich 1980 (85)
*The Museum of Modern Art, New York. Charles and
Anita Blatt Fund and purchase, 1971*

Inscribed on back, upper left in oil, 'RYMAN
66'; 'TWIN' in felt-tip pen; 'TOP' in oil.

In 'Twin' and its companion painting,
'Allied' (collection Wadsworth Atheneum,
Hartford, Connecticut), Ryman further
explored the possibilities of the broad brush he
used to paint 'Mayco' (see no.37). 'Twin' is
1.3cm in depth. The thickness of the stretchers
affects the viewer's perception of the finely
painted surface. It gives the work a particular
visual weight and presence that would not
exist if the stretchers were thinner.

39 Adelphi 1967

Oil on unstretched linen canvas with staples, waxed paper and masking tape 259.3 × 259.3 (102 × 102)

Exh: Heiner Friedrich Gallery, Munich, Oct.–Nov. 1968; *Gordon, Lozano, Ryman, Stanley*, Contemporary Arts Centre, Cincinnati, May–June 1968 (repr. p.[7]); *Sammlung 1968; Karl Ströher*, Neue Staatsgalerie, Munich 1968; Kunstverein, Hamburg, Neue Nationalgalerie, Berlin, March–April 1969, Kunsthalle, Düsseldorf, April–June 1969, Kunsthalle, Bern, July–Sept. 1969 (174, repr.); Amsterdam 1974 (50, repr.); London 1977 (45, repr.)

Lit: *Bildnerische Ausdrucksformen 1960–70, Sammlung Karl Ströher*, Hessisches Landesmuseum, Darmstadt, April–June 1970 (repr. 342); Phyllis Tuchman, 'An Interview with Robert Ryman', *Artforum*, vol.9, no.9, May 1971, p.48; Lucy Lippard, *Six Years: The Dematerialisation of the Art Object from 1966–1972*, London 1973, pp.25–6, repr. p.26; Naomi Spector, 'Robert Ryman Brand Paintings' in *Bilder, Objekte, Filme, Konzepte*, exh. cat., Stadtische Galerie im Lenbachaus, Munich 1973, p.156; Barbara Reise, 'Robert Ryman: Unfinished I (Materials)', *Studio International*, vol.187, Feb. 1974, p.78, repr; London 1977, p.9; *Karl Ströher, Sammler und Sammlung*, Ferpiclos 1982, p.485. Also repr: Naomi Spector, 'Robert Ryman: une chronologie' in 'Dossier Robert Ryman', *Macula* (Paris), no.3/4, Sept. 1978, pp.122, 135; Paris 1981, p.54; *Bilder für Frankfurt, Bestandskatalog des Museums für Moderne Kunst*, Munich 1985, p.133

Museum für Moderne Kunst, Frankfurt-am-Main

'Adelphi' relates to earlier oil on unstretched linen paintings of 1961 (see for example London 1977, nos.26 and 27). In Ryman's use of wax paper, it anticipates the 'Surface Veil' paintings of 1970–2, and also his recent 'Versions' paintings of 1991–2 (nos.79–81). It has a replaceable frame of waxed paper and is one of six similar-sized white linen paintings, each stapled directly to the wall and exhibited at the Heiner Friedrich Gallery in Munich in 1968. The others are 'Orrin', 1967, 'Aacon', 1968, 'Exeter', 1968, 'Impex', 1968, 'Essex', 1968 and 'Medway', 1968. All save 'Impex', which is now in the Guggenheim Collection, and 'Essex', are reproduced in Zurich 1980, pp.91–9. 'Impex' is reproduced in *Gordon, Lozano, Ryman, Stanley* (exh. cat., Cincinnati 1968, p.[8]. (See Barbara Reise, *Studio International*, March 1974, p.127 for a description). 'Essex' is reproduced in Paris 1991, p.107.

According to Ryman, 'Adelphi' saw his first use of wax paper as a frame for one of his paintings:

RR: It was also part of a group which consists of 'Adelphi' and 'Impex' . . . there were about five of them altogether. They're in Europe, mostly; I don't have them.
(RR and LZ)

RR: Since that time I have been aware of wax paper. I know it's possibilities . . . it's a translucent surface. You can see through it, [and] it has a reflection . . . yet it's very simple. It's not like a plastic or something, that would also be shiny and translucent. The wax paper is such a simple thing – direct, and it can be replaced.
(Tuchman 1971, p.48)

In 1968 Ryman continued his series of unstretched linen paintings attached directly to the wall, now using frames of masking tape, or, as in 'Impex' discussed above, a narrow blue chalk line drawn above the painting. Ryman provided hanging instructions for his early installations:

RR: Usually, no-one can find the instructions again. It's the same with the more recent paintings. I always give the owner a little folder with the title of the painting and all the information and it is invariably lost . . . 'Adelphi' is oil on unstretched linen with waxed paper and tape. That is, it was stretched on the wall, not on stretchers. And of course it was primed and I think . . . it was sized with rabbit skin glue. I don't know where the name came from. It's just . . . a name you couldn't associate with too much. The wax paper is like a frame that goes around all four sides and crosses at the corners, and it's actually taped to the wall but the tape is glued, so it doesn't come loose. I can't remember now if the papers were stapled . . . the paper goes right behind the painting. [Every time it is installed] new paper goes on and then it's destroyed when the painting comes down . . . The paper is replaced all the time, so it's always new . . . Actually, for '67 this was very radical . . . it was shown in Germany . . . there were several paintings like that, where the canvas was stapled to the wall, in fact there's one at the Guggenheim now . . . from the same period, 'Impex'. It has a blue line that runs from the ceiling down to one of the corners. And that angle changes wherever the painting is hung.
(RR and LZ)

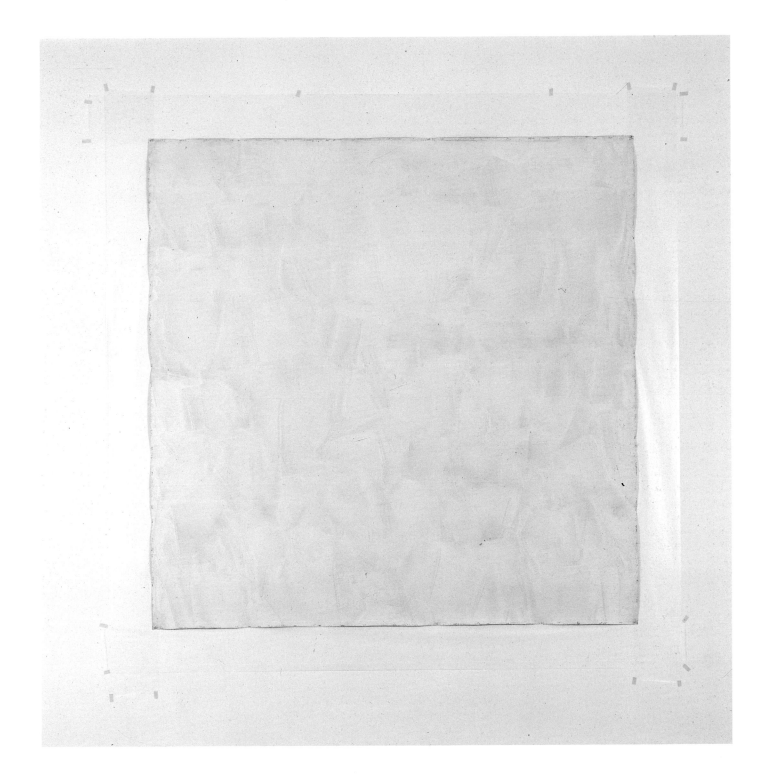

40 Lugano 1968

Acrylic on twelve sheets of handmade
Lugano paper, overall size 228.8 × 228.8
(90 × 90)
Exh: *Robert Ryman: Bilder*, Konrad Fischer
Gallery, Düsseldorf, Dec. 1968; Zurich 1980
(35, repr. p.101); Paris 1981 (39, repr. p.56);
Schaffhausen 1983–
Lit: Paris 1991, repr. p.105. Also repr:
Documenta 7, Kassel, exh. cat., 1982, vol.1,
p.68.; as postcard in col., Schaffhausen
Crex Collection, Hallen für neue Kunst, Schaffhausen

In 1967 Ryman started to use paper, cardboard
or composite surfaces in large formats, fixed
flush to the wall, glued to the wall or stapled.
This is one of a group of multi-panelled paint-
ings on paper exhibited at the Konrad Fischer
Gallery in Düsseldorf in 1968.

Like 'Classico 5' (no.41), the title of
'Lugano' is taken from the make of paper used.
While Ryman made only one 'Lugano' paint-
ing, there were six 'Classico' works. Numbers
'1', '3', '4', and '5' each have twelve sheets of
paper; 'Classico 2' has six sheets; 'Classico 20'
has twenty sheets. All are dated 1968, except
'Classico 20', which is dated 1968–9. In addi-
tion to the 'Classico' paintings, Ryman
remembers exhibiting a work from the
'Murillo' series and a painting called 'J. Green'
at the Konrad Fischer Gallery. Also closely
related to 'Lugano' is 'A. Millbourn' (repr. Paris
1991, p.103 in col.).

RR: 'Lugano' was very similar to the
'Classico' paintings. It was made up of several
panels ... The panels were originally taped to
the wall, overlapping, and I painted them
right on the wall. Then they were removed
from the wall and separated. The traces of the
tape were left, and it formed an important
part of the composition, in that there would
be this movement of these traces across the
surface. And then, of course, there were the
lines of individual panels which formed a
grid. The pieces of paper were mounted on
Featherboard panels, and then they were
remounted to the wall. You don't see the
Featherboard at all, because that's smaller
than the paper. I think now some of those
backs have been changed to different
supports. But essentially it's the same.
(RR and LZ)

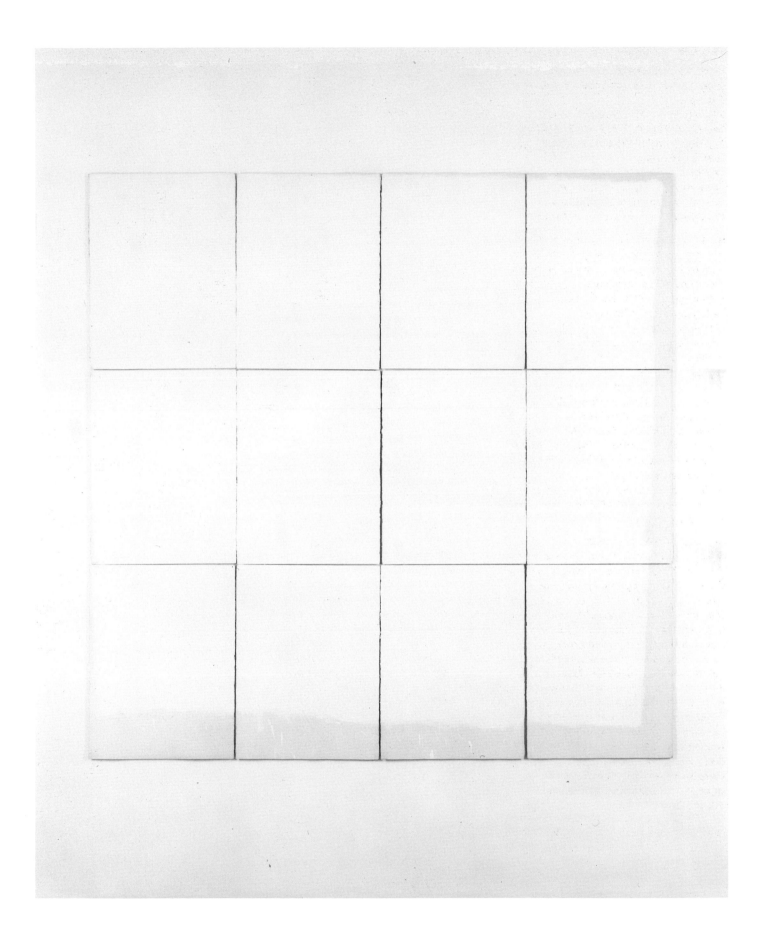

41 Classico 5 1968

Acrylic on twelve sheets of handmade
Classico paper, overall size 234 × 224
$(92\frac{1}{8} \times 88\frac{1}{4})$
Exh: *Robert Ryman: Bilder*, Konrad Fischer
Gallery, Düsseldorf, Nov.–Dec. 1968; *Op Losse
Schroeven*, Stedelijk Museum, Amsterdam
1969; *Bilder, Objekte, Filme, Konzepte*, Stadtische
Galerie im Lenbachaus, Munich, April–May
1973 (repr. no.223, as 'Classico No 5'); *Kunst
der sechziger fahre in der Neue Galerie Kassel*, Neue
Galerie, Kassel 1982
Lit: Lucy Lippard, *Six Years: The Dematerialisation of
the Art Object from 1966–72*, London 1973,
p.26; Naomi Spector, Amsterdam 1974,
pp.18–19; Barbara Reise, 'Robert Ryman:
Unfinished I (Materials)', *Studio International*,
vol.187, no.964, Feb. 1974, pp.76–7, repr.
p.76; Naomi Spector, 'Robert Ryman: une
chronologie', in 'Dossier Robert Ryman',
Macula (Paris), no.3/4, Sept. 1978, p.123,
repr. no.21. Also repr: New York 1972, fig.39;
Zurich 1980, p.103
*Staatliche Museen, Neue Galerie, Kassel (on loan from a
private collection)*

Ryman made a group of paintings without
stretchers in 1964. With the 'Standard' series,
shown in his first one-person exhibiton held at
the Bianchini Gallery, New York in 1967, he
exhibited thirteen flat steel panels with white
brushstrokes, hung flush to the wall. Like
'Adelphi' and 'Lugano' (no.40) the 'Classico'
paintings and the related 'A. Millbourn',
extend Ryman's investigation of the flattest
possible supports for his painting.

 Named, like 'Lugano', after the brand of
paper used, 'Classico 5' is one of six 'Classico'
paintings on paper exhibited at the Konrad
Fischer Gallery in Düsseldorf in 1968 (see
no.40).

RR: They were taped to the wall and they
were painted and then removed from the
wall; you had the traces where the tape was,
which were compositional elements. They
were then mounted on individual panels and
there was a definite order they were to be
hung in. In this case twelve panels and
then there was one of twenty panels
['Classico 20', 1968–9, repr. Zurich 1980,
p.109] and there was one of six panels and so
on [see 'Classico 2', 'Murillo' and 'J. Green',
all 1968, repr. *Das Bild einer Geschichte, Die
Sammlung Panza di Biumo*, Milan 1980, pp.
252–3] ... there were smaller ones and also
the size of the panels varied slightly. Like 'A.

Millbourn' [repr. in col., Paris 1991, p.103]
and 'Lugano' [no.40], the 'Classicos' were
titled after the paper used.
(RR and CK)

RR: There again, it was a matter of solving a
problem. I wanted to work with something
thin, and I was thinking of paper. I had just
finished the 'Standard' paintings, and they
were very heavy. I liked the thinness and I
liked the way the 'Standard' panels sat on the
wall very softly. They were heavy and hard,
but they didn't look that way. I wanted to
continue in a sense, but I wasn't quite sure
how to go about it. I came to paper, because
there was the thinness and it was light. I
started exploring thinner papers, and how I
could work with them. Also I wanted to work
on a larger scale. The 'Standards' were four
feet. I experimented with different weights of
paper and colors. And then it was a matter
how to do them. It just seemed very direct to
tape a lot of these sheets to the wall, which is
what I did. And then I took them apart after I
painted them, and the tape marks became
part of the composition, as I realized they
would. And you had the horizontal and
vertical lines where the papers joined,
though, of course, in the actual painting,
there were no straight lines. I had to change
my paint because of the paper: I used acrylic
on all those papers. The painting was done
very softly. For some, I used varnish in the
paint, because I wanted the light to bounce.
The paper was very matt and soft, and I
wanted the contrast.

 And then it came to be a matter of how to
hang these on the wall. I just glued them to
the Featherboard. I did some experiments
with that. I used this hot melt glue, with
which you can instantly glue them to the
wall. And I found that, by using spots of it, I
could reach back with a spatula and just
knock them off the wall when I needed to
take them down.
(RR and LZ)

Discussing his use of modular units in the
1960s Ryman has commented:

RR: At that time, my modular painting did
not fit very well into the 'Minimal' aesthetic.
The Minimalists wanted work to be more
machine-like. They didn't like to see brush
marks and the 'handmade' look of each panel
being slightly different.
(RR and LZ)

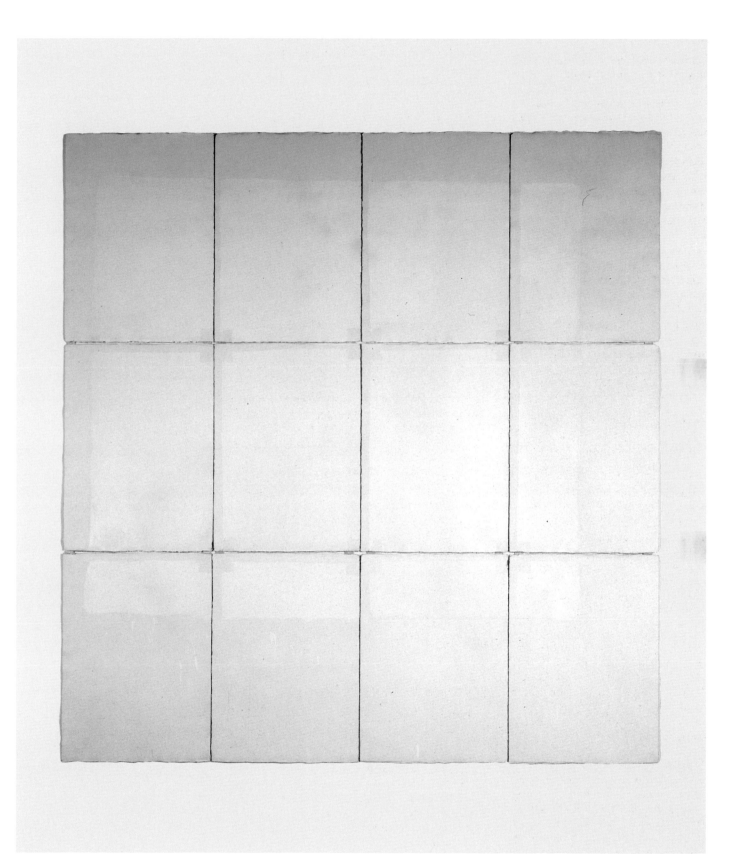

42 VII 1969

Enamelac on corrugated paper, seven units,
each 152.4 × 152.4 (60 × 60)
Exh: Fischbach Gallery, New York, April–May
1969; *American Exhibition, Second Triennale – India*,
New Delhi, 1971; Amsterdam 1974 (52,
repr.); *Fundamentale Schildenkunst/Fundamental
Painting*, Stedelijk Museum, Amsterdam,
April–June 1975 (3); *60/80 Attitudes, Concepts,
Images*, Stedelijk Museum, Amsterdam,
April–July 1982
Lit: Katherine G. Kline, 'Reviews and
Previews: Robert Ryman' *Art News*, vol.68,
no.4, Summer 1969, p.21; Phyllis Tuchman,
'An Interview with Robert Ryman', *Artforum*,
vol.9, no.9, May 1971, p.53, repr. p.50;
Naomi Spector, 'Ryman Brand Paintings', in
Bilder, Objeckte, Filme, Konzepte, exh. cat.,
Stadtische Galerie im Lenbachhaus, Munich
1973, p.156; Diane Waldman, New York
1972, p.16; Barbara Reise, 'Robert Ryman:
Unfinished I (Materials)' and 'Robert Ryman:
Unfinished II (Procedures)', *Studio International*,
Feb. 1974 and March 1974, vol.187,
nos.963–4, p.77, repr. p.126; Naomi Spector,
'Robert Ryman: une chronologie', in 'Dossier
Robert Ryman', *Macula* (Paris), no.3/4, Sept.
1978, p.124, repr. 22; Christel Sauer, Zurich
1980, p.[20], repr. p.113; *Tate Gallery Illustrated
Catalogue of Acquisitions 1984–86*, 1988, p.558
Stedelijk Museum, Amsterdam

This is one of four multi-panelled works composed of three, four, five and seven separate and successive squares of five foot square corrugated cardboard, painted with a fast-drying paint. The panels were painted together, the artist working from left to right. They were exhibited together as four separate works at the Fischbach Gallery in New York in 1969 (see installation photograph in Zurich 1980, p.113). The title of each work indicates the number of panels it contains. Closely related was 'Untitled Painting', 1969, consisting of nine corrugated cardboard panels, arranged to measure 15 × 15 ft, for *Anti-Illusion: Procedures Materials* at the Whitney Museum in 1969, but afterwards divided into three separate works, the 'Whitney Revision Paintings' (see p.26 of this catalogue).

RR: [This is] Enamelac on corrugated paper, and there are seven panels. It's quite a large piece. Enamelac is a sealer; its actually pigmented shellac. Shellac comes from trees. It's a resin; its a natural substance that dissolves in alcohol. So, Enamelac is really alcohol-based. Enamelac is the brand name of a paint that is tough and non-porous.
I used it because of the corrugated paper [in 'VII']. I thought it wouldn't affect the paper the way oil would. It would not cause it to deteriorate later, with the oil eating the paper. And also it sealed the paper so it was really the ideal medium for this situation.

Ordinarily, you wouldn't think to use corrugated board, because it's supposedly so acidic. You know they make boxes out of it. It's brown and it's made from pulp that is not bleached. I don't really know how they make it. But I had it tested at Orrin Riley's [Ryman's restorer in New York] for ageing and humidity, and he was amazed with it – it really held up beautifully. It didn't shrink, it didn't crumble or anything.

There were actually four of those paintings. One was made of seven panels ['VII'] which is at the Stedelijk, and then there was a four panel painting, another of five, and then there was one of three panels – all odd numbers except for the four panel work. And I preferred the odd numbers because you had a panel in the center with an odd number. The wall became the center with the even numbered panels. They were originally shown at the Fischbach Gallery [New York, April–May 1969].
(RR and LZ)

VII 1969, installation, Stedelijk Museum, Amsterdam

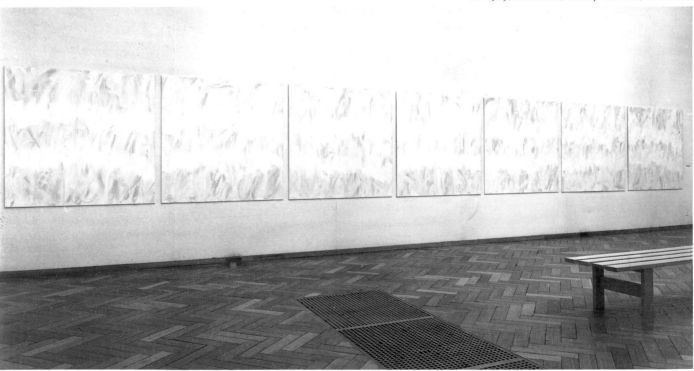

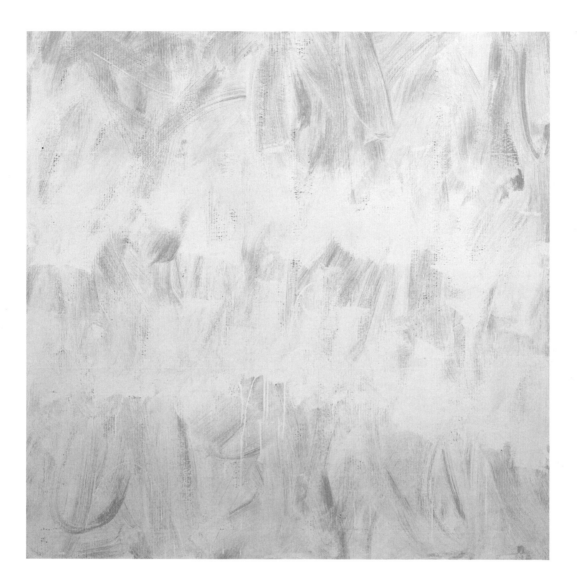

43 General 48½ × 48½ 1970

Enamel and Enamelac on cotton canvas
123.7 × 123.7 (48½ × 48½)
Exh: Fischbach Gallery, New York, Jan.–
Feb. 1971; *From Brancusi to Bourgeois: Aspects of the Guggenheim Collection*, Guggenheim Museum SoHo, New York, June 1992
Lit: Carter Ratcliff, 'Robert Ryman's Double Positive', *Art News*, vol.70, no.1, March 1971, pp.54–6, 71–2; Kenneth Baker, 'New York: Robert Ryman', *Artforum*, vol.9, no.8, April 1971, pp.78–9; Diane Waldman, New York 1972, p.[16]; Naomi Spector, 'Ryman Brand Paintings' in *Bilder, Objekte, Filme, Konzepte*, ex. cat., Städische Galerie im Lenbachaus, Munich 1973, p.156; Naomi Spector, Amsterdam 1974, pp.23–4; Barbara Reise, 'Robert Ryman: Unfinished I (Materials)' and 'Unfinished II (Procedures)', *Studio International*, vol.187, Feb. 1974, p.80 and March 1974, p.126; Phyllis Tuchman 'An Interview with Robert Ryman, *Artforum*, vol.9, no.9, May 1971, pp.46–53; Barbaralee Diamonstein and Robert Ryman, *Inside New York's Art World*, New York 1979, p.335; 'Dossier Robert Ryman', *Macula* (Paris), no.3/4, Sept. 1978, p.126; Christel Sauer, Zurich 1980, p.[20]
Solomon R. Guggenheim Museum, New York. Panza Collection, 1991

This is one of a series of fifteen paintings, first exhibited together as a group at the Fischbach Gallery in 1971. They look close in size but range from approximately four to five feet square. Each consists of a central square of brilliant gloss enamel, built up of six coats, each painted and sanded, surrounded by an exposed border of Enamelac underpainting. Enamelac is a primer-sealer. The artist used special flat stretchers for the series. The width of the unbevelled stretchers determined the width of the Enamelac border of each painting. He had used Enamelac previously on the corrugated paintings (no.42).

RR: The 'Generals' were all different sizes. Actually the size is part of the title. The sizes varied by about a half inch from painting to painting. A title might be 'General 48 × 48'.

That distinguished it from the others. The Guggenheim has two. One is on exhibition now [in the opening of the Guggenheim Museum SoHo in New York in 1992]. I don't have one myself.

I don't remember now how big the smallest and largest were, but the smallest was probably close to four feet. Anyway, when they were shown [at the Fischbach Gallery in 1970] they came into the gallery by truck I believe, and the truckmen put them along the wall with the wrapping on them. There were fifteen all together, I think. I didn't want to show them from the smallest to the largest or vice versa. So, actually, I hung them exactly where they were sitting when they were taken from the truck and leaned against the wall. I didn't plan that. But, when it came to the hanging, I thought, how am I going to do this? And then I thought well, here they are. Why not just put them up? I felt it really didn't matter. Since they were different sizes, but only by a half inch, it would work all right, no matter how you put them together.
(RR and LZ)

When the paintings were exhibited at the Fischbach Gallery in 1971, Ryman deliberately varied the intensity of the light and one bank of the gallery lights was not used:

RR: They were more peculiar, more sensitive than most because of the reflective surface of the paintings. They looked very different in daylight or under incandescent light or in the shadow light. They always looked different so I wanted to try and . . . point that up if I could.
(Tuchman 1971, p.52)

RR: In showing them, I turned off the gallery's lights on one side. The paintings were on two walls, and one side was lit and the other was dark, lit only by reflected light from the other side. And so you saw them differently, because of the way the light reacted with them. Even though they were the same, they appeared very different. I thought maybe someday they might all get together again.
(RR and LZ)

One of the fine things about Bob Ryman is the way he titles his work . . . the word general . . . means common, widespread, not specific. On the other hand of course, it means in military terms, the highest rank. Moreover, it approaches the high sense of 'universal' – one of the most complimentary things that can be said of any work of art.
(Spector 1973, p.156)

RR: So I had the Enamelac, which is a very matt dry kind of dead looking surface. Then I reversed it . . . you had the shiny enamel. The very glossy surface which does reflect the light and the Enamelac which absorbs the light, I wanted that . . . I wanted that reflection. I think it was more interesting to me, anyway, in the process of doing it.

I have done groups of paintings very much related to each other. For instance, there's a group on paper, there's a group on linen, unstretched; the group on cotton (the 'General' series); there are the 'Standard' paintings on steel. It has to do sometimes with a space that you have to work with; sometimes not a space at all. I didn't do the 'General' paintings for any place in particular.
(Tuchman 1971, p.48)

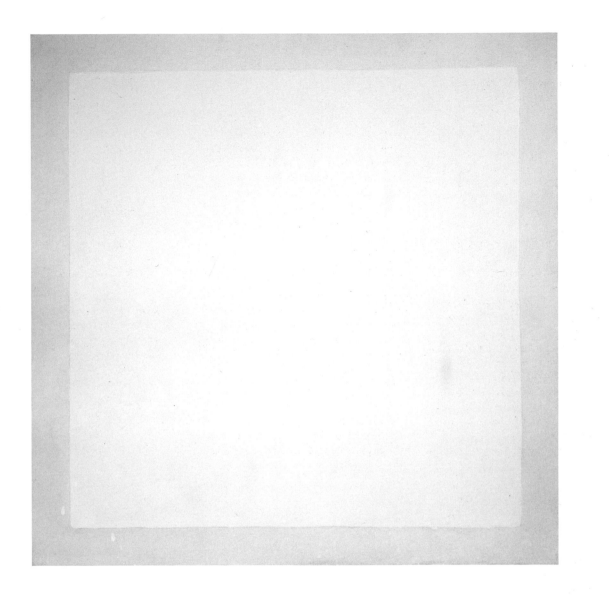

44 Surface Veil 1970

Oil on fibreglass on Featherboard 50.5 × 50.5
($19\frac{7}{8} \times 19\frac{7}{8}$)
Exh: Dwan Gallery, New York, 1971; London
1977 (52)
Private collection, courtesy Lisson Gallery, London

Between 1970 and 1972, Ryman made eighteen related works, which he titled 'Surface Veils'. His aim, as Naomi Spector notes, was 'to realise a tendency which had long been evident in various efforts towards getting the paint close to the wall by making the supporting material either thinner or less visible' (Spector, Amsterdam 1974, p.21). The larger works were executed on fabric (cotton or linen canvas), and the smaller 'Surface Veils' on thin fibreglass called 'Surface Veil', which is the origin of the series' title, mounted on Featherboard, a foam core support.

This is one of a series of small 'Surface Veil' paintings exhibited at the Dwan Gallery, New York in 1971. All these were different sizes, ranging from twelve to twenty-six inches.

RR: At that time, that was part of the problem, working with different sizes, which made each painting more personal and a little bit more difficult for me. I had to switch brushes and I had to change my concept of how it was going to work – and the scale. Whereas, if you're doing all the same size, you don't have the problem because you know it right away, which brush and whatever.
(Phyllis Tuchman, 'An Interview with Robert Ryman', *Artforum*, vol.9, no.9, May 1971, p.47)

RR: The fiberglass was mounted on Featherboard instead of wax paper. Featherboard is very light. It's paper with a core of foam. The fiberglass was very thin; it was like canvas. It wasn't stiff like the fiberglass I am using now. It was a different type of material – actually, it was called 'Surface Veil', that's where the title came from. It had to be mounted on something that would give it some stability. Some of these smaller paintings were mounted on Featherboard, and some, not many, were on the wax paper.
(RR and LZ)

45 Surface Veil 1970

Oil on fibreglass on Featherboard 31.5 × 30.5
($12\frac{1}{4}$ × 12)
Exh: New York 1972 (22); Zurich 1980 (39,
repr. pp.131, 133); Paris 1981 (43);
Kunsthalle, Düsseldorf, Dec.–Jan. 1982;
Schaffhausen 1983–9; Paris 1991 (no
number, repr. in col. p.111)
Private collection

See also nos.44, 47.

46 Surface Veil 1970

Oil on fibreglass with waxed paper frame and
masking tape 33 × 33 (13 × 13)
Exh: *Robert Ryman*, Dwan Gallery, New York,
Feb. 1971
Lit: Christel Sauer, Zurich 1980, p.20, repr.
p.133. Also repr: Paris 1981, pp.64–5
The Museum of Modern Art, New York. Gift of the
Denise and Andrew Saul Fund and the Scaler Foundation

A photograph of Ryman's studio wall taken in
1970 shows this and other small 'Surface Veil'
paintings (Zurich 1981, p.133). For a discus-
sion of the small 'Surface Veils' see nos.44 and
47.

47 Surface Veil 1970–1

Oil on fibreglass, with wax paper frame and
masking tape 33 × 33 (13 × 13); overall size
as installed 55.9 × 48.3 (22 × 19)
Exh: New York 1988–9 (no number, repr.
p.40); Paris 1991 (repr. p.133)
Private collection

The smaller 'Surface Veils' were painted on
fibreglass with a wax paper backing that had
been taped to the wall.

The method of attaching this painting to the
wall, using a frame of wax paper, compares
with Ryman's method when making 'Adelphi'
(see no.39). The overall dimensions of this
work vary because the position of the securing
tapes varies slightly with each installation.
According to Ryman, these inevitable slight
changes are quite acceptable:

RR: ... the paper being replaced every time,
naturally it's going to be slightly different in
dimension, but very slightly ... the tapes are
put on more or less how you feel, to hold the
paper, and incidentally the tape is glued. [The
paper] is not really held by the tape, it's held
by glue, because the tape would come loose
after a bit. I don't have to be there for the
installation ... One time this painting was
installed and the tape was put in exactly the
same places as in the photograph ... copied as
exactly as they could, which was kind of
curious ... because originally it was a very
immediate, intuitive thing. All of the smaller
'Surface Veils' were done on a thin fiberglass
which, in most cases was painted to the
support (which was a foam core board) ... In
other cases, it was painted directly onto wax
paper, so that the works varied from the wax
paper to the foam cored support.
(RR and CK)

Ryman has recounted that he bought this
painting back from a collector in Minnesota:

RR: I had a note with the painting saying that
if it was ever sold I would have first choice ...
So they called me and said they had this little
'Surface Veil' and ... it was in a Plexiglas box
when I found it. I took it out of the box so it
could work with the wall plane as originally
intended.
(RR and CK)

48 Surface Veil 4 1970–1

Oil on fibreglass on Featherboard 99.1 × 99.1
(39 × 39)
Exh: Dwan Gallery, New York 1971; New
York 1972 (21, repr.); New York 1988–9
(no number). Also repr: London 1977, p.25;
Zurich 1980, p.135
Emily and Jerry Spiegel

See note on smaller 'Surface Veil' paintings
(nos.44, 47).

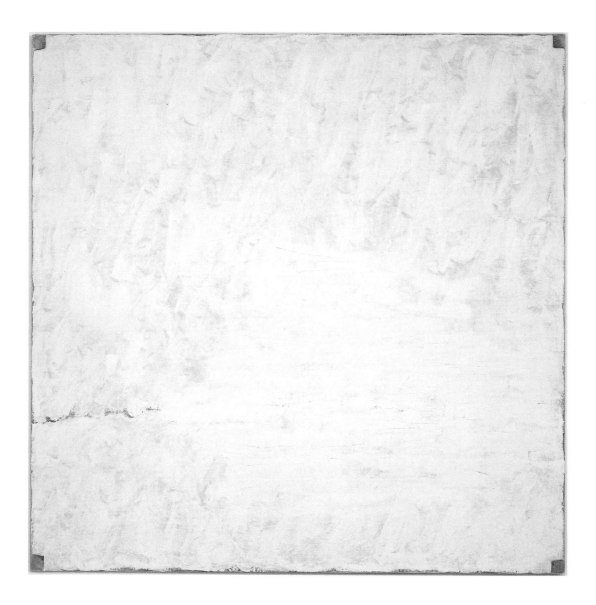

49 Surface Veil I 1970

Oil and blue chalk on linen canvas
365.8 × 365.8 (144 × 144)
Exh: New York 1972 (19, repr.); *Documenta 5*,
Kassel 1972; Amsterdam 1974 (57, repr.)
Lit: Phyllis Tuchman, 'An Interview with
Robert Ryman', *Artforum*, vol.9, no.9, May
1971, p.53; Diane Waldman, New York,
1972, p.[16]; Naomi Spector, Amsterdam
1974, pp.21–2; 'Dossier Robert Ryman',
Macula (Paris), no.3/4, Sept. 1978, p.125,
repr. p.24; Germano Celant, *Das Bild einer
Geschichte 1956/1976, Die Sammlung Panza di
Biumo*, Italy 1980, repr. p.257. Also repr:
Zurich 1980, pp.137, 139; Paris 1981, p.66
*Solomon R. Guggenheim Museum, New York. Panza
Collection*, 1991

This is the first of four numbered paintings,
'Surface Veils' I–IV, each measuring twelve feet
square. Numbers I and II are on linen and num-
bers III and IV on cotton. 'Surface Veils' I, II and
III were originally in the collection of Count
Giuseppe Panza di Biumo, at Varese, Italy. They
were among twenty-four works by Ryman
acquired by the Guggenheim Museum in
1991.

RR: All the 'Surface Veil' paintings are from
the same source. Actually the big ones came
from the little ones in terms of the
configuration of paint. The way the paint is
handled is very similar. It was generally a
vertical brushstroke, and there was usually
some kind of break in the surface, and there
was an area that went in the opposite
direction, horizontally.
(RR and LZ)

RR: I went out and found out where I could
get 12 foot linen – which was kind of a
problem actually, since they don't have that
too often. That's the way the materials come
about. It's true, sometimes I will stumble on
something by accident and I'll think that
would be interesting to work with or, what
could I do with this? That's not the usual case.
Usually it's decided that I want either a
smooth surface or a hard surface or a certain
textured surface to work on at the moment.
Then I go around and see what's available.
(Tuchman 1971, p.53)

RR: They were painted unstretched, and to
mark my space, I used blue chalk. There is a
blue line that runs down the edges that is
partially painted over . . . it's not distinct. It's a
kind of a nebulous line, which I knew would
be there – I didn't mind the blue on the edge.
But it was also used to mark the edge of the
canvas, for when it was stretched. Actually, I
had the stretchers, I just didn't have the
ceiling height to assemble them. So I painted
these works flat.
(RR and LZ)

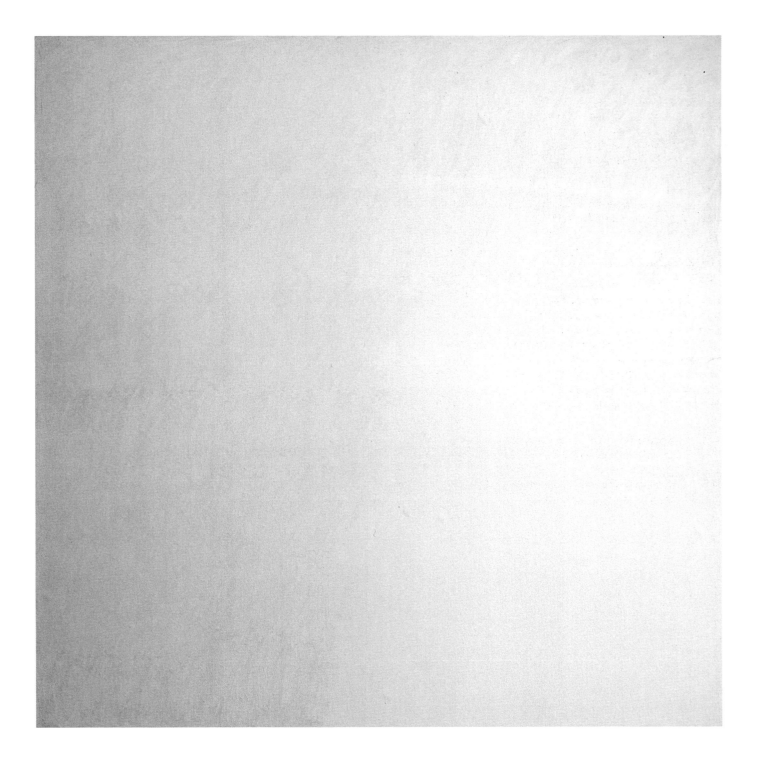

50 Surface Veil II 1971

Oil and blue chalk on linen canvas
365.9 × 365.9 (144 × 144)
Exh: London 1977 (51); *From Brancusi to
Bourgeois: Aspects of the Guggenheim Collection,*
Guggenheim Museum, SoHo, New York,
June 1992
Lit: Zurich 1980, p.141; Paris 1981, p.66;
Germano Celant, *Das Bild einer Geschichte 1956/
1976, Die Sammlung Panza di Biumo,* Milan 1980,
repr. p.257
*Solomon R. Guggenheim Museum, New York. Panza
Collection, 1991*

This painting is closely related to 'Surface Veil
I' (no.49) in that each carries an area of more
opaque paint in the bottom right quarter. The
dimensions of the large 'Surface Veils' were
determined by the reach of the artist's arm in
relation to the lower right-hand corner. The
near horizontal break in the paint surface, run-
ning from the left side into the opaque areas,
denotes breaks in the artist's working process.
Nos.I, II and III have blue chalk borders.

51 Surface Veil III 1971

Oil and blue chalk on cotton canvas
366.4 × 366.4 ($144\frac{1}{4}$ × $144\frac{1}{4}$)
Exh: New York 1972 (25, repr.); *From Brancusi
to Bourgeois: Aspects of the Guggenheim Collection,*
Guggenheim Museum SoHo, New York, June
1992
Lit: *Robert Ryman, Galleria San Fedele, Milan,
April 1973, p.[19]; Paris 1981, p.67;
Germano Celant, Das Bild einer Geschichte 1956/
1976, Die Sammlung Panza di Biumo, Milan 1980,
repr. p.257
Solomon R. Guggenheim Museum, New York. Panza
Collection, 1991*

Like 'Surface Veil IV', this was painted on
cotton canvas. Both were exhibited in Ryman's
exhibition at the Guggenheim Museum in
1972 (No.IV was cat.no. 26 but was not illus-
trated). See also nos.49 and 50. Count Panza di
Biumo at one time owned the large 'Surface
Veils', Nos.I, II and III.

RR: He didn't have them installed all the time
... One time he had a room and it was quite
beautiful with the three big 'Surface Veils' in
the room. That was exceptional to see but [it]
was only for a short time and then he
changed it ... He would do that kind of thing
from time to time, do installations of certain
paintings, but he never had them all together
at once, because he didn't really have the
space for it.
(RR and CK)

52 Untitled 1973

Baked enamel on copper, 5 panels, each
39 × 39 ($15\frac{3}{8}$ × $15\frac{3}{8}$)
Exh: *Robert Ryman: New Paintings*, Konrad Fischer,
Düsseldorf, Nov. 1973; Amsterdam 1974
(64, repr. in col.); ?Zurich 1980 (not listed,
repr. p.165); *Fundamentale Schildenkunst/*
Fundamental Painting, Stedelijk Museum,
Amsterdam, April–June 1975 (6); 60/80
Attitudes, Concepts, Images, Stedelijk Museum,
Amsterdam, April–July 1982 (3, repr.)
Lit: Naomi Spector, Amsterdam 1974,
pp.24–5
Stedelijk Museum, Amsterdam

This work relates to nos.57, 58 in London
1977 and no.43 in Zurich 1980, repr. p.167.

In Germany in autumn 1973, Ryman made
two groups of works on metal. This comes
from a group of six five-panelled works of
baked enamel on copper. In each set of five, an
'L' shape of copper remains exposed. In three
of the six works, the copper has been oxidized.
The works in the series, all 'Untitled', 1973,
are identified by panel sizes: 20 × 22 cm;
37 × 37 cm; no.52; 40 × 40 cm; no.53; collec-
tion the artist, 20 × 20 cm.

Ryman went to Germany to make the
enamel works. This was the first and only time
he had worked with enamel on copper and he
made prototypes to calculate the sizes for the
panels. According to him the work was done in
a 'very tiring' day:

RR: That's the only time I used enameling
and I did, I think, five paintings using that
medium. They were all done in Germany. I
have one, one is in Schaffhausen, the Stedelijk
has one. Most of them are five panels; one of
them is three panels.
(RR and LZ)

RR: There was a sort of assembly line going. I
would be working with the powder, putting
it on the copper – it was all done by hand –
and then someone else would move it into
the oven, and then when they were ready

they would come out and another one would
go in ... And I had no idea how they would
come out – what the copper was going to be
like ... then it was a matter of working out
the fastening.
(RR and CK)

RR: They were going to be shown at Konrad
Fischer's in Düsseldorf and I talked to him
about a place to make them because I needed
special equipment. We arranged that and they
were done there. I had them pretty much
worked out before I went, but I worked out
the details there in an industrial technical
school. The oven had to be big enough to
handle these pieces. You can get ovens for
small things, but an oven to handle larger
pieces was more difficult to find. I remember
we had to work at night, or maybe on the
weekend, because of the amount of
electricity it took to heat the oven ... I think at
the time there was an oil shortage. You had to
take care how much power was used ... I did
the work, the placing of the powder on the
panels. I did the whole thing myself. The only
thing I didn't do was put them in the oven ...
I don't remember exactly how [the idea to
work with enameling] came about. I think
the process interested me, because I knew it
was something that would not change –
enameling is really forever. It doesn't yellow
like paint; it doesn't crack or anything. Of
course it breaks; it's glass. But otherwise, it's
just indestructible. And then I simply wanted
to see what it was like ... It's just the
challenge of doing something that I hadn't
done before – to see what the result of it
would be. I only wanted to work in that
medium that one time. It was another way of
preparing the pigment, and it was a different
kind of surface. Also I had a color ... brown –
actually it wasn't so brown. It was almost red,
the color of the copper. [It] was untreated so
that the panels will turn green after a number
of years, which is nice.
(RR and LZ)

53 Untitled 1973

Double-baked enamel on oxidized copper,
5 panels, each 24.1 × 26.7 ($9\frac{1}{2}$ × $10\frac{1}{2}$)
Exh: *Robert Ryman: New Paintings*, Konrad Fischer,
Düsseldorf, Nov. 1972; John Weber Gallery,
New York, Sept.–Oct. 1974; *Twentieth Century
American Masterworks*, Whitney Museum of
American Art, July–Sept. 1977; New York
1988–9 (repr. p.41)
Lit: *Minimal and Conceptual Art from the Collection of
the Gilman Paper Company*, exh. cat., Sept. 1974;
Christie's, New York, 5 May 1987, lot 44,
repr. in col.
Emily and Jerry Spiegel

See also note for no.52.

RR: [The panels] were changed chemically
and it'll stay permanently darker. In this
piece, the panels are not square. It was the
only one I think that had rectangular
modules.
(RR and LZ)

54 Untitled 1973

Enamel on aluminium 99.5 × 99.5
$(39\frac{1}{8} \times 39\frac{1}{8})$
Exh: *Robert Ryman: New Paintings*, Konrad Fischer,
Düsseldorf, Nov. 1972; Schaffhausen
1983–
Lit: Paris 1991, p.170
Crex Collection, Hallen für neue Kunst, Schaffhausen

Ryman produced two series of works in Germany in the autumn of 1973. This work is one of a group of eight (six single and two multi-panel works), each executed in enamel on metal. One of the multi-panelled works is in five parts (enamel on aluminium, each panel 50 × 54 cm). The other consists of three parts (enamel on steel, each panel 22 × 25 cm).

For this painting, Ryman sealed the metal with automobile sealer before paint was applied. It consists of three coats of matt white enamel, the first two sanded, over a clear coat of lacquer applied to aluminium.

RR: It was painted directly on aluminum. First, it was taken into an auto body shop. The problem was, I wanted the aluminum sealed so it wouldn't oxidize. So they sprayed it with something they use on cars to protect the metal. It was like a synthetic lacquer. When I got the panels back, I painted them in Germany.
(RR and LZ)

55 Embassy I 1976

Oil and Elvacite on Plexiglas, black oxide
fasteners and four-sided bolts 160 × 160
(63 × 63)
Exh: London 1977 (74); Zurich 1980 (48,
repr. p.189); Schaffhausen 1983– (repr. Paris
1991, p.123)
Lit: 'Robert Ryman interviewed by Barbaralee
Diamonstein', *Inside New York's Art World*, New
York 1979, p.334
Crex Collection, Hallen für neue Kunst, Schaffhausen

Commenting in 1979 on his use of fasteners,
Ryman said that he had the fasteners made
specially for his paintings, taking into account
the scale and shape, colour and light reflec-
tiveness (some of the fasteners used were steel,
some cadmium and some black oxide).

RR: But the thinking behind the fasteners has
to do with the way a painting hangs on a
wall; usually paintings, if they're pictures,
hang invisibly on a wall, because we're not
so interested in that. It's the image we're
looking at in the confined space ... My
paintings don't really exist unless they're on
the wall as part of the wall, as part of the
room.
(Diamonstein 1979, p.334).

RR: Actually, the oil is mixed with Elvacite.
Elvacite was new at that time. It was a plastic
synthetic material that you could mix with
oil. Orrin Riley told me about it. I used that
because I wanted the paint to be stable on the
Plexiglas. Usually oil on plastic is a little
difficult, because it can chip off. And, of
course, the Plexiglas was five feet, and it
wasn't absolutely rigid. I didn't want the
paint to pop off. Mixing it with this Elvacite
gave it an elasticity that bonded it to the
Plexiglas very well. But yet, the paint kept
the characteristics of the oil. It worked quite
well. The problem was, it took forever to dry.
Elvacite is used in conservation still, as a
varnish I believe ...

That was the year [1976] I began using the
visible fasteners. These are black oxide steel
squares with oxide bolts. On the painting you
had two squares at the top and two at the
bottom which held it to the wall. And I
remember I drilled the holes in the plastic,
hoping that it wasn't going to split ...

The black oxide was really a kind of
rustproofing. But I used it for a color. But I
also used others – I used just a steel color,
which I coated with a sealer, which, I think,
was not all that permanent. But it could be
cleaned.
(RR and LZ)

56 Untitled Drawing 1976

Pastel and pencil on Plexiglas with black
oxide steel plates and steel hex bolts
126 × 126 (49½ × 49½)
Exh: Drawing Now, The Museum of Modern Art,
New York, Jan.–March 1976 and travelling to
Kunsthaus, Zurich, Kunsthalle, Baden Baden,
Albertina Museum, Vienna, Sonja Henie–
Niels Onstad Foundation, Oslo, Tel Aviv
Museum, Tel Aviv, Sept. 1976–July 1977; *A
View of a Decade*, Museum of Contemporary Art,
Chicago, Sept. 1977; London 1977 (64);
Zurich 1980 (repr. pp.187, 195); Paris 1981
(50, repr. p.76); Schaffhausen 1983–
Lit: Paris 1991, repr. p.125 in col.
Crex Collection, Hallen für neue Kunst, Schaffhausen

Robert Ryman made four drawings for *Drawing
Now*, an exhibition organized by Bernice Rose
and held at The Museum of Modern Art in
New York in 1976. These were pastel and
pencil, metal and Plexiglas. According to the
artist, the metal plates and steel bolts securing
this painting were covered in a transparent
seal.

There is another drawing in the series in the
collection of The Museum of Modern Art
('Untitled', 1976, see no.58).

RR: The Plexiglas was sandblasted to hold
the pastel. The sandblasting gave a little tooth
to the surface. And it also made it translucent;
it wasn't transparent anymore. The pastel
would work right in, like on paper. In fact, I
did those for a drawings show at the
Modern, *Drawing Now*. I did those specially for
that show. That's the first time they were
shown.
(RR and LZ)

57 Advance 1976

Oil on blue Acrylivin with vinyl, Elvacite and sanded Plexiglas fasteners with cadmium bolts 90.2 × 86.4 (35½ × 34)
Exh: Works and Projects of the Seventies, P.S. 1 Institute for Art and Urban Resources, New York, Jan. 1977; Zurich 1980 (50, repr. p.197); Paris 1981 (54, repr. p.80)
Franz Meyer

'Advance' is related to 'Embassy I' (no.55), and was made at about the same time when Ryman was working with several synthetic materials including Plexiglas and Acrylivin:

RR: I haven't seen 'Advance' in so many years. I think actually that it has oil and Elvacite also (see no.55). In this, the strap-like elements that hold the painting to the wall were a blue color, and made of Acrylivin, a very tough kind of plastic material, almost indestructible. It was much tougher than Plexiglas. Anyway, the Elvacite, there again, worked very well on that surface. The painting was not fastened directly to the wall. It was set on two little squares of steel, held to the wall with a bolt. The bolt also fastened the vinyl strips, which, as I said, had kind of a blue tinge when the light hit them. It was actually transparent, but it had a bluish color. The painting sat on the steel pieces, and the vinyl went across it, and was fastened at the top, also on the wall, by two more squares of steel. So the vinyl strips kept the painting from falling off the wall. And, compositionally you had the blue edge of the Acrylivin, and . . . the blue edge of the vinyl going across the surface, which reflected light. And then of course the actual painted surface absorbed the light, and you had the steel bolts, two at the top, two at the bottom. So it was very active visually, this painting.

. . .the Elvacite I got from Orrin Riley, but I don't remember where I got the Acrylivin. It was a building material, used for things like subway cars. It was a very tough plastic, almost like a flooring material. It was used for baseboards and things like that in subway cars. It's flexible, but not like Plexiglas; it isn't breakable like Plexiglas. And it came in colors – that's what interested me. And also, it had a surface that would hold paint. So it was the color of it and the toughness of it that I liked. And of course the thinness, too. It was only one-eighth of an inch thick.
(RR and LZ)

58 Untitled 1976

Pastel and graphite pencil on sandblasted Plexiglas with black oxide steel bolts and fasteners 126.1 × 126.1 (49½ × 49½)
Exh: *Drawing Now*, The Museum of Modern Art, New York, Jan.–March 1976 and travelling to Kunsthaus, Zurich, Kunsthalle, Baden Baden, Albertina Museum, Vienna, Sonja Henie–Niels Onstad Foundation, Oslo, Tel Aviv Museum, Tel Aviv, Sept. 1976–July 1977; *Art Inc: American Paintings from Corporate Collections*, Montgomery Museum of Fine Arts, March–May 1979 and travelling to Corcoran Art Gallery, Washington, Indianapolis Museum of Art, Indiana, San Diego Museum of Art, California, June–Dec. 1979, *Selections from the Collection*, The Museum of Modern Art, New York, Sept. 1992–Feb. 1993
The Museum of Modern Art, New York. Fractional Gift of the Paine Webber Group Inc.

Inscribed 'RRyman' bottom left, in pencil.

This is closely related to no.56 and one of the four drawings made for *Drawing Now* at The Museum of Modern Art, New York.

Most of the surface is covered with a painterly application of white pastel. Two square bolts at the top of the work are placed parallel to two at the bottom. Each is about six inches from the vertical edge closest to it. There is an area without pigment between the top two bolts and another between the bottom two bolts; both are the height of the bolts. These areas are further defined by ruled pencil lines. The shape of the top left bolt is echoed in a square of its size, without pigment and outlined in pencil, immediately below it. There is a more amorphous area without pastel above the bottom right bolt, and another such area to its right. The pastel ends in an uneven line that runs the length of the work's right side, about one to one and a half inches from the edge. Several ruled pencil lines appear, usually placed in relation to the bolts.

59 Monitor 1978

Oil on cotton canvas with metal fasteners
175.3 × 167.6 (69 × 66)
Exh: *Robert Ryman*, Sidney Janis Gallery, New
York, Jan. 1979 (4, repr.)
Stedelijk Museum, Amsterdam

This is one of a series of nine closely related
paintings, some oil on cotton, others oil on
linen with metal fasteners, exhibited together
at the Sidney Janis Gallery the year after their
completion. These varied in size from 'State'
(223.5 × 213.4cm), to 'Center' (66 × 61.9cm).
'Region', 'Pilot' and 'Center' are also repro-
duced in the Janis catalogue, and 'Summit' is
reproduced in colour in Paris 1991, p.131. The
other works exhibited were 'Signal', 'Register'
and 'Canon':

RR: It's a pretty good size painting ... that
was when I went back to canvas. I hadn't
worked on canvas for quite a while. And I
think that was also with oil, and the paint
was quite heavy. I do that from time to time. I
go back to canvas and working with paint in
a more immediate way ... how to explain it? I
let the paint become more of an image of
itself than in certain other paintings. You see,
I use paint in different ways for different
problems. For example, with 'Advance'
[no.57] it was different, because I was
working with the light and the soft surface
and ... the blue material, Acrylivin. And so,
with a painting like 'Monitor', I was going
back to canvas and ... working with the paint,
letting the paint become an image of itself.
Also, I was working with the color of the
canvas, which was probably a brown. But
sometimes I painted it grey ... I guess
traditionally, when a painter approaches a
painting, the painter is not concerned so
much with the material, the canvas,

whatever. The painter is concerned with
putting the paint on the surface and making
the paint into an image. But I approach a
painting in a different way. I approach
painting beginning with the material. The
traditional painter would say that the canvas
was empty, and they would put the paint on
it and make an image with the paint. When I
approach a painting, I say the surface that I'm
using, whether it's canvas or whatever it is,
isn't empty; it's something in itself. It's up to
the paint to clarify it, in a sense. And also to
make an image, yes. But to make the surface
or the structure something to see. It's a
slightly different way of beginning a painting.
So sometimes I go back and work more with
just paint, to let the paint become an image
of its own. The curious thing is that, even
with all my other paintings, the paint is an
image on its own also. But the approach to it
has been different. It's been considered with
the material, with the structure and the paint,
not just with the paint.

In this work, I used metal fasteners to
make the painting project from the wall. All
my canvases at that time extended off the
wall a few inches. It seemed to make them
actually closer to the wall, curiously ...
because you saw it attached, and you saw it
coming off the wall, but it was also very
much part of the wall. It was important that it
had an immediate relationship with the wall
plane, because this was not a picture of
anything. So I wanted it to really look like it
and the wall were together. They had to be
together for it to be complete. And so you
would see it attached. And when it came
away from the wall – it looked more as if it
were a thing of its own, with the wall.
(RR and LZ)

60 Phoenix 1979

Varathane on steel 44.5 × 36.8 ($17\frac{1}{2}$ × $14\frac{1}{2}$)
Exh: *Wall Paintings*, Museum of Contemporary
Art, Chicago, Spring 1979; *Robert Ryman, New
Work*, Kunstraum, Munich, Dec. 1980; *Robert
Ryman*, Sidney Janis Gallery, New York,
May–June 1981 (3)
The artist

This was completed in March 1979. Eight
paintings with the same title but varying
dimensions were shown at the Sidney Janis
Gallery in 1981, together with 'Sonnet',
'Chapter', 'Paramount' and 'Institute'.

RR: They were all relatively small and all cut
from one piece of steel. However, the
composition was quite different, one from
another. And they were all painted with
different paints . . . well, not entirely different
paints. Some were very soft and matt and
some had many coats; some had different
bolts . . . sometimes different colored bolts. So
there were a number of things that were
working there compositionally: the color, the
bolt size, and the paint, different surfaces.
And the thinness of them: they are so thin
that when they're on the wall, they just kind
of melted into it. And I wanted to keep them
together. Actually, it wasn't my original
intent, but after I did them, I thought those
really were different paintings. But, if
someone were going to have them, they
should have all of them. So I have all of them.
None of them were ever sold, and they were
only shown a couple of times I think. It
would be interesting to see them in a
relatively small room, maybe three on a wall,
three on another wall, something like that.
(RR and LZ)

61 Archive 1980

Oil on steel 34.1 × 30.2 ($13\frac{1}{2} × 11\frac{7}{8}$)
Exh: Ryman, Twombly, Tuttle, Blum Helman
Gallery, Sept.–Oct. 1972; *La Grande Parade,*
Stedelijk Museum, Amsterdam, Dec.1984–
April 1985 (repr. p.301 in col.); New York
1988–9 (no number, listed); Paris 1991 (no
number, repr. p.135 in col.)
Private collection

'Archive' combines traditional oil paint and an
'industrial' support. Here Ryman has used a
red rustproof paint as his ground. He has else-
where used a similar grey paint because of its
neutral quality as a ground. 'Archive' relates in
format, but not material, to 'Acme' (repr. Paris
1991, p.137).

RR: The structure that 'Archive' was done on
is a steel plate with flat protrusions where it's
bolted to the wall. It's all welded together.
Those plates were made originally as frames
for drawings that I was doing at the time in
Switzerland ... The frames were made in
Switzerland, at a place that did metal
fabrication. I had these panels, so I painted on
some of them. And that's how this one,
'Archive', came about. It was coated with rust
preventive paint, and then I painted them.
There were several others that I did at the
time, I remember, which were not
successful, but 'Archive' came out very well
... In fact it's been in several shows, mainly
because I have it, so it was easy to show it.

[The drawings] exist. They're in Europe,
most of them. They never came here. There
weren't many, only about six or seven. They
were shown, originally in InK, in Zurich [in
1980].
(RR and LZ)

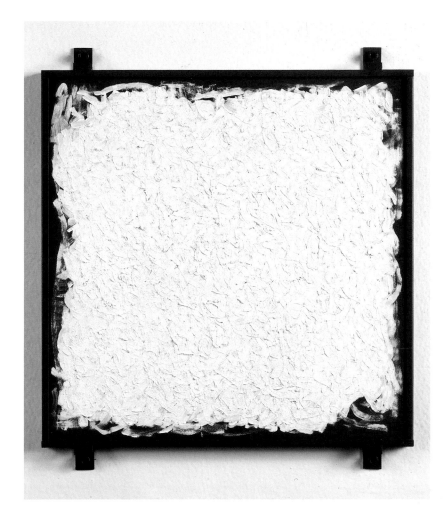

62 Paramount 1981

Oil on linen canvas with metal fasteners
223.5 × 213.4 (88 × 84)
Exh: Robert Ryman, Sidney Janis Gallery, New York, May–June 1981 (11); From Twombly to Clemente, Kunsthalle, Basel, July–Sept. 1985 (28)
Courtesy Thomas Ammann, Zurich

RR: Here again, I was going back to the canvas, working with paint. It's actually very similar to 'Monitor' (no.59) ... there were five or six, at least. I think those were shown at Janis, in '81.
(RR and LZ)

63 Crown 1982

Enamelac on fibreglass panel with aluminium fasteners 102.9 × 96.5 (40½ × 38)
Exh: *Robert Ryman – Recent Paintings*, Mayor Gallery, London, Nov.–Dec. 1983; *La Grande Parade*, Stedelijk Museum, Amsterdam, Dec. 1984–April 1985 (no.221, repr. in col.)
Lit: *Tate Gallery Illustrated Catalogue of Acquisitions 1984–86*, 1988, p.558
Stedelijk Museum, Amsterdam

This is one of a group of about nine paintings from the same period, including 'Ledger', 1983 (Tate Gallery, repr. *Tate Gallery Illustrated Catalogue of Acquisitions 1984–86*, p.558), exhibited at the Mayor Gallery in 1983.

Here Ryman increased the size of his fibreglass support by connecting a number of panels together. The joins between the panels become a compositional element (see also 'Charter' (discussed with no.73) and the 'Versions' series, nos.79–81. Ryman's construction method took precedence over design considerations.

RR: There were a number of those. They were on the fiberglass panels that I began working with at that time. These were different from the fiberglass that I'd used in the past. This was a sandwich of fiberglass sheets with an aluminum honeycomb core, which gave it a rigidity and strength. But also, you could get a relatively thin panel from it, and it was impervious to heat and moisture. You didn't have to worry about it warping. I did a number of paintings on these panels, various sizes and various paints, Enamelac and oil, even acrylic I think. The Modern has a painting which is similar ... but the one they have is quite different in a particular way. [Attendant', 1984, listed in *Ryman, peintures recentes*, Galerie Maeght Lelong, Paris, April–June 1984 (7).] It was the only one I ever did like that. It's supposed to be hung higher than most paintings, above eye level. I think I wrote that on the back, I don't remember. It was shown in Paris, originally, and then the Modern got it ... I can't even remember how. Anyway, it was the only one I painted that was to hang above eye level.

Well, this opened up some possibilities that I hadn't worked with before: the fasteners became much more of a structural part of the painting. Aside from being visible, they developed in a surprising, quite radical

way; they lengthened and came off the wall an inch or so. So, I had the color of the metal which was sometimes polished, sometimes brushed, depending on how the light was going to work with it; and then I had the fiberglass which was kind of greenish. I liked the color very much – kind of a light yellowish-green color. Sometimes it was totally covered, sometimes not. Then I had the edge which was the honeycomb, which I mostly covered, at that time, with redwood [see also 'Ledger', 1983]. So you had a red edge to the painting. It gave me a lot of elements to work with compositionally.

I had [the brackets] made. I would figure out the size and scale of them, do drawings, and have them made, usually out of aluminum because that was lighter, and also it was a nicer metal. Aluminum is really a very soft-feeling metal. They were made out of steel a few times, but mostly aluminum. In fact I have the drawings for all of those fasteners. They're not art drawings; they're just technical drawings. But a folder of them was shown at Matthew Marks Gallery. I think it was one of those opening shows he did [*Artists' Sketchbooks*, Matthew Marks Gallery, New York, March–May 1991]. These brackets just opened up more possibilities, because there are so many things to work with. [The fiberglass] was made to size. They couldn't make one piece any larger than about 4 feet. If you went larger than that, it had to be in sections, which some of my paintings were. That always presented a problem because you had a seam. And of course in my work, a seam is a line. In fact, I used that in one of my paintings later. It's called 'Director' (repr: *Art of Our Time, The Saatchi Collection, Vol.I*, London/New York 1984, 110 in col.). It has a seam that runs right across the centre of the painting. Anyway, I painted up to the seam, and I left it. Because I knew if I painted it over, it would read as a construction line. But by leaving it open, it became literally a line, and so there was no problem, really. But to try and hide it was difficult. The painting was shown at Peder Bonnier when he first opened his public gallery in New York. It looked like a band was going across the centre of the painting, which was where the paint had stopped.
(RR and LZ)

64 Access 1983

Oil and Enamelac on fibreglass panel with
steel fasteners 50.8 × 45.7 (20 × 18)
Exh: Chia, Gorchov, Judd, Mangold, Marden, Ryman,
Shapiro, Stella, True, Twombly, Bonnier Gallery,
New York, March 1983; La Grande Parade,
Stedelijk Museum, Amsterdam, Dec. 1984–
April 1985 (219)
Private collection, The Netherlands

According to Ryman, this is related to 'Crown'
(no.63) and 'Range' (no.65).

RR: They're all done around the same time in
a similar manner . . . it gave me a lot of things
to work with, a lot of different elements.
There was redwood on the sides here, too
(see no.63). Most of them [have redwood],
though some may not. Although it might
have been a little later, at some point I had an
epoxy filler that was grey instead of red.
(RR and LZ)

65 Range 1983

Oil and Enamelac on fibreglass panel with
aluminium 131.4 × 121.3 ($51\frac{3}{4}$ × $47\frac{3}{4}$)
Exh: Paula Cooper, New York, 1983
Hannelore B. Schulhof

See note on 'Access' (no.64).

66 Pace 1984

Lascaux acrylic on fibreglass panel with wood and aluminium; aluminium wall plugs varnished on underside $151.5 \times 66 \times 71.1$ ($59\frac{1}{2} \times 26 \times 28$); panel size $66 \times 66 \times 67.6$ ($26 \times 26 \times 26\frac{5}{8}$)

Exh: Galerie Maeght Lelong, New York, Feb.– March 1984 and Paris, April–June 1984 (4, repr. in col. pp.6, 7 in French catalogue); *Abstract Painting by Three European and Three American Artists: Federle, Knooebel, Richter, Mangold, Marden and Ryman,* Galerie Nachst St Stephan, Vienna, Oct.–Dec. 1986; *L'epoque, la mode, la morale, la passion, aspects de l'art d'aujourd'hui 1977–87,* Musée national d'art moderne, Paris, May–Aug. 1987 (repr. p.279, in col.); *Devil on the Stairs: Looking Back at the Eighties,* April–June 1991, Newport Harbor Art Museum, Newport Beach, California, Oct.1991–Jan. 1992, Institute of Contemporary Art, Boston
Lit: Henry Gerrit, 'New York Reviews: Robert Ryman', *Art News,* no.4, April 1984, pp.162, 167; Rosemarie Schwarzwalder, *Abstract Painting of America and Europe,* Klagenfurt 1988, repr. p.224; Garry Garrels, 'Interview with Robert Ryman at the Artist's Studio', New York 1988–9, pp.14–15, repr. p.14; Robert Storr, Paris 1991, p.35
Courtesy Galerie Lelong

This is one of two paintings where Ryman experimented in a more extreme way with the relationship between wall and painted plane. According to the artist, the outer edge of the work, which is at eye level, is natural unpainted redwood. The uppermost surface, which reflects light, was painted with a very hard, and therefore reflective enamel paint, whereas the underside is painted with a matt, soft surface that absorbs light. The painting is supported at the wall by fasteners and also on long alumimium rods that extend to the floor. The other closely related painting is 'Pair Navigation' described below. In 'Factor', 1983, which also relates to 'Pace' (repr. New York 1988–9, exh. cat., p.14). Ryman projected the painted plane out parallel from the wall. Although these have been seen as sculptural,

Ryman regards this interpretation as incidental.

RR: There were two of [these paintings]. There was 'Pace' and there was 'Pair Navigation' [repr. in col., Paris 1991, p.145], which came off the wall horizontally. Those are related works. I was just thinking how painting is always vertical, always against the wall. For good reason of course, because generally, they are pictures that need to be seen that way. I thought . . . since I'm not really making pictures, a work could possibly not be vertical. It could be just the opposite. I felt it was important that it be partly on the wall; the wall had to be in it. I thought I was a little crazy, but I thought, 'I'll try it; it'll be interesting, a challenge.' The painting is basically one of the panels with the redwood sides [see also 'Access', no.64] that I mounted coming off of the wall at eye level. The front fasteners extend down to the floor, simply to keep it from falling, and the other fasteners went into the wall. At eye level, you pretty much saw the red line of the wood, but you could see the top a little bit, and that was very reflective. And the bottom was also painted, because, since it came off the wall, I could paint both planes. The bottom was soft, meaning it absorbed the light. And it wasn't painted to the edge, as I remember. There was an edge of green, I believe (I can hardly remember what it looked like) and then the aluminum fasteners were brushed so that they were soft, also. So, there again, it was a challenge to see what would happen. I did another one, which was related but quite different, actually. It's larger and closer to the floor. That's the one in Paris ['Pair Navigation', 1984]. That one is concerned with gravity. The paint plane is not really attached. It's just sitting on the surface which was, in that case steel, not fiberglass.

I didn't do more of that type of work because I didn't feel the need to pursue the problem.
(RR and LZ)

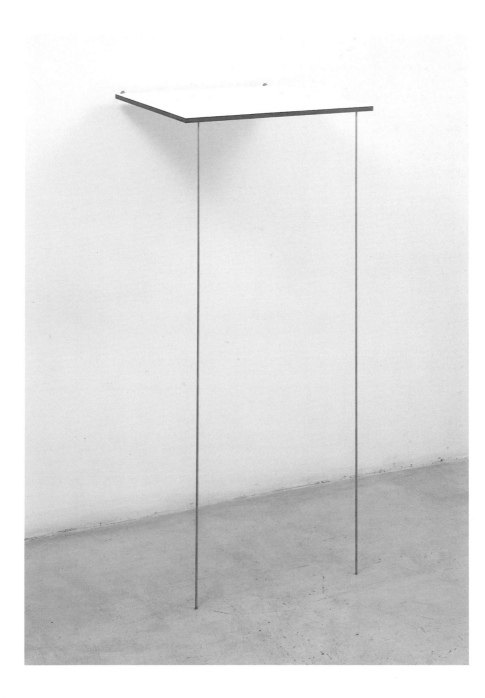

67 Spectrum II 1984

Ink on anodized aluminium 21.3 × 21.3
(8¾ × 8¾)
Exh: *Wolfgang Laib, Robert Ryman, Ian Wilson*,
Galerie Lelong, New York, April–June 1985
Lit: Bernice Rose, 'Introduction' in *New Works
on Paper 3*, exh. cat., The Museum of Modern
Art, New York, June–Sept. 1985, pp.12–13,
repr. [p.57] (as 'Untitled no.2')
Stedelijk Museum, Amsterdam

This is one of six untitled drawings, originally
numbered 2, 3, 4, 6, 7, 8, specially made by
the artist as catalogue illustrations for *New
Works on Paper 3*, selected by Bernice Rose.
Ryman afterwards gave titles to these works. In
her catalogue introduction for the exhibition,
Bernice Rose wrote:

The exhibition departs from the format of
works on paper only to include drawings on
other supports, while the catalog, written
and designed in advance of the exhibition's
final selection, gives an idea of each artist's
work appropriate to the catalog format.
(p.5)

The drawings Ryman made for this catalog
present a clear case of opposition to the
reproducibility of art. The support for each
drawing is an anodized aluminium plate,
square in format, to be hung ½ inch from the
surface of the wall at a height of 60 inches to
the center; the mediums used are pencil, ink
and brush, ink wash and enamel ... The use
of aluminum as a support challenges the
fragility and impermanence of drawing. Light
reflected from an aluminum surface is real
light, and for Ryman light equals space: at
one moment the aluminum is tough and
resistant, in another it dissolves into sheer
light – volume – itself.
(pp.12–13)

RR: This is one of the drawings that I did ...
for the drawing show at the Modern ... This
drawing actually was done for the catalog.

She [Bernice Rose] wanted the drawings in
the catalog to be different to the drawings in
the show, which was unusual, because she
wanted the drawings in the catalog to be
reproduced full size. She gave everyone who
was in the show the size that the catalog was
going to be, so we could do the drawings for
the catalog that exact size. I did these the
exact size of the catalog, which was small. But
I did them on metal, not knowing that the
title of the show was *New Works on Paper*. And
because of the nature of the way I did them,
they couldn't be reproduced full size,
because you needed the wall. They came off
the wall about a quarter of an inch. And it
was very important how they worked with
the wall. When they were reproduced full
size you lost all of that. So we had to reduce
them. Anyway, all of these were done at the
time, for this catalog. Most of these were not
shown in the exhibition. I did bigger
drawings for the exhibition. I had the
aluminum anodized. It's put in some kind of
chemical bath that etches it slightly. It gives it
a soft-feeling surface. In this case, I wanted to
treat the metal so that it wouldn't oxidize,
and so that I could put something on it
without the metal coming through later on
and without it's changing color. All of those
drawings [in the series] were called
'Spectrum'.

It's a kind of basic theory of thinking about
drawing that it has to do with line. I don't
work with line in that way with my painting
at all. When I draw, I'm usually thinking
about line, and what kind of line it can be.
Really, that's how I look at drawings. It's
more involved than that, too. As with any
painting, you do have a surface to put the
line on – what is that? How's the light going
to work on it? and so on, so forth. So the
approach is very similar to painting, but the
focus is on the line.
(RR and LZ)

68 Catalyst III 1985

Impervo enamel on aluminium with steel
bolts 58.4 × 58.4 (23 × 23)
Exh: *New Works on Paper 3*, The Museum of
Modern Art, New York, June–Sept. 1985;
Currents, Institute of Contemporary Art,
Boston, Feb. 1986; Leo Castelli Gallery, New
York, June–Sept. 1986; *Non-Representation (The
Show of the Essay)*, Anne Plumb Gallery, New
York, Jan. 1989
Private collection

This work is bolted to the wall by four bolts.
The support is aluminium.

RR: It's one of my favourite drawings. That
was shown at the Modern, in Bernice's show
[The Museum of Modern Art, New York,
listed]. It's not very large, 23 by 23 inches,
but it's probably my favourite drawing. It's
just one of those things that is so seemingly
simple, but it's very complex and everything
works ... What you're not seeing in the
photograph is this line [the aluminium edge
of the drawing]. It's just the line of the metal,
but it's there and it's important.
(RR and LZ)

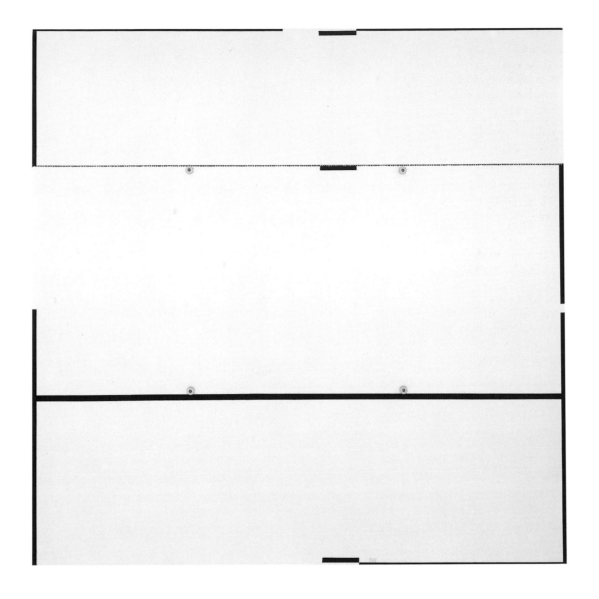

69 Courier 1 1985

Impervo enamel on aluminium with
aluminium fasteners 121.5 × 114 ($47\frac{3}{4}$ × $44\frac{7}{8}$)
Exh: New Works on Paper 3, The Museum of
Modern Art, New York, June–Sept. 1985
FAE Musée d'Art Contemporain, Pully/Lausanne

This was exhibited at The Museum of Modern
Art in 1985 with no.68 and is part of the same
series of drawings.

RR: This was one of those that sat on the wall.
It wasn't actually bolted to the wall, but it
was sitting on these brackets that kept it from
falling over … like the vinyl I'd used before.
But this was different.
(RR and LZ)

70 Expander 1985

Oil on aluminium with four black oxide steel
bolts 71.1 × 71.1 (28 × 28)
Exh: *Individuals: A Selected History of Contemporary Art
1945–1986*, Museum of Contemporary Art,
Los Angeles, Dec. 1986–Jan. 1988; New York
1988–9 (no number)
Lit: Robert Storr, 'Robert Ryman: Making
Distinctions', Paris 1991, p.39
Private collection

Robert Storr notes that, with a few exceptions,
Ryman's paintings of 1985 divide into three
main categories; flat white painted fields on
wood and fibreglass laminated panels, mount-
ed on aluminium bars; large vertical paintings
also on fibreglass, screwed to the wall, such as
'Accord', 1985 (repr. in col. Paris 1991,
p.149); smaller works consisting of square
aluminium and Lumasite plates, screwed to
the wall with small bolts, e.g. 'Expander', and
'Administrator' (no.71).

RR: It is on aluminum, but on a thin piece –
it's not on one of the sandwiched sheets. It
has four bolts which are more or less toward
the center of the painting, not at the edges as
they usually would be. They became very
much a focal point of the composition. They
were small, but from a distance they look like
four black circles. They aren't actually
perfectly in the center. I did that on purpose,
so they they would seem like they were in
the center. Curious. If you actually put them
in the center, they look wrong. The paint
surface was very soft and extremely thin next
to the wall plane. So it just melted into the
wall. Then you saw that it was attached by
these four black spots. I would never paint
four black spots but it's okay if they're bolts,
holders. It's just a different thing ... by
painting them, you would be painting an
image of four spots, whereas here they're
real. They're bolts that are holding the
painting. I know how it's going to look, how
it's going to be. It's just a different approach.
If I painted four spots, somehow it would be
strange.

I used [black bolts] off and on [see also
'Embassy I', no.55]. The black is just a rust
preventative, an industrial material. It isn't
the best rust preventative either. But I used it
because I wanted the bolts to be black. The
paint on 'Expander' is flat; it has a very soft
feeling.
(RR and LZ)

71 **Administrator** 1985

Lascaux acrylic on Lumasite with round black oxide bolts 121.8 × 121.8 (48 × 48)
Exh: *Robert Ryman: Recent Paintings*, Galerie Lelong, New York, Jan.–Feb. 1986; Paris 1991 (no number, repr. p.153, in col.)
Lit: Robert Storr, *Robert Ryman: Making Distinctions*, Paris 1991, pp.37–9
Crex Collection, Hallen für neue Kunst, Schaffhausen

RR: Lumasite is another plastic material that is very similar to the Acrylivin I used earlier. It came in colors, and it was strong. I think 'Administrator' is on black. You can see the color around the edge of the painting. In this case, I used fasteners more compositionally. They were black points which also held the work to the wall. The surface is very similar to 'Expander' [cat.70] – in approach that is. It's very soft and quiet and absorbing and light.
(RR and LZ)

Robert Storr remarks on the holes that Ryman has drilled along the bottom edge of this painting, which 'establish the co-ordinated systems which implicitly divide the basic quadrilateral shape of the [painting] into the irregular grids which apportion the space within them'. He relates these 'complementary' holes to the exposed canvas hemline Ryman incorporated into earlier works (Paris 1991, pp.37–8).

72 **Transport** 1985

Oil and Enamelac on fibreglass panel with polished redwood edge and non-anodized aluminium fasteners 128.6 × 120 ($51\frac{1}{4}$ × $47\frac{3}{4}$)
Exh: Rhona Hoffman Gallery, Chicago, May 1985; Paris 1991 (no number, repr. p.151 in col.)
Private collection, Paris

'Transport' relates to other works with a redwood edge but was made a year or so later. See note for 'Credential' (no.73).

73 Credential 1985

Oil on aluminium with four round-faced
steel bolts 159.4 × 55.9 × 5.1 (62¾ × 22 × 2)
Exh: Rhona Hoffman Gallery, Chicago, May,
1985; *Individuals: A Selected History of Contemporary
Art 1945–1986*, Museum of Contemporary
Art, Los Angeles, Dec. 1986–Jan. 1988
Lit: Neal Benezra, *Robert Ryman: The Charter Series,
New Work*, exh. cat., San Francisco Museum of
Modern Art, Jan.–March 1988
Ralph and Helyn Goldenberg

'Credential' is one of a series of paintings made
in 1985, a number of which involved the pro-
jection of a paint plane some inches off the
wall and into space. Other works in the series
were 'Converter', 1984, 'Charter', 'Issue',
'Century', 'Appointment', 'Instructor', 'Trans-
port' and 'Accord', all from 1985. These were
exhibited at the Rhona Hoffman Gallery, Chi-
cago in 1985. The works differed in construc-
tion. Paint planes projected to varying degrees;
some works had aluminium supports, while
others used fibreglass; some had redwood
edges, and others had edges of aluminium.
'Charter' later became the basis of another
series. Ryman has compared the double paint
plane to that of 'Pace' (no.66).

The 'Charter' paintings, to which Ryman
refers below, are a series conceived in May
1985, when the Chicago collector, Gerald S.
Elliot, asked him to paint a series of works that
could be exhibited in a single room. The point
of departure for the series was an existing
work, 'Charter', 1985, a vertical rectangular
painting composed of two evenly painted
white panels, with the upper panel overhang-
ing (projecting some inches) over the lower
one. The two areas are divided by a thin strip of
aluminium. There are also bands of aluminium
at the top and bottom of the work. Ryman
added four more paintings ('Charter' II–V,
1987) to make up the series, but these have a
square, rather than a vertical rectangular
format.

RR: This is one of the rectangular paintings.
There were several of those. Generally I used
two paint planes. One came off of the wall
about three inches. What interested me about
this was the material. The aluminium was so
thin, and here was the paint plane coming off
the walls. It was almost like a sheet of paint
that came forward about three inches. And
then the second one was very close to the
wall, and generally repeated in size, though
sometimes not. But, compositionally, the
planes were arranged in different ways. The
aspect of the paint coming off and being
close to the wall at the same time was what
interested me, but there was more to it than
that, and it had to do with the light on the
metal and on the paint. One is in a room in
the Art Institute of Chicago that has five
paintings. It was the only time I ever actually
made a room. It's called the Charter Room,
after one of the works. [see Lit.]. It has the five
paintings, which are always to be kept
together in one room. They don't have to be
in the *same* room, or even in the same
configuration, as long as they're together. The
room has been shown in Chicago and in San
Francisco, and also in Pittsburgh at the
Carnegie International. Gerald Elliot came to
me and wanted to know if I would consider
making a room for him, a meditating room. I
had never done that. I thought about it, and I
thought it might be an interesting thing to
do, once. He already owned this one
painting, 'Charter', which was part of this
series. So I did four other paintings; actually, I
worked on them here [in Ryman's studio in
New York]. They were quite different from
this ['Credential'] in a sense, but of a similar
aesthetic. They didn't come off the wall like
this, but the way they were painted was
similar. And the material was different. So, he
had the paintings, but he didn't have a room.
He was going to make a room at his home,
and meanwhile he lent the room to different
places, San Francisco, Pittsburgh. Then he
ended up giving them [the paintings] to the
Art Institute [of Chicago]. He never really had
the room.
(RR and LZ)

74 Express 1985

Oil and Enamelac on fibreglass with black
oxide octagonal steel bolts and fasteners
273.7 × 120.7 ($107\frac{3}{4}$ × $47\frac{1}{2}$)
Exh: Robert Ryman, Recent Paintings, Galerie
Lelong, New York, Jan.–Feb. 1986
Lit: Robert Storr, 'Robert Ryman: Making
Distinctions', Paris 1991, p.37
Crex Collection, Hallen für neue Kunst, Schaffhausen

Ryman has described this painting as solving
the same problem as 'Credential' (no.73) but
in a different way:

RR: There again, there's the double paint
plane. But the approach is totally different. It's
on fiberglass. The band is the fiberglass; it's
kind of a greenish-yellow color. I left that
part unpainted. Well, actually I think this has
Enamelac on it, but very thin. It's soft and
then the two black squares, which again hold
it to the wall . . . the whole structure is only
about a quarter inch thick. The two painted
areas are flat.
(RR and LZ)

75 Constant 1987

Lascaux acrylic on Gator board 43.2 × 42.6
($17 × 16\frac{7}{8}$)
Exh: Robert Ryman: New Paintings, Konrad Fischer
Gallery, Düsseldorf, Oct. 1987; New York
1988–9 (repr. p.45 in col.)
Barbara Gladstone

RR: This was a little painting that was on red.
You can see it at the edges. Actually I painted
[the board] red. Gator board is like
Featherboard, except, instead of paper, it has
a wood veneer with a sandwich of foam in
between. I seal the edges with paint, so the
air doesn't get in. It was in the Dia show
[New York 1988–9] ... there were a number
of those. They were shown in Germany, at
Fischer. ['Constant', 1987; 'Leader', 1987;
'Receiver', 1987; 'Pledge', 1987].

And they weren't all done on the Gator
board. Some were on fiberglass. They were all
painted with a very similar approach ...
there's the red edge to this one. Actually this
painting isn't square [one side is a little
shorter than the other]. When you hang it,
you can't do it using a level. In fact, I put
instructions on the back to explain that. There
are two paintings I did which are not square,
which are very interesting when they're on
the wall, because they look straight but they
have a certain kind of energy to them which
is hard to pinpoint, because they're not quite
straight. But you see, the painted line is
straight. So, if you hung it by that line, it
would be straight ... But, it really wouldn't be
straight if you put a level on it. I own the
other painting. ['Transfer', 1987, exh. New
York, 1988–9]
(RR and LZ)

76 Journal 1988

Lascaux acrylic on Lumasite and plastic with
steel 243.8 × 243.8 (96 × 96)
Exh: New York 1988–9 (no number, repr.
pp.37–8)
Lit: Robert Ryman and Garry Garrels in New
York 1988–9, pp.33–7; Robert Storr,
'Making Distinctions', in Paris 1991, p.35
Bonnefantenmuseum, Maastricht, The Netherlands

Inscribed 'Ryman88' across centre.

The artist signed his name in block letters
because he couldn't just paint black squares.
This relates back to the idea that he would not,
on an earlier work, have painted black spots,
though he found it acceptable to have the bolts
serve the same visual purpose (see no.71). He
had used a concave surface before for
'Resource', 1984. He had tried to work with
several curved surfaces, but there was a prob-
lem with how to hang them. 'Resource' is held
by long bolts attached to the top and bottom
corners which fit into plates and are held by
screws. The bolts are larger at the top because
the smaller ones didn't hold it.

RR: That was in the Dia show (New York
1988–9) . . . It's a painting that sits on
metal flanges that come out from the wall.
They have a little curve; the lip kind of goes
back; it's not straight up at a ninety degree
angle. And then the surface of the painting
curves. It sits on the flanges, then it curves
back and touches the wall, then it curves out
again and the top is held by a similar device.
(RR and LZ)

RR: ['Journal'] is very complicated . . . It came
about because I wanted to work on a curved
surface, and I wanted it to lean against the
wall without being actually attached to the
wall. A curved surface was challenging
because of the way the line was touching the
wall. It was so thin, but then it was . . . away
from the wall too . . . It was difficult to
engineer . . . I tried leaning the panels and
then putting them together, but they weren't
fitting right because of the built-in code. [All
materials, wood plastic, metal, etc., have a
specific way of acting because of the way
they are made. They cannot be forced to act
in a way that is different from that. They have
a built-in code that must be considered] . . .
Once the basic structure was done, then the
painting began. That didn't happen right
away. The band in the center was always a
problem. It had to be there visually because
its part of the the structure, but it was hard to
work that in with the composition. Visually, I
raised the center by extending that line up,
which is not really a line but an edge of an
area. In fact I almost never paint a line. I
mean, all of my lines are planes meeting. So,
in this case I raised the center above that
central bar. Then came the problem with the
bar. I couldn't get rid of it and I needed
something visual, some reason for it. So I
signed the painting across the center, which
was a little radical . . . It's not fastened to the
wall, it's just leaning.
(Gary Garrels 1988, pp.33–7, revised by the
artist, 1992)

77 Initial 1989

Oil on Gator board with wood 60.3 × 58.4
$(23\frac{3}{4} \times 23)$
Exh: Robert Ryman, New Paintings, Pace Gallery,
New York, April–May 1990 (8, repr. in col.)
Private collection

This painting, which relates to 'Constant' (no.75) and 'Locate' (no.78) rests on two asymmetrically positioned wood blocks that protrude from the wall, to which they are attached with Elmer's glue. The painting itself is fixed to the wall with the same glue, so that it lies flat. From the 'Classico' series of 1968 onwards (see no.41) Ryman has used glue to install his lighter works. This method of fixing allows the paintings to be 'naked', that is, without visible means of support. 'Initial', like earlier works similarly fastened, may be removed from the wall with the aid of a spatula. It is one of several works from 1989–90 where Ryman has addressed the problem of asymmetry in his work.

78 Locate 1989

Oil on Gator board and aluminium with
painted steel 50.8 × 48.3 (20 × 19)
Exh: *Robert Ryman, New Paintings*, Pace Gallery,
New York, April–May 1990 (4, repr. in col.)
Lit: Yve-Alain Bois, 'Surprise and Equanimity'
in *Robert Ryman, New Paintings*, exh. cat., Pace
Gallery, New York 1990, p.11; Jean Frémon,
Robert Ryman: Le paradoxe absolu, Caen 1991, p.20
Linda and Harry Macklowe

Ryman told Lynn Zelevansky that in this paint-
ing, a lip of aluminium makes a line next to the
wall and the metal plates are fastened to the
aluminium. The paint is heavy and brushed in
all directions except at the sides. The paint is
applied in horizontal strokes on the left side
and vertical strokes on the right. The painting is
part of a series with 'Condition', 'Match', and
'Roll'. 'Converse' is also somewhat similar; it
uses the same materials and has the aluminium
line. All these works were exhibited with
'Locate' at the Pace Gallery in 1990 (nos.3, 6,
5, 10). As with 'Context' (repr. Paris 1991,
p.161), the thicker, or more textured brush-
work and formal elements in the composition
link this recent painting to paintings of the
early 1960s (for example the stacked horizon-
tal lines in no.21).

79 Versions VII 1991

Oil on fibreglass with wax paper
112.4 × 104.2 (44½ × 41)
Exh: *Robert Ryman: Versions*, Schaffhausen,
May–Oct. 1992; Pace Gallery, New York, Dec.
1992–Jan. 1993 (repr. p.5 in col.)
Lit: Christel Sauer, pp.7–11; Urs Raussmüller,
'A Talk in Robert Ryman's Studio, 4 April
1992', pp.13–36, in *Robert Ryman: Versions*, exh.
cat., Schaffhausen 1992
Constance R. Caplan, Baltimore, Maryland

This is one of a group of sixteen paintings
made between summer 1991 and spring 1992
and first exhibited together in Schaffhausen at
the Hallen für neue Kunst. These are all titled
'Versions' (in the plural) and distinguished by
Roman numerals. 'Versions' I–IV are big paint-
ings made in 1992. 'Versions VII' is from a
group of three medium-sized works ('Ver-
sions' V–VII). The smaller works are divided
into two sub-groups, 'Versions' VIII to XIII (all
1991) and Nos.XIV to XVI (1992). Ryman
used Roman numerals for this group of paint-
ings so as not to imply a chronology.

For two of the 'Versions' paintings, Ryman
used an interference paint which is opalescent
and changes as the light changes. He is also
interested in the way the waxed paper appears
soft and fragile against the solid surface of the
wall. In a telephone conversation with Lynn
Zelevansky (24 November 1992), the artist
said that when he began the 'Versions' series,
he wanted to create a very thin work with a
visually 'soft' surface. He made a number of
paintings on handmade paper bonded to
extremely thin sheets of fibreglass, along with
others that were mounted on one-eighth inch
fibreglass panels with an aluminium core. He
was not satisfied with the results and decided
not to use the paper but to work directly on the
thinner fibreglass sheets. He began by making
works that were forty-five inches square,
which he nailed directly to the wall. He liked
the 'softness' of the surfaces and the way the
fibreglass draped itself against the wall. Since
the size of the fibreglass was limited, he

devised a way of making larger panels from
smaller ones, creating different linear patterns
by varying the position and quantity of the
joins between sheets. He used the joins as a
grid and, in some cases, added a grid in pencil
because it, acting with the straight edges of the
fibreglass, gave the works a kind of visual stab-
ility. He framed the tops and bottoms of the
works with waxed paper, but ultimately
restricted this element to the top edges, where
it extends the paintings visually and gives an
uplifting feeling to them.

RR: In these recent paintings, the paint plane
itself and the structure, being so thin, are
large parts of the aesthetic. And then there is
the very thin wax paper and the way that
works with the light and the paint plane and
the space of the environment that the
painting is in. All this has to do with the way
the painting reacts with the wall plane.

The wax paper, being very soft and
impermanent, creates an aspect of fragility,
the opposite of strength. Of course, the paper
can be replaced, and the paper is very
different from all the other aspects of the
painting. Not only because of the reflected
light but . . . [because it extends] the structure
[of the paintings] . . . There are also the nails
that hold the paintings, and make them an
essential part of the wall plane itself. I used
the nails simply because it seemed the most
direct way to put the paintings on the wall . . .
In the 'Versions' I wanted to let the paint
itself have more importance in terms of how
it functioned as opposed to ways I had used
paint in the past.

These paintings . . . are not done at one
time, they are worked on over a period of
time, sometimes quite a number of weeks or
even a few months. And the surface is built
up slowly and can expand through the space
of the structure. On certain areas it can
become more opaque through the addition
of more paint. It is hard to say exactly how I
do that, because it develops on its own.
(Raussmüller 1992, pp.25–35)

80 Versions XII 1991

Oil on fibreglass with wax paper 47.6 × 43.2
($18\frac{3}{4}$ × 17)
Exh: *Robert Ryman: Versions*, Schaffhausen,
May–Oct. 1992; Pace Gallery, New York, Dec.
1992–Jan. 1993 (repr. p.64 in col.)
Lit: Christel Sauer, pp.7–11; Urs Raussmüller
'A Talk in Robert Ryman's Studio, 4 April
1992', pp.13–36 in *Robert Ryman: Versions*, exh.
cat., Schaffhausen 1992
Crex Collection, Hallen für neue Kunst, Schaffhausen

See no.79.

81 Versions XVI 1992

Oil and graphite pencil on fibreglass with
wax paper 36.2 × 33 (14¼ × 13)
Lit: Christel Sauer, pp.7–11; Urs Raussmüller
'A Talk in Robert Ryman's Studio, 4 April
1992', pp.13–36 in *Robert Ryman: Versions*, exh.
cat., Schaffhausen 1992
Crex Collection, Hallen für neue Kunst, Schaffhausen

Inscribed 'Ryman 92' vertically on right.
See no.79.

Chronology

COMPILED BY LYNN ZELEVANSKY

All galleries and museums referred to are in New York unless otherwise stated.

1930

30 May: Robert Tracy Ryman born Nashville, Tennessee. Father is in the insurance business; mother, a grade school teacher, is musical.

1948

Enters Tennessee Polytechnic Institute, Cookville, Tennessee.

1949

Transfers to George Peabody College for Teachers in Nashville, Tennessee, where he studies music.

1950

12 September: Enlists in the United States Army Reserve Corps, assigned to an Army Reserve Band. Is activated shortly thereafter and, during the Korean conflict, serves in the Southern United States. Plays the tenor saxophone.

1952

17 May: Is discharged from active service.

June: Moves to New York City with the intention of becoming a jazz musician. Studies with jazz pianist Lenny Tristano.

March–June: *15 Americans*, exhibition at The Museum of Modern Art (MoMA), includes William Baziotes, Herbert Ferber, Frederick Kiesler, Jackson Pollock, Mark Rothko, Clifford Still, and Bradley Walker Tomlin.

June: Ad Reinhardt has one-person exhibition at Betty Parsons Gallery. Shows almost annually with Parsons throughout the 1950s and more intermittently in the 1960s.

December: Harold Rosenberg publishes 'The American Action Painters' in *Art News*. The author defines the practitioners of the new American painting not as a school, but rather as a group of individuals to whom 'at a certain moment the canvas began to appear . . . as an arena in which to act – rather than as a space in which to reproduce, re-design, analyze or ''express'' an object, real or imagined.'

1952–3

Ryman works at odd jobs in New York. Lives at 171 East 60th Street: 'I had no money and I was working . . . little funky jobs, occasionally making forty dollars a week or something like that . . . I usually only kept a job maybe eight or nine months. Then I would go somewhere else.' (Robert Ryman in taped conversation with Robert Storr, June 1992)

1953

January–February: Philip Guston has one-person exhibition at Charles Egan Gallery. Shows at the Sidney Janis Gallery yearly from 1956 to 1961.

January–February: Roy Lichtenstein has one-person exhibition at John Heller Gallery, where he shows until 1959. In 1962, joins Leo Castelli Gallery.

April: Willem de Kooning has one-person exhibition at Janis Gallery. Shows every few years throughout the 1950s and 1960s with Janis, Martha Jackson Gallery, and M. Knoedler & Co.

11 May: Bradley Walker Tomlin dies of a heart attack aged 54, one month after his second one-person exhibition at Parsons Gallery.

30 June: Ryman begins temporary employment as a vacation relief guard at MoMA. He stays on as a guard for seven years.

In 1953, MoMA has an already rich collection of works by Henri Matisse, as well as the following works by American Abstract Expressionists:

Arshile Gorky: 'Composition Horse and Figures', 1928; 'Argula', 1938; 'Garden in Souchi', c.1943; 'Agony', 1947.
Adolph Gottlieb: 'Voyager's Return', 1946.
Franz Kline: 'Chief', 1950.
Willem de Kooning: 'Painting', 1948; 'Woman I', 1950–1; 'Woman II', 1952.
Robert Motherwell: 'Pancho Villa, Dead and Alive', 1943; 'Western Air', 1946–7.
Jackson Pollock: 'She Wolf', 1943; 'Full Fathom Five', 1947; 'Number 1', 1948; 'Number 12', 1949.
Mark Rothko: 'Number 10', 1950.

Ryman in his twenties

11 September: Ryman is honourably discharged from the Army Reserve Corps.

September–October: Robert Rauschenberg has one-person exhibition at the Stable Gallery. Shows monochrome white and black paintings. Shows the 'Red Paintings' at Egan Gallery in 1954 and, beginning in 1958, exhibits annually at Castelli Gallery.

Sometime in 1953 Ryman makes his first paintings.

1954

February: Jackson Pollock has one-person exhibition at Janis Gallery. Janis shows Pollock's work annually until 1958.

16 June: Painter (Elliott) Budd Hopkins begins work at MoMA's front desk. Continues in this job until September 1955. He and Ryman become friends.

1 July–10 September: Al Held works at MoMA as an art handler. However, Ryman gets to know him better some years later, through the artist-run Brata Gallery on East 10th Street, where Held is a founding member.

April–May: Franz Kline has one-person exhibition at Charles Egan Gallery. Beginning in 1956, Kline shows annually at Janis Gallery until his death in 1962.

May–July: *Younger American Painters* at the Solomon R. Guggenheim Museum includes 57 artists, among them Baziotes, James Brooks, Richard Diebenkorn, Jimmy Ernst, Leon Golub, Guston, Kline, de Kooning, Matta, Motherwell, and Pollock.

3 November: Matisse dies in Nice.

Sometime in 1954, Ryman quits music and begins painting in earnest.

MoMA acquires Still's 'Painting', 1951 and Matta's 'The Spherical Roof around our Tribe', 1952.

1955

Spring: Clement Greenberg publishes '"American/Type Painting"' in the *Partisan Review*, a study of Abstract Expressionism that considers Gorky, de Kooning, Motherwell, Pollock, Mark Tobey, Kline, Still, Newman, and Rothko.

April–May: Rothko has one-person exhibition at Janis Gallery. Shows again with Janis in 1958; between 1958 and his death in 1970, his solo exhibitions in New York are at museums.

May–August: *The New Decade: 35 American Painters and Sculptors* at the Whitney Museum includes work by Baziotes, Brooks, Gottlieb, Kline, de Kooning, Motherwell, Pollock, Reinhardt, and Tomlin.

MoMA acquires Matisse's 'Jeanette II', 1911 and 'Tiari', 1930.

Ryman begins the largely monochrome 'Orange Painting' (no.1), which he considers his earliest professional work.

1956

May–June: Ellsworth Kelly has his first one-person exhibition in New York at Parsons Gallery. Kelly shows every few years at Parsons until 1967, when he joins Janis Gallery. Shows with Castelli, beginning in 1975, and at Castelli and Blum-Helman Galleries in the 1980s.

May–September: *12 Americans*, exhibition at MoMA, includes work by Ernest Briggs, Brooks, Sam Francis, Fritz Glarner, Guston, Raoul Hague, Grace Hartigan, Kline, Ibram Lassaw, Seymour Lipton, José de Rivera, and Larry Rivers.

11 August: Pollock is killed in a car accident in the Springs, New York aged 44.

December–February: *Jackson Pollock*, Memorial exhibition at MoMA.

MoMA acquires Matisse's 'The Serf', 1900–1 and 'The Back II', 1913 and Philip Guston's 'Painting', 1954.

1957

February: Leo Castelli Gallery opens with an exhibition of work by de Kooning, Robert Delaunay, Jean Dubuffet, Alberto Giacometti, Marsden Hartley, Fernand Léger, Piet Mondrian, Francis Picabia, Pollock, David Smith, and Theo Van Doesburg.

February: Kenneth Noland has first one-person exhibition in New York at Tibor de Nagy Gallery. Shows at de Nagy in 1958, French & Co. in 1959, and joins André Emmerich in 1961.

March–April: *Artists of the New York School: Second Generation*, at the Jewish Museum, includes work by 23 artists, among them Helen Frankenthaler, Grace Hartigan, Jasper Johns, Allan Kaprow, Alfred Leslie, Joan Mitchell, Rauschenberg, and George Segal. The exhibition is curated by Meyer Schapiro, with an introduction by Leo Steinberg.

October–November: *Bradley Walker Tomlin*, retrospective exhibition at the Whitney Museum.

MoMA acquires Pollock's 'Painting', 1953–4 and Motherwell's 'Personage with Yellow Ochre and White', 1947.

Agnes Martin returns to New York, where she lived from 1941–6 and from 1951–2. She settles on Coenties Strip. The community includes Robert Indiana, Johns, Kelly, Larry Poons, James Rosenquist, Rauschenberg, and Jack Youngerman.

Around 1975–8, Ryman and co-workers meet Rothko at the MoMA Cafeteria. Practical issues such as conservation and studio accommodation are discussed.

Between 1957 and 1961, Ryman makes small works on paper, or tracing paper, in pencil, casein, and/or gouache, or in oil. He also produces oil paintings on pre-primed cotton. These works are predominantly white, but underpainting in vibrant colour is, to varying degrees, visible. He has already begun to include his signature as a compositional element.

1958

January–February: Johns has his first one-person exhibition in New York at Castelli Gallery. 'Green Target', 1955, 'Target with Plaster Casts', 1955, 'Numbers', 1957, 'White Numbers', 1957, 'Flag', 1955 and 'Flag', 1957 are among the 15 works exhibited. Shows annually or biannually with Castelli into the 1970s.

March: Rauschenberg shows 'Combines' in first exhibition at Castelli Gallery.

June–July: Donald Judd has his first one-person exhibition at Panoras Gallery. Shows at Green Gallery in 1963 and 1964, and almost annually with Castelli from 1966 to the mid-1980s.

September–November: *New Images of Man* at MoMA includes work by Karel Appel, Francis Bacon, Diebenkorn, Dubuffet, Golub, de Kooning, Pollock, and others. Catalogue essay claims for the artists a shared form of figurative Expressionism that owes a debt to earlier twentieth-century movements, while it manifests a contemporary approach to materials, to 'color as pigment' and 'surface as surface'.

November–December: Martin has first one-person exhibition at Section 11 Gallery. Shows with Parsons and Robert Elkon Galleries almost yearly into the mid-1970s. Shows with Pace Gallery from 1975.

Sometime in 1958, Ryman participates in a staff exhibition at MoMA. This is the first public showing of his work; it takes place in the gallery used by MoMA's art lending service, located in the museum's penthouse, outside the Members' Dining Room. Ryman contributes one small painting to the exhibition, and it is sold to Gertrud A.

Mellon, a member of the museum's Painting and Sculpture committee.

December: Ryman's work is probably included in the Christmas group exhibition at Brata Gallery, run by brothers John and Nicholas Krushenick. Ryman had become friendly with Nicholas Krushenick at MoMA where, from September 1953 to May 1957, Kruschenick worked in the frame shop.

Sometime in 1958 Jules Olitski has first one-person exhibition in New York at Zodiac Gallery, part of Iolas Gallery. Following that, shows at French & Co., Poindexter Gallery, Emmerich Gallery, Lawrence Rubin Gallery, and Knoedler Contemporary Art.

MoMA acquires Pollock's 'Untitled', 1945 and 'Painting', ?1945; Gottlieb's 'Blast I', 1957; and Johns's 'Green Target', 1955, 'Target With Four Faces', 1955, and 'White Numbers', 1957.

1959

March–April: Newman has first one-person exhibition in New York since 1951 at French & Co. Shows with de Kooning at Allan Stone Gallery in 1962 and with Knoedler & Co. in 1969.

March: Claes Oldenburg has first one-person exhibition in New York at the library of the Cooper Union Museum. He shows at the Judson Gallery, Reuben Gallery, Martha Jackson Gallery, Green Gallery, Sidney Janis Gallery, and, beginning in 1974, at Castelli Gallery.

25 April: Dan Flavin begins working at MoMA as a guard. Continues in the job until August 1960. He and Ryman become friends.

22 June: Michael Venezia begins work at MoMA as mailroom clerk. Continues in the job until September 1960. He and Ryman become friends, but lose contact when Venezia moves first to Europe and then to Rochester, New York. They meet up again when Venezia returns to New York City in the late 1970s.

May–September: *The New American Painting*, MoMA international touring exhibition, makes its final stop in New York following showings in Basel, Milan, Madrid, Berlin, Amsterdam, Brussels, Paris, and Tate Gallery, London. It includes the work of Baziotes, Brooks, Francis, Gorky, Gottlieb, Guston, Hartigan, Kline, de Kooning, Motherwell, Newman, Pollock, Rothko, Theodore Stamos, Still, Tomlin, and Jack Tworkov and provides an international audience with its first comprehensive look at Abstract Expressionism.

Studio View 1959, oil on photograph 8.2 × 11.4 $(3\frac{1}{8} \times 4\frac{1}{2})$ *The artist*

October–November: Robert Smithson has first one-person exhibition at Artists' Gallery. Shows at Richard Castellane Gallery in 1962 and, beginning in 1966, almost yearly at Virginia Dwan until the gallery closes in 1971.

Autumn: Allan Kaprow, artist and student of John Cage, organizes *18 Happenings in 6 Parts* at the Reuben Gallery, one of the earliest opportunities for a somewhat wider audience to attend live 'events' that had previously been performed more privately.

December: Ryman's work is probably included at the Brata Christmas group exhibition.

December–February: *Sixteen Americans* at MoMA includes work by J. de Feo, Wally Hendrick, James Jarvaise, Johns, Kelly, Leslie, Landes Lewitin, Richard Lytle, Robert Mallary, Louise Nevelson, Rauschenberg, Julius Schmidt, Richard Stankiewicz, Albert Urban, Youngerman, as well as five black paintings by Stella. Catalogue has text on Stella by Carl Andre.

MoMA acquires Rothko's 'Red, Brown, and Black', 1958; Newman's 'Abraham', 1949; and Guston's 'The Clock', 1956–7.

1960

January–February: Held has first one-person exhibition in New York at Poindexter Gallery. He shows with them almost yearly until 1965, when he joins André Emmerich Gallery.

17 March: Jean Tinguely's 'Homage to New York', motorized assemblage, set in motion and destroyed in sculpture garden of MoMA.

18 March: Sol LeWitt begins work at MoMA as a desk assistant. Works at the museum continuously until October 1965. He and Ryman become good friends a year or so later, when they are neighbours on the Lower East Side.

15 May: Ryman resigns from staff of MoMA. On 17 June begins work as a clerical assistant at the New York Public Library, in the Art Division: 'I shied away from teaching for a long time because I was afraid it would take too much from my painting. I felt I would become too immersed in the education aspect, so I would pick up jobs that left my mind free. Working in a library or as a museum guard were the kinds of jobs that seemed ideal.' (Maurice Poirier and Jane Nicol, 'The '60s in Abstract: 13 Statements and an Essay', *Art in America*, Oct. 1983, pp.123–4)
 Becomes friendly with critic Lucy Lippard, who does research at the library, and whom he knows from MoMA, where she

worked as a library assistant from September 1958 to May 1960.

September–October: Frank Stella has one-person exhibition at Castelli Gallery. Shows almost biannually with Castelli through the mid-1970s. Later, shows at Castelli and M. Knoedler & Co.

October–November: *Twenty-five Years of Abstract Painting*. Reinhardt mounts his own retrospective at Parsons and Section 11 Galleries.

MoMA acquires Matisse's 'Venus in a Shell I', 1930 and Kelly's 'Running White', 1959.

1961

January–March: *Mark Rothko*, at MoMA, includes 54 works by the artist, who is 58 years old. First one-person exhibition at a New York museum.

April: Yves Klein has first one-person exhibition in New York at Castelli Gallery. Visits the United States.

31 May: Ryman quits his job at the Public Library to devote himself to painting full-time.

May–June: Flavin has his first one-person exhibition at Judson Gallery. Shows throughout the 1960s and 1970s at Kaymar, Green, Kornblee, Dwan, and Castelli Galleries.

19 August: Ryman marries critic Lucy Lippard. They remain together until 1966. Wedding is in Maine, where her parents have a house. They live on Avenue D on the Lower East Side, and Ryman takes a small studio at 163 Bowery. Artists Robert and Sylvia Mangold are his upstairs neighbours. At Ryman's request, Sylvia Mangold gives him her last abstract painting, a small work with the word 'Cancel' written across it. LeWitt also lives nearby, on Hester Street.

October–November: *Art of Assemblage* at MoMA, a survey including art from Marcel Duchamp to de Kooning, Rauschenberg, and Johns.

October–December: *American Abstract Expressionists and Imagists* at the Whitney Museum includes work of 63 artists, among them Josef Albers, Baziotes, Brooks, Francis, Frankenthaler, Michael Goldberg, Gorky, Gottlieb, Guston, Hartigan, Held, Hans Hofmann, Johns, Kelly, Kline, de Kooning, Leslie, Morris Louis, Matta, Mitchell, Motherwell, Newman, Noland, Pollock, Richard Pousette-Dart, Rauschenberg, Reinhardt, Rothko, Leon Polk Smith, Stamos, Stella, Still, Mark Tobey, Tomlin, and Youngerman.

December–January: *Claes Oldenburg: The Store* at Ray Gun Manufacturing Co., 107 East 2nd Street, New York. Exhibition mounted in cooperation with Green Gallery.

Greenberg publishes 'Modernist Painting' in *Arts Yearbook* 4. (It is reprinted, with some changes, in the Spring 1965 issue of *Art and Literature*). He sees the history of painting as an evolution toward flatness, which he defines as the single property exclusive to that medium. Although he does not mention them in this essay, his argument serves as an historical justification for the work of such contemporary artists as Noland and Olitski, whose painting he endorses.

Ryman begins a series of small paintings in oil on unstretched canvas squares.

1962

March–May: *Geometric Abstraction in America* at the Whitney Museum includes 70 artists, among them Gorky, Held, Hofmann, Kelly, Martin, Noland, Reinhardt, David Smith, Polk Smith, and Stella.

13 May: Franz Kline dies of heart disease shortly before his 52nd birthday.

6 June: Yves Klein dies of heart failure in his Paris apartment aged 34.

May–July: *Philip Guston: Recent Paintings and Drawings* at the Guggenheim Museum. First one-person exhibition at a New York museum. The artist is 49 years old.

November: Andy Warhol has first one-person exhibition in New York at Stable Gallery. Shows at Stable again in 1964 and thereafter at Castelli Gallery.

November–December: *The New Realists* at Janis Gallery includes the work of artists from England, France, Italy, Sweden, and the United States. Among them are John Latham, Arman, Christo, Yves Klein, Daniel Spoerri, Tinguely, Oyvind Fahlstrom, Jim Dine, Indiana, Lichtenstein, Oldenburg, Rosenquist, Segal, Warhol, and Tom Wesselmann. The exhibition marks a shift in emphasis for the gallery – and the art world – from Abstract Expressionism to what will become known as Pop Art. Janis notes in the catalogue, 'As the Abstract Expressionist became the world recognized painter of the 50s, the new Factual artist (referred to as the Pop Artist in England, the Polymaterialist artist in Italy, and here as in France, as the New Realist) may already have proved to be the pacemaker of the 60s.'

Ryman makes a series of paintings in which short, curved, white brushstrokes cover similar coloured strokes visible beneath.

1963

6 February: Piero Manzoni dies of liver disease and exposure in his studio in Milan aged 30.

Spring: Eva Hesse and Tom Doyle move to the Bowery, and it is around this time that Hesse, Doyle, Ryman, and Lippard become friends. Ryman shows Hesse 'how to frame her drawings cheaply with glass and tape'. (Lucy Lippard, *Eva Hesse*, New York 1976, p.67)

March: Hesse has first one-person exhibition at Allan Stone Gallery, New York. She shows at Fischbach Gallery in 1968 and 1970.

March–May: *Robert Rauschenberg*, at Jewish Museum, includes works from 1949–62. First one-person exhibition at a New York museum. The artist is 38 years old.

April–June: *Five Mural Panels Executed for Harvard University by Mark Rothko* at the Guggenheim Museum.

June: Three-hour programme at the Judson Church leads to the formation of the Judson Dance Group, which includes Trisha Brown, Lucinda Childs, Sally Cross, Carolee Schneeman, John McDowell, Philip Corner, Deborah Hay, Yvonne Rainer and others. By 1963 artists such as Robert Morris are participating in their concerts.

May–August: *Americans 1963*, the last of curator Dorothy Miller's shows of contemporary American art at MoMA, includes work by Richard Anuszkiewicz, Lee Bontecou, Chryssa, Sally Hazelet Drummond, Edward Higgins, Indiana, Gabriel Kohn, Michael Lekakis, Richard Lindner, Marisol, Oldenburg, Rosenquist, Reinhardt, Jason Seley, and David Simpson.

October: Robert Morris has first one-person exhibition in New York at Green Gallery. Shows almost annually in New York at Green Gallery, Dwan Gallery, and, beginning in 1967, Castelli Gallery.

December–February: *Black and White* at the Jewish Museum includes work by 20 artists, among them Albers, de Kooning, Gorky, Johns, Kelly, Kline, Motherwell, Newman, Pollock, Rauschenberg, Stella, Tomlin, and Youngerman.

1964

January: Ryman shows as a guest in the *American Abstract Artists 28th Annual Exhibition* at New York University's Loeb Student Center. Joins the organization later that year. He remains a member until 1981. In 1965, the annual exhibition, held at the Riverside Museum, includes, along

with Ryman, George Rickey, Salvatore Scarpitta, and George Sugarman. In 1966, guests include Hesse, Will Insley, LeWitt, and Robert Smithson. 'It was a very laid back organization. We would talk about where we would show that year and someone would find a place.' (Ryman to Storr, 1992).

January: Robert Mangold has first one-person exhibition at Thibaut Gallery. Throughout the 1960s, 1970s, and 1980s shows annually or biannually at Fischbach, John Weber, and Paula Cooper Galleries.

February–April: *Jasper Johns*, exhibition at the Jewish Museum. The artist is 34 years old.

March–April: Ryman participates in *Eleven Artists*, held at Kaymar Gallery and curated by Flavin. Other artists include Jo Baer, Walter Darby Bannard, Flavin, Irwin Fleminger, Ward Jackson, Donald Judd, LeWitt, Poons, Stella, Leo Valledor. The exhibition runs only two weeks, from 31 March to 14 April.

4 December: Son born to Ryman and Lippard, Ethan Isham Ryman.

In 1964, Ryman makes his first paintings on metal (vinyl polymer on aluminium).

1965

February–March: *Kenneth Noland*, exhibition at the Jewish Museum. First one-person exhibition at a New York museum. The artist is 41 years old.

February–April: *The Responsive Eye* at MoMA includes the work of Albers, Kelly, Louis, Noland, Reinhardt, and Stella. The exhibition attempts to understand contemporary abstraction through art that explores the extremes of optical situations, from work that is almost invisible to work that is intensely visually active.

March–April: Reinhardt has three simultaneous one-person exhibitions, showing red paintings at Graham Gallery, blue paintings at Stable Gallery, and black paintings at Parsons Gallery.

April–May: *Three Americans*, curated by Michael Fried at the Fogg Art Museum, Harvard University, contains the work of Noland, Olitski, and Stella. Lengthy catalogue text by Fried is a defence and elaboration of Greenberg's Formalist criticism. Fried adopts Greenberg's term, 'modernist painting'.

April–May: Andre has one-person exhibition at Tibor de Nagy Gallery. Shows yearly or twice yearly, at de Nagy, Dwan, John Weber, and Sperone Westwater Fischer Galleries. Joins Paula Cooper Gallery in the 1980s.

September: Richard Tuttle has first one-person exhibition at Parsons Gallery. Shows with Parsons until 1984, when he is represented by Blum-Helman Gallery. Shows with Mary Boone Gallery in 1992.

Judd publishes 'Specific Objects' in *Arts Yearbook 8*. Essay posits the existence of a new art that is neither painting nor sculpture. Judd notes that the new three-dimensional work does not constitute a movement or school. Article reproduces work by Morris, Stella, Flavin, Lucas Samaras, Yayoi Kusama, Judd, and others.

There is a major shift in Ryman's painting during 1965. The work begins to develop more systematically. From now on works are titled as a means of identification. He starts the 'Winsor' series (see no.36).

1966

February: *European Drawing* at the Guggenheim Museum includes work by Lucio Fontana, Klein, and Manzoni. This is the first time Manzoni's work is seen in New York.

February: Robert Morris publishes Part I of 'Notes on Sculpture' in *Artforum*. Parts II and III appear in the October 1966 and June 1967 issues of the magazine. The artist sees the concerns of sculpture as 'not only distinct from but hostile to those of painting'. (Sculpture has generally not been involved with illusionism, so the evolution of modern painting can have little relevance to it. He speaks of the lack of an image and the literal use of materials as essential conditions of contemporary sculpture.)

April–June: *Barnett Newman: The Stations of the Cross: Lema Sabachthani* at the Guggenheim Museum. First one-person exhibition at a New York museum. The artist is 61 years old.

April–June: *Primary Structures: Younger American and British Sculptors* at the Jewish Museum, curated by Kynaston McShine, includes work by 42 artists, among them Andre, Larry Bell, Ronald Bladen, Robert Grosvenor, Judd, Kelly, LeWitt, Walter de Maria, Morris, Smithson, Anne Truitt, and William Tucker. This is the first major exhibition to include a comprehensive view of what will come to be known as Minimalism.

September–November: Ryman shows work in *Systemic Painting*, curated by Lawrence Alloway, at the Guggenheim Museum. Exhibition includes 28 artists, among them Baer, Held, Kelly, Nicholas Krushenick, Mangold, Martin, Noland, Poons, Polk Smith, Stella, and Youngerman. Ryman is one of only two artists for whom the catalogue has no exhibition history or bibliography.

Unfinished Painting 1965, oil on canvas 158.7 × 158.7 (62½ × 62½) *Helen and Ralph Goldenberg, Chicago*

November–December: Brice Marden has first one-person exhibition in New York at Bykert Gallery. Shows annually or biannually at Bykert, Sperone Westwater Fischer, Mary Boone, and Pace Galleries throughout the 1960s, 1970s, and 1980s.

November–January: *Ad Reinhardt: Paintings*, retrospective exhibition at the Jewish Museum emphasizing the late black paintings, curated by Sam Hunter with Reinhardt and Lucy Lippard. Catalogue essay by Lippard. Reinhardt is 53 years old.

Ryman paints 'Winsor 20', 'Mayco' (no.37), 'Twin' (no.38), and 'Delta I'.

1967

January: Tony Smith has first exhibition in New York, sponsored by the Office of Cultural Affairs, New York City Department of Parks; co-sponsored by the Bryant Park Committee of the Avenue of the Americas. Sculptures are shown in Bryant Park, behind the New York Public Library. Smith subsequently shows at Fischbach, Knoedler, Fourcade-Droll, and Pace. Following his death in 1980, there are exhibitions at Pace, Fourcade-Droll, and Paula Cooper Galleries.

January–March: *Yves Klein*, exhibition at the Jewish Museum.

April–May: Ryman has first one-person exhibition at Paul Bianchini Gallery. He shows the 'Standard' series, 13 paintings on rolled steel: 'My first show was at Paul Bianchini's gallery in 1967. It turned out nothing was sold, even though the paintings were very inexpensive. [An acquaintance of Ryman's visits the exhibition and buys a Rembrandt drawing from Bianchini. Delighted, the dealer gives Ryman $100. Gallery closes shortly thereafter] ... he gave me $100. So something came from the show ... and at that time $100 meant a lot. I had no money at all. I was kind of living by my wits. (Maurice Poirier and Jane Necol, 'The 60's in Abstract: 13 Statements and an Essay' *Art in America*, Oct. 1983, pp.123–4)

April–June: *Jackson Pollock*, exhibition at MoMA.

June: Michael Fried publishes 'Art and Objecthood', a critique of Minimalism that begins with artist Tony Smith, in *Artforum*.

Summer: LeWitt publishes a personal manifesto, 'Paragraphs on Conceptual Art', in *Artforum*.

31 August: Reinhardt dies in his studio, probably of a heart attack, aged 53.

December: Robert Smithson publishes 'The Monuments of Passaic' in *Artforum*, returning to the town of his birth with an instamatic camera, not to record objects of civic pride, but industrial and other relatively prosaic sites. Painting is increasingly marginalized in the New York art world, displaced by various forms of Minimalism and Conceptual art.

Ryman produces his first works combining canvas with wax paper that is masking taped to the wall (e.g. 'Adelphi'). He also produces his first works incorporating elements drawn directly on the wall.
German dealers Konrad Fischer and Heiner Friedrich visit Ryman's studio and each buys a work. These are Ryman's first major sales. 'That was the time I felt there was beginning to be some interest ... I had a show in both galleries in Germany, and then shortly after there were shows in Italy and Paris with Yvonne Lambert.' (Ryman to Storr, 1992)

1968

January–February: Bruce Nauman has first one-person exhibition in New York at Castelli Gallery. Continues to show annually or biannually in New York at Speronë-Westwater Gallery, as well as at Castelli.

October–November: Ryman has first one-person exhibition in Europe at Galerie Heiner Friedrich, Munich. Shows six similar-sized paintings on linen that are stapled directly to the wall. 'Adelphi' (no.67) has a waxed paper frame.

November–December: Ryman has one-person exhibition at Galerie Konrad Fischer, Düsseldorf. Shows modular works on paper executed that year.

In 1968, in addition to modular works on paper (the 'Classico' series (no.41), 'Lugano' (no.40)), Ryman does works on canvas that are stapled to the wall. 'Essex' has a bright yellow border painted directly on the wall, while 'Impex' incorporates a narrow blue chalk line drawn above the painting (see no.39).

1969

31 January: Ryman marries artist Merrill Wagner, whom he met in 1968, when he attempted to acquire a dog from her for his son.

March–April: Ryman participates in *When Attitudes Become Form: Works, Concepts, Processes, Situations, Information*, curated by Harald Szeeman at the Kunstmuseum Berne. Exhibition includes 70 artists, among them Andre, Richard Artschwager, Joseph Beuys, Mel Bochner, Hanne Dar-

'Standard' series 1967: installation view of exhibition at the Paul Bianchini Gallery, 1967

Ryman's studio wall, New York, early 1970s, showing works from his 'Surface Veil' series (photograph by John Weber Gallery)

'General' series 1970: installation view of exhibition at the Fischbach Gallery, 1971

boven, Ger van Elk, Rafael Ferrer, Barry Flanagan, Hans Haacke, Michael Heizer, Hesse, Neil Jenny, Klein, Joseph Kosuth, Janis Kounellis, LeWitt, Richard Long, Walter de Maria, Mario Merz, Morris, Nauman, Oldenburg, Michelangelo Pistoletto, Richard Serra, Smithson, Keith Sonnier, Tuttle, William Wegman, and Lawrence Weiner. **The exhibition helps disseminate American Minimalism, Post-Minimalism, and Conceptual Art in Europe.**

March–April: *Willem de Kooning*, retrospective exhibition of 147 works organized by the Stedelijk Museum, Amsterdam, travels to MoMA. First one-person exhibition in New York. The artist is 65 years old.

April–May: *The Sculpture of Jules Olitski*. Olitski becomes the first living artist to have a one-person exhibition at The Metropolitan Museum of Art. He is 47 years old.

May: LeWitt publishes 'Sentences on Conceptual Art' in *Artforum*.

May–July: Ryman is included in *Anti-Illusion: Procedures / Materials* at the Whitney Museum, curated by Marcia Tucker. Also included are Andre, Michael Asher, Lynda Benglis, William Bollinger, John Duff, Ferrer, Robert Fiore, Philip Glass, Hesse, Jenny, Barry La Va, Robert Lobe, Morris, Nauman, Serra, Joel Shapiro, Michael Snow, and Tuttle. Post-Minimalism is defined in terms of an emphasis on process.

September–November: *Claes Oldenburg*, exhibition at MoMA. First one-person museum exhibition in New York. The artist is 40 years old.

September–November: *Roy Lichtenstein*, exhibition at the Guggenheim Museum. First one-person exhibition in New York. The artist is 46 years old.

October, November, December: Kosuth publishes his manifesto, 'Art after Philosophy Parts 1, 2, and 3' in successive issues of *Studio International*.

28 December: Son born to Ryman and Wagner, William Tracy Ryman.

December–January: Serra has first one-person exhibition in New York at Castelli Warehouse. Shows with Castelli every few years thereafter.

Vito Acconci records simple body movements with a camera in pieces such as 'Toe-Touch'.

Ryman makes first paintings on corrugated board as well as on fibreglass.

1970

25 February: Rothko takes his own life aged 66.

March–April: *Dan Flavin*, exhibition at the Jewish Museum. First one-person exhibition at a New York museum. The artist is 37 years old.

March–May: *Frank Stella*, retrospective exhibition at MoMA. First one-person exhibition at a New York museum. The artist is 31 years old.

April–May: *Robert Morris*, exhibition at the Whitney Museum. First one-person exhibition at a New York museum. The artist is 39 years old.

May–June: Ryman exhibits in *Using Walls*, curated by Susan Tumarkin Goodman, at the Jewish Museum. The exhibition includes 14 artists, among them Artschwager, Bochner, Daniel Buren, LeWitt, Morris, Tuttle, Weiner, and Barbara Zucker.

29 May: Hesse dies of a brain tumour at New York Hospital. She is 34 years old.

4 July: Newman dies aged 65, following a heart attack.

Ryman makes the first of the 'Surface Veils', a series on which he works until 1972; also paints 'General' series. Makes works on mylar that is taped to the wall and then painted. When painting is completed, pieces of tape are removed, but their outlines remain as part of the piece. Uses the same method for paintings on dark red vinyl in 1971.

1971

October–January: *Barnett Newman*, retrospective exhibition at MoMA.

November–January: *Tony Smith: 81 More*, exhibition at MoMA. First one-person exhibition at a New York museum. The artist is 59 years old.

Chris Burden does his first body-art pieces.

28 December: Second son born to Ryman and Wagner, George Cordyon Ryman.

Ryman buys a building on Greenwich Street previously used for painting theatre sets, which still serves as his three-floor studio.

'Before its dissolution Abstract Expressionism was also on the verge of dealing seriously with the theme of Nothing. In this sense, Ryman, along with Jasper Johns, might be the last functional member of the third generation of Abstract Expression-

ism. That is to say, he has focused his attention on coaxing paint as a natural material with a life of its own to express that life'.
(Willis Domingo, 'Robert Ryman', *Arts Magazine*, March 1971, p.17)

'Ryman's white paintings seem to make more sense of the idea of serial work than almost anyone else's do ... Whether their order is arbitrary or in some way necessary one simply cannot tell; all one can be sure of is their interdependence. Most striking perhaps is the way they energize the gallery space after a while by being exterior to themselves. Watching them differentiate themselves from mere white is like seeing entropy reversed.'
(Kenneth Baker, 'Ryman at Fischbach', *Artforum*, April 1971, p.79)

1972

March–April: *Robert Ryman*, curated by Diane Waldman, at the Guggenheim Museum. Exhibition includes 38 works from 1965–72. First one-person exhibition at a New York museum. Ryman also has exhibition of earlier work at John Weber Gallery. He is 42 years old.

'Although Ryman is aligned with the Minimalist movement, he has more recently been claimed for both Process and Conceptual Art. These shifting classifications, if somewhat arbitrary, do nonetheless point out the fact that he eludes categorization'.
(Diane Waldman, *Robert Ryman*, exh. cat., Solomon R. Guggenheim Museum, New York 1972 [np])

March–May: *Bruce Nauman: Work from 1965 to 1972* comes to the Whitney Museum. First one-person exhibition at a New York museum. The artist is 31 years old.

Summer: Ryman is included in *Documenta 5*, Kassel, Germany. He shows 'Aacon', 1968, 'Surface Veil 1', 1970 (no.49), and 'General', 1970 (see no.43). Other American artists include Acconci, Artschwager, Chuck Close, Hesse, Johns, LeWitt, Mangold, Marden, Martin, Malcolm Morley, Nauman, Oldenburg, Edward Rusha, Tuttle, and Wegman.

December–February: *Eva Hesse: A Memorial Exhibition* at the Guggenheim Museum.

Ryman makes a series of paintings in oil on canvas composed of horizontal lines made with many small, vertical brushstrokes (e.g. 'Paragon').

'Pollock's example that a painting could have no structural subdivision between that of the picture format and individual factural units was hardly elaborated upon ... until the 60's, when Robert Ryman [produced] serial paintings in which constructive facture attains a measure of pictorial autonomy, perhaps exceeding even that of Pollock's drip paintings. Ryman cancels out color, design and gestural inflection as pictorial elements to feature instead the simple, workmanlike way that the painter's brush systematically covers the picture surface ... Despite the uniformity of materials and procedures through a given series, each series member exhibits subtle distinguishing traits and elusive factural deviations from the series norm. Notwithstanding their austere simplicity, the works unmistakably manifest their nature as handmade products with the inevitable uniqueness of each member that that implies, i.e. the viewer is led to discover visual evidence that no two paintings are exactly alike. Thus in a sense, Ryman's painting is as much about the essential individuality of handmaking as Pollock's. That such individuality, a manifestation of the presence of the human fabricator, can persist within such apparently barren settings is as remarkable and poignant, in its way, as the profuse, extrovert individualism of Pollock's florid calligraphy'.
(Richard Channin, 'The Rise of Factural Autonomy', *ArtsMagazine*, Nov. 1972, pp.30–7)

1973

20 July: Smithson is killed in a plane crash in Amarillo, Texas aged 35.

September–November: *Ellsworth Kelly: Retrospective* at MoMA. First one-person exhibition at a New York museum. The artist is 50 years old.

Autumn: Ryman travels to Düsseldorf. Does works in baked enamel on copper at the Werkkunstschule in Essen, a technical-industrial school where they have the necessary equipment (see nos.52–4). While in Germany, Ryman also executes works in oil directly on aluminium. These are painted at Galerie Konrad Fischer. Baked enamel and oil on aluminium works are both shown in November exhibition at that gallery.

'In one sense, it is easy to approach Ryman's paintings in terms of what they are not, because so much that is conventionally present in paintings is absent from his. Perhaps this absence of conventional elements gives a clue as to why painters generally speaking, tend to disregard Ryman's work, and artists who otherwise have no use for painting make his paintings an exception.'

Installation view of *Robert Ryman: Exhibition of Works*, The Solomon R. Guggenheim Museum, 1972

Installation view of exhibition held at the John Weber Gallery, 1972 (photograph by Walter Russell)

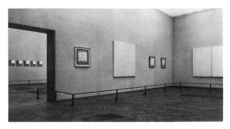

Installation view of *Robert Ryman* exhibition, Stedelijk Museum, Amsterdam 1974

Ryman working on installation of *Robert Ryman* exhibition, Palais des Beaux-Arts, Brussels, 1974

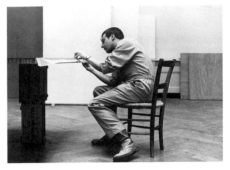

Ryman working on installation of *Robert Ryman* exhibition, Kunsthalle, Basel 1975

Installation view of *Rooms P.S. 1* exhibition, P.S. 1 Institute for Art and Urban Resources, 1976 (photograph by Jonathan Dent)

(Bruce Boice, 'Robert Ryman', *Artforum*, Sept. 1973, pp.78–81)

October–November: Jackie Winsor has first one-person exhibition in New York at Paula Cooper gallery.

Ryman is awarded a fellowship by the John Simon Guggenheim Foundation. Uses money for general living and working expenses.

1974

January–March: *Robert Ryman*, retrospective exhibition, Stedelijk Museum, Amsterdam. Exhibition and catalogue organized by Naomi Spector, E. de Wilde, and Geert van Beijeren in close cooperation with the artist.

'Light reflection and absorption, opaque and translucent, shiny and matte, smooth and rough, thick and thin: these words keep coming up regardless of the material referent in Ryman's work. This is neither a simple matter of chance nor because such qualities are properties of all physical matter. It is because Ryman's use of materials is very much in terms of these qualities. As such, it is important to note that these qualities share certain characteristics; they are essentially physical rather than cultural, inviting direct phenomenological rather than conceptual reaction; as physical qualities they are primarily pictorial, inviting visual before tactile exploration and virtually cancelling significance of other sense explorations ... In each case the chosen materials and their accentuated qualities are few to an extreme; such nakedness makes their choice and manipulation a high risk activity ... For Ryman's art is not at all simply a matter of compatibility of materials; it is also a matter of congruity with their usage; and finally of the particularity of Ryman's "used materials" among that of contemporary artists and of painters throughout time.'
(Barbara Reise, 'Robert Ryman: Unfinished I (Materials)', *Studio International*, Feb. 1974, p.80)

September–November: *Robert Ryman*, one-person exhibition, Palais des Beaux-Arts, Brussels. Curated by Y. Gevaert.

October–December: Al Held, exhibition at the Whitney Museum. First one-person exhibition at a New York museum. The artist is 46 years old.

Ryman does oil paintings on wood ('Midway', 'Zenith'). During this period (1972–5) he is also working with a variety of printmaking processes.

1975

March–April: *Brice Marden*, exhibition at Guggenheim Museum. First one-person exhibition at a New York museum. The artist is 37 years old.

June–August: *Robert Ryman*, one-person exhibition at the Kunsthalle, Basel. Curated by Carlo Huber.

October–November: Susan Rothenberg has first one-person exhibition at 112 Greene Street. Shows almost yearly at Willard Gallery between 1976–85. Joins Sperone Westwater Gallery in 1987.

Ryman paints 'Vector' series, 11 panel paintings of vinyl acetate on wood, each 95 × 95 cm.

'Ryman's paintings remind one that a painting is a space hung on a wall, a void interpenetrating a void. The transition from one to the other is the passage from the determined to the indeterminate, from the identifiable to the imponderable, from an institution, replete with a historically accumulated body of terms and customs, to ourselves'.
(Jeremy Gilbert-Rolfe, 'Appreciating Ryman', *ArtsMagazine*, Dec. 1975, p.73)

1976

January–February: Richard Tuttle, exhibition at the Whitney Museum. First one-person exhibition at a New York museum. The artist is 35 years old.

June: Ryman is included in *Rooms P.S. 1*, the inaugural exhibition at P.S. 1, Institute for Art and Urban Resources, Long Island City. Curated by Alanna Heiss.

September–October: David Salle has first one-person exhibition in New York at Artist's Space. In 1979, he shows with Gagosian-Nosei-Weber and, beginning in 1981, with Mary Boone and Castelli galleries. Joins Gagosian Gallery in 1991.

November: Elizabeth Murray has first one-person exhibition in New York at Paula Cooper Gallery.

Ryman introduces visible fasteners of his own design which connect his paintings directly to the wall ('Embassy', 'Concord', 'Criterion'). 'Concord' is the first Ryman work in low relief. Also uses vinyl strips as fasteners ('Advance', 'Tower I', and 'Tower II'), and draws in pastel on sandblasted Plexiglas.

1977

January–February: *Robert Ryman: Paintings 1976*, exhibition at P.S. 1 includes 17 recent works and inaugurates P.S. 1's more formal exhibition wing. Curated by Alanna Heiss. Ryman shows paintings with visible fasteners. He coats gallery windows with spray-on frosting material to soften the light and enclose the space.

September–October: *Robert Ryman*, retrospective exhibition at the Whitechapel Art Gallery, London, curated by Nicholas Serota.

'The Ryman show becomes two things to the spectator. First it is a concentration on the mechanics of painting with its queer resonant beauties following form and function. The paintings, prints and drawings have to be stared at. They become vehicles for contemplation, and the mind skitters off them as the eye remains mesmerized. The paintings are simultaneously summations and suggestions.'
(Marina Vaizey, 'Robert Ryman', *Arts Review*, 30 Sept. 1977, p.622)

October–January: *Jasper Johns: A Retrospective* at the Whitney Museum.

1978

February–April: *Sol LeWitt*, retrospective exhibition at MoMA. First one-person exhibition at a New York museum. The artist is 50 years old.

October–January: *Mark Rothko, 1903–1970: A Retrospective* at the Guggenheim Museum.

December–January: *New Image Painting*, exhibition at the Whitney Museum includes work by Nicholas Africano, Jennifer Bartlett, Jenny, Lois Lane, Rothenberg, and others. Brings together figuration of a less overtly emotional nature than that of European and American painting associated with the early to mid-1980s.

Ryman makes oil on linen paintings that are raised slightly off the wall and attached to it with steel bolts, like 'Monitor' and 'Summit'.

1979

January–March: *Jackie Winsor*, exhibition at MoMA. First one-person exhibition at a New York museum. The artist is 38 years old.

February–March and November–December: Julian Schnabel has two exhibitions at Mary Boone Gallery in one year, signalling the re-emergence of bravura gestural painting as a central concern for the New York art world. This is the American manifestation of 'Neo-Expressionism' which, in Europe, involves artists such as Anselm Kiefer, Georg Baselitz, Sigmar Polke, Enzo Cucchi, Francisco Clemente, and Sandro Chia. Their work begins to be seen in New York in 1980 and 1981.

Ryman does the 'Phoenix' series, relatively small works, each with surface and fasteners cut from a single piece of steel.

'I don't know. I must have been crazy. I thought when I got the white canvas, you know, I put fifteen coats of web-sanded gesso oil on a canvas; and said if I were Bob Ryman I'd be done already.'
(Chuck Close, interviewed by Barbaralee Diamonstein in *Inside New York's Art World*, New York 1979, p.77)

1980

7 June: Guston dies of a heart attack shortly before his 67th birthday.

Spring: Ryman travels to Switzerland, works on surfaces fabricated to his specifications that were originally designed as frames for drawings. Paints in his hotel room, using a rust preventative as underpainting. Works are shown in Zurich retrospective that begins in June.

June–August: *Robert Ryman*, retrospective exhibition of 57 works done between 1955 and 1979 at InK Halle für Internationale Neue Kunst, Zurich. Travels to Städtische Kunsthalle, Düsseldorf. Curated by Urs Raussmüller.

26 December: Tony Smith dies of heart failure aged 68.

1981

Spring: Douglas Crimp publishes 'The End of Painting' in *October*. Sees painting as politically conservative, debased, and, after artists like Daniel Buren, fundamentally pointless. According to Crimp, Buren's art poses as painting in order to subvert the medium and the institutions that support it: Buren 'knows only too well that when his stripes are seen as painting, painting will be understood as the "pure idiocy" that it is'.

October: Thomas Lawson publishes 'Last Exit: Painting' in *Artforum*. In part a response to Crimp, the article posits painting as 'a matter of faith', the only alternative to despair for the radical artist. Interestingly, Lawson endorses the work of, among others, Jack Goldstein and Troy Brauntuch, who were included in *About Pictures*, Crimp's fall 1977 exhibition at Artists' Space in New York.

Ryman in his studio, New York, 1978 (photograph by Otto E. Nelson)

Ryman with Bruce Nauman, Zurich, late 1970s

Installation view of *Robert Ryman* exhibition at the Dia Art Foundation, 1988–9

Installation view of exhibition at the Daniel Weinberg Gallery, Los Angeles, 1983 (photograph by Douglas M. Parker Studio)

Installation view of *Ryman: peintures récentes* exhibition at the Galerie Maeght Lelong, Paris, 1984

October–November: *Robert Ryman*, retrospective exhibition at Musée national d'art moderne, Centre Georges Pompidou, Paris, includes 62 works from 1958–81. Curated by Alfred Paquement.

Ryman returns to oil on canvas ('Paramount' (no.62)). Creates an oil on aluminium series where fasteners are bands that stretch the length of the top and bottom surfaces, overlapping them ('Media', 'Department', 'Post').

'Even now, when some eyes see only standardized, robotic Rymans he signs his own presence into being on the surfaces of his art ... Monochrome is what allows Ryman's idea of himself, which seems to be about as far from universal as an idea can be, to lodge itself in a series of facts – his paintings, which are always cool, but always aggressive in their particularity. Ryman has made the bluntness of all-white painting the vehicle of his exceedingly complex will to be distinctly himself'.
(Carter Ratcliff, 'Mostly Monochrome', *Art in America*, April 1981, pp.123–4)

1982

Ryman appointed member of the Art Commission, City of New York.

Ryman does first works on fibreglass panels of his own design. These form a sandwich with an aluminium honeycomb core ('Crown', 'Bond').

'The territory opened up by his experiments with techniques, materials, ways of placing a brushstroke, dullness and brightness, and smoothness of surface and relief, is vast ... In each painting all his knowledge, one might say all his science, is brought into play in establishing an intense surface intended both for meditation and for the disruption of meditation. Ryman's squares do not attain a fixed perfection, and this is what distinguishes him from Mark Rothko and Ad Reinhardt, with whom he is often associated. On the contrary, he renounces perfection by a detail, an anomaly; the brackets which held the support to the wall during the work's execution, for example. The introduction of this "defect" is no doubt connected to Ryman's desire to make painting exist in its own realm, one which lays claim to its own codes ... Once its vocabulary and grammar are mastered, this language leads neither to meditational void, nor to an "essence" of any material; instead it involves a clarity of awareness of the behaviour of light, the quality of its spectrum, the release of colour by the movement

away from colour, and the revelation of truths which belong not to the field of geometric ideas but to an internal exploration whose end is still unknown, and which we are privileged to watch.'
(Gerard-Georges Lemaire, 'Robert Ryman', *Artforum*, April 1982, p.88)

1983

Summer: Permanent retrospective exhibition of Ryman's work installed at the Hallen für neue Kunst, Schaffhausen.

1984

Ryman does his most sculptural works to date ('Pace' (no.66), 'Pair Navigation') and a series of enamel drawings on anodized aluminium. Creates 'Resource', his first work with a concave surface.

1985

Ryman does series of paintings on relief surfaces ('Credential' (no.73), 'Accord', 'Charter'), as well as a series in acrylic on Lumasite.

It is around this time that an interest in geometric painting recurs with the emergence of artists like Ross Blechner, Peter Halley, Peter Schuyff, and Philip Taffe.

1986

February–May: *Richard Serra: Sculpture*, exhibition at MoMA. First one-person exhibition at a New York museum. The artist is 47 years old.

1987

January–March: *David Salle*, exhibition comes to Whitney Museum. First one-person exhibition at a New York museum. The artist is 35 years old.

October–January: *Frank Stella: 1970–1987* at MoMA.

Ryman is awarded the Skowhegan School of Painting and Sculpture Medal for painting.

Ryman designs a room for Chicago collector Gerald Elliot around the 1985 work, 'Charter', already in Elliot's collection. Following a tour, Elliot donates the room to the Art Institute of Chicago. Ryman also does paintings on Gator board (e.g. 'Constant', no.75).

1988

April–June: *Elizabeth Murray: Paintings and Drawings* comes to the Whitney Museum. First one-person exhibition at a New York museum. The artist is 48 years old.

October–June: *Robert Ryman*, one-person exhibition at Dia Art Foundation includes 33 works, mostly from the 1980s. Ryman makes 'Journal' (no.76), his second work with a concave surface and works with no visible fasteners (e.g. 'Summary'). He also does works on linen or linen over fibreglass with redwood edges ('Duration', 'Convert').

'Together these paintings form a show – and a visual experience – that is as luminous as it is rigorous, as materialist as it is religious. The religion is high modernism, but the means are so straightforward that you don't have to be a true believer to be touched by its spirit ... Mr Ryman has kept the modernist faith more strictly than Frank Stella and also more personally. And he meets the critic Clement Greenberg's requirements about reducing paintings to its essence more successfully than any of the color field artists whom Mr Greenberg continues to endorse.'
(Roberta Smith, 'Works by Robert Ryman in Redone Dia Galleries', *New York Times*, 7 Oct. 1988, p.C29)

November–January: *Julian Schnabel: Paintings 1975–1987* comes to the Whitney Museum. First one-person exhibition at a New York Museum. The artist is 37 years old.

1989

Ryman does asymmetrical works (e.g. 'Context'), as well as some symmetrical paintings with heavy impasto at their centers and a flatter paint application along the borders ('Locate', 'Press'). 'Initial' (no.77) sits on two small, assymetically placed wooden blocks that are attached to the wall.

'Not for the first time I can't decide if his single-mindedness, undeterred by inner promptings of expression and by outward imperatives of style, is mainly exemplary or mainly bizarre. It makes for a very particular beauty, in any case ... However this show does give me a distinct feeling of being called to account, somehow, as if by some personal religious authority who knows my soul's waywardness and has reason to be concerned about me. He may be the last of the great modern artists who, believing that human endeavours partake of pure essences, once strove to put art on a philosophically equal footing with science. Certainly he is the only current painter who can turn my reminiscences of that perishing idealism into a specific ache rather than just a vague and global disillusionment. It's an effect of his radiant modesty, craftsmanly virtues and incredible steadiness.'

(Peter Schjeldahl, 'White-out', *7 Days*, 15 Feb. 1989, pp.55–6)

'The rhetorical center of gravity of this work, then, rests on the literal fulcrum between a collection of facts and its poetics.'
(Pat McCoy, 'Robert Ryman', *Arts Magazine*, April 1989, p.77)

1991

October–July: *Robert Ryman*, exhibition at Espace d'art contemporain, Paris. Includes work from 1958–81.

'Ryman's work defies ideological exegesis and disdains the melodrama of stylistic rupture upon which so much criticism thrives ... the infinite nuances of which his work avails itself can only be arrived at by total concentration on sensory fact.'
(Robert Storr, 'Robert Ryman: Making Distinctions', in *Robert Ryman*, exh. cat., Espace d'art contemporain, Paris 1992, p.35)

Ryman begins a series of paintings titled 'Versions'. Works vary in size, but all are painted on very thin fibreglass. All but one have wax-paper borders along the upper edge (see nos.79–81).

'In fact, contrary to historical belief about the nature of avant garde innovation, Ryman is clearly one of the few figures working today for whom one feels that it wouldn't really make a great difference had he been the first to do what he's doing ... or not'.
(Dan Cameron, 'Robert Ryman: Ode to a Clean Slate', *Flash Art*, Summer 1991, p.90)

'Light is another important element, since light with realism acts differently. It acts in a real sense, whereas with representational painting and abstraction, the light is primarily used in order to see the painting. With realist painting, the light becomes literally a real element in the painting reflecting on surfaces or being absorbed into surfaces of the painting and into the wall itself'
(Speech by Ryman delivered at Dannheiser Foundation, New York, Jan. 1991)

1992

May–October: Ryman shows 'Versions I–XVI' at Hallen für neue Kunst, Schaffhaussen.

'Whenever we installed your works, we always saw how tremendously important it was to know exactly how the painting was conceived and how it was made. Some

Ryman and Gerald Elliot standing in front of **Charter V** 1987 (photograph by Robert E. Mates)

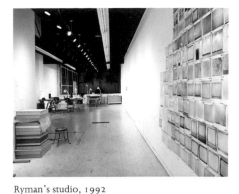

Ryman's studio, 1992

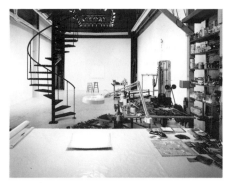

Ryman's studio, 1992

works are extremely quiet and, in fact, absorb everything. Others can be virulent and work outwards a lot. They can be small in size but big in force of action. Every time we worked with them we experienced again how differently each painting works under the unique circumstances of space and light. And only when we allowed each painting to display its character and strength by not restricting its possibilities, did it really come alive and become active.

It is quite amazing to see how the different steps involving the paintings relate to one another. First and above all is the creation of a painting which, in itself, is a compression of different steps and decisions. But as you said in your text, the painting is not yet complete then. It has to be presented "in the world in a way that makes the aesthetic clear". This is the next step. This is where another person comes into play, as I did with our common installations. And this person has to know exactly what he or she is dealing with in order to present the painting in an appropriate way. Then the painting starts to live its own life, interacting with its surroundings. This is the final and decisive step, where the painting works as an independent object in relation to a space. And this, I think, is actually an opening to new possibilities in painting. It allows the paintings to become active in a way that is excluded in representational painting. (Ryman and Urs Rausmüller in *Robert Ryman: Versions*, 1992).

November–January: *Agnes Martin*, retrospective exhibition at the Whitney Museum. It is her first one-person exhibition of paintings at a New York Museum. She is 80 years old.

One-Person Exhibitions

1967
Paul Bianchini Gallery, New York, April – May

1968
Galerie Heiner Friedrich, Munich, Oct. – Nov.
Galerie Konrad Fischer, Düsseldorf, Nov. – Dec.

1969
Fischbach Gallery, New York, April – May
Wall Show – Part I, Ace Gallery, Los Angeles, Aug.
Galerie Konrad Fischer, Düsseldorf, Nov. – Dec.
Robert Ryman Drawings, Galerie Heiner Friedrich, Munich, Nov. – Dec.
Robert Ryman, Galerie Yvon Lambert, Paris, Nov. – Dec.
Galerie Françoise Lambert, Milan, Dec.

1970
Robert Ryman: Delta Paintings, 1966, Fischbach Gallery, New York, Feb. – March

1971
Fischbach Gallery, New York, Jan. – Feb.
Dwan Gallery, New York, Feb. – March
Galerie Heiner Friedrich, Cologne, June – July
Current Editions, Seattle

1972
Robert Ryman, Solomon R. Guggenheim Museum, New York, March – May
Robert Ryman: Early Paintings, John Weber Gallery, New York, April
Galerie Annemarie Verna, Zurich, Sept. – Oct.
Lisson Gallery, London, Dec. 1972 – Jan. 1973
Galerie Heiner Friedrich, Cologne
Current Editions, Seattle
Galleria Il Cortile, Rome

1973
Robert Ryman, Galleria San Fedele, Milan, April
Robert Ryman, *Paintings and Etchings*, John Weber Gallery, New York, April – May
Art & Project, Amsterdam, Sept.
Galerie Konrad Fischer, Düsseldorf

1974
Robert Ryman, Stedelijk Museum, Amsterdam, Feb. – March
Robert Ryman: Komplete Graphik, Westfälischer Kunstverein, Münster, May – June
John Weber Gallery, New York, Sept. – Oct.
Palais des beaux-arts, Brussels

1975
Robert Ryman, Kunsthalle Basel, June – Aug.
Robert Ryman, Paintings and Prints, John Weber Gallery, New York, Nov.

1977
Robert Ryman: Neue Bilder, Galerie Annemarie Verna, Zurich, May – June
Robert Ryman, Whitechapel Art Gallery, London, Sept. – Oct.
Robert Ryman: Paintings 1976, P.S. 1, Institute for Art and Urban Resources, Long Island City
Galleria Gian Enzo Sperone, Rome
Galerie Charles Kriwin, Brussels

1978
Institut für Neue Kunst, Zurich

1979
Robert Ryman, Sidney Janis Gallery, New York, Jan.
Institut für Neue Kunst, Zurich

1980
Robert Ryman: Neue Bilder, Kunstraum, Munich, Nov. – Dec.
Galerie Konrad Fischer, Düsseldorf

1980–2
Robert Ryman, InK, Halle für Internationale neue Kunst, Zurich, June – Aug. 1980; Musée national d'art moderne, Centre Georges Pompidou, Paris, Oct. – Nov. 1981; Städtische Kunsthalle, Düsseldorf

1981
Robert Ryman, Sidney Janis Gallery, New York, May – June

1982
Robert Ryman: Paintings, Young Hoffman Gallery, Chicago, March
Robert Ryman, Recent Paintings, Mayor Gallery, London, Nov. – Dec.

1983
Robert Ryman, Bonnier Gallery, New York, March
Daniel Weinberg Gallery, Los Angeles

1983–
Hallen für neue Kunst, Schaffhausen, Switzerland (permanent installation)

1984
Ryman, *New Paintings*, Galerie Maeght Lelong, New York, Feb. – March
Ryman, *peintures récentes*, Galerie Maeght Lelong, Paris, April – June

1985
Robert Ryman, Rhona Hoffman Gallery, Chicago, May

1986
Robert Ryman, Recent Paintings, Galerie Maeght Lelong, New York, Jan. – Feb.
Leo Castelli Gallery, New York, Jan. – Feb.
Currents, Institute of Contemporary Art, Boston
Raum für Malerei, Cologne

1987
Galerie Konrad Fischer, Düsseldorf

1987–8
Robert Ryman: The Charter Series: A Meditative Room for the Collection of Gerald S. Elliot, The Art Institute of Chicago, May – June 1987; San Francisco Museum of Modern Art, Jan. 1987 – March 1988

1988–9
Robert Ryman, Dia Art Foundation, New York, Oct. 1988 – June 1989

1989
Robert Ryman Prints, The Projects Room, John Weber Gallery, New York

1990
Robert Ryman: New Paintings, Pace Gallery, New York, April – May
Robert Ryman: Six Aquatints, Nohra Haine Gallery, New York

1991–2
Robert Ryman, Espace d'art contemporain, Paris, Oct. 1991 – July 1992

1992
Robert Ryman: Works on Paper, Galerie Konrad Fischer, Düsseldorf, Sept.

1992–3
Robert Ryman: Versions, Hallen für neue Kunst, Schaffhausen, Switzerland, May – Oct. 1992; Pace Gallery, New York, Dec. 1992 – Jan. 1993

Bibliography

Select bibliography, compiled by Clare Storey from information supplied by the Pace Gallery and The Museum of Modern Art, New York.

1 Statements by the artist
2 Interviews
3 One-person exhibitions: catalogues and related publications
4 Group exhibitions: published catalogues
5 Periodical and newspaper articles
6 Books and sections in books

Section 6 is arranged in alphabetical order; all other sections are arranged chronologically.

Some publications, particularly those containing statements and interviews, appear in more than one section of the bibliography.

In order to keep this bibliography to manageable proportions and yet make it as useful as possible, very brief exhibition reviews and articles have been omitted. A comprehensive bibliography is available for consultation in the library of the Tate Gallery.

1 Statements by the Artist

1969

Art in progress IV. ill. Exhib. Finch College Museum of Art, New York, Dec. 1969 – Jan. 1970.

1970

Using walls (indoors). 28p., ill. 1 installation. Introd. by Susan Tumarkin Goodman. Exhib. at Jewish Museum, New York, 1970.

Conceptual art, arte povera, land art. 227p., ill. 4 installations. Italian/English text. Exhib. Galleria Civica d'Arte Moderna, Turin, 1970.

1971

Jackson Ward. [Notes on Robert Ryman]. *Art Now: New York,* vol.3, no.3, Sept. 1971, p.3.

1972

Robert Ryman. 1p., ill. German text. Exhib. Galerie Annemarie Verna, Zurich, 1972.

Grids. 31p., ill. 2 works. Introd. by Lucy R. Lippard. Exhib. Institute of Contemporary Art, University of Pennsylvania, Philadelphia, 1972.

1973

Robert Ryman: exhibition of works. 28p., ill. 26 works. Introd. by P. Alessio Saccardo, text by Luca M. Venturi. Exhib. Galleria San Fedele, Milan, 1973.

Some recent American art. 95p., ill. 4 works. Introd. by Jennifer Licht. Exhib. National Gallery of Victoria, Melbourne, 1973. Travelling to Perth, Sydney, Adelaide, Auckland.

1974

Basically white. 66p., ill. 1 work. Introd. by Carel Blotkamp. Exhib. Institute of Contemporary Art, London, 1974.

1975

Fundamentele schilderkunst/Fundamental painting. 84p., ill. 6 works. Introd. by Rini Dippel. Parallel Dutch/English text. Exhib. Stedelijk Museum, Amsterdam, 1975.

Prints: Bochner, LeWitt, Mangold, Marden, Martin, Renouf, Rockburne, Ryman. 59p., ill. 2 portfolios. Introd. by Nancy Tousley. Exhib. Art Gallery of Ontario, Toronto, Dec. 1975 – Jan. 1976.

1976

Minimal Art: Druckgraphik. 61p., ill. 1 installation. Introd. by Norbert Lynton. German text. Exhib. Kestner-Gesellschaft, Hanover, Dec. 1976 – Jan. 1977.

1977

Robert Ryman. 32p., ill. 77 works. Introd. by Naomi Spector. Exhib. Whitechapel Art Gallery, London, 1977.

1978

Works from the Crex Collection, Zurich. 135p., ill. 3 works. Essay by Georg Jappe *et al.* Parallel German/English text. Exhib. InK, Halle für Internationale neue Kunst, Zurich, 1978. Travelling to Humlebaek, Munich and Eindhoven.

1982

'60–'80: attitudes/concepts/images. 2 vols., ill. 5 works. Essay by Edy de Wilde. Parallel Dutch/English text. Exhib. Stedelijk Museum, Amsterdam, 1982.

Documenta 7. 2 vols., ill. 8 works. Introd. by R.H. Fuchs. Parallel German/English text. Exhib. Documenta, 1982.

1983

Maurice Poirier and Jane Necol. The 60's in abstract: 13 statements and an essay. *Art in America,* vol.71, no.9, Oct. 1983, pp.122–37.

1984

American art since 1970: painting, sculpture and drawing from the collection of the Whitney Museum of American Art, New York. 122p., ill. 1 work. Essay by Richard Marshall. Exhib. Museum of Contemporary Art, La Jolla,

1984. Travelling to Mexico City, Raleigh, Lincoln and Miami 1985.

Amy Baker Sandback. Art on location. *Artforum,* vol.24, no.3, Nov. 1985, pp.4–5.

Carnegie International 1985. 235p., ill. 4 works. Introd. by John R. Lane *et al.* Exhib. Museum of Art, Carnegie Institute, Pittsburgh, Nov. 1985 – Jan. 1986.

1988

Robert Ryman. 54p., ill. Introd. by Gary Garrels. Interview and statement by the artist. Exhib. Dia Art Foundation, New York, Oct. 1988 – June 1989.

Carnegie International 1988. 201p., ill. 5 works. Introd. by Vicky A. Clark *et al.* Exhib. Carnegie Museum of Art, Pittsburgh, Nov. 1988 – Jan. 1989.

1991

Robert Ryman. 195p., ill. Introd. by Christel Sauer, Urs Raussmüller and Robert Storr. Includes a speech by the artist originally given on 9 Jan. 1991 at the Dannheiser Foundation, New York, in the context of 'The Guggenheim Museum's Salon Series'. Parallel French/German/English text. Exhib. Espace d'art contemporain, Paris, 1991.

2 Interviews

1971

Phyllis Tuchman. An interview with Robert Ryman. *Artforum,* vol.9, no.9, May 1971, pp.46–53. Reprinted in *Macula* (Paris), no.3/4, Sept. 1978, pp.132–41.

1972

Bruce Kurtz. Robert Ryman. *ArtsMagazine,* vol.46, no.8, Summer 1972, p.42.

1973

Achille Bonito Oliva. Robert Ryman interviewed. *Domus,* no.519, Feb. 1973, p.49.

1974

Marian Verstraeten. Robert Ryman: le geste. *O, Revue d'Art Contemporain* (Paris), Nov. 1974, pp.10–11. Reprinted in *Macula* (Paris), no.3/4, Sept. 1978, pp.141–5.

1978

Robert Ryman. Deux entretiens. *Macula* (Paris), no.3/4, Sept. 1978, pp.132–45. Reprint of interviews given to Phyllis Tuchman and Marian Verstraeten.

1979

Barbaralee Diamonstein. *Inside New York's art world*. New York: Rizzoli, 1979, pp.330–40.

1980

Peter Blum. It's not a case of painting white paintings. *Du*, no.8, 1980, pp.68–9.

1981

Madeleine Deschamps. Robert Ryman: la technique et au-delà. *Art Press* (Paris), no.52, Oct. 1981, pp.12–13, 42.

1986

Rosemarie Schwarzwälder. *Abstract painting of America and Europe: Brice Marden, Gerhard Richter, Helmut Federle, Robert Mangold, Robert Ryman*. Klagenfurt: Ritter Verlag, 1988. 8 works. Published on the occasion of an exhibition 'Abstract paintings by three European and three American artists: Federle, Knoebel, Richter, Mangold, Marden, Ryman', which took place in the Galerie nächst St Stephan, Vienna, from Oct. – Dec. 1986. Parallel German/English text. Interview between the artist and Robert Storr, pp.199–230.

1987

Robert Storr. Robert Ryman: une approche réaliste de la peinture. *Art Press*, no.112, March 1987, pp.19–23.

1988

Robert Ryman. 54p., ill. Introd. by Gary Garrels. Exhib. Dia Art Foundation, New York, Oct. 1988 – June 1989.

1992

Robert Ryman: versions. 95p., ill. 16 works. Introd. by Christel Sauer. Includes an interview between Urs Raussmüller and the artist. Parallel German/English/French text. Exhib. Hallen für neue Kunst, Schaffhausen, 1992. Travelling to New York.

3 One-Person Exhibitions: Catalogues and Related Publications

1969

Robert Ryman. Paris: Galerie Yvon Lambert, 1969. Folded card, ill. Exhib. Nov.– Dec. 1969.

1972

Robert Ryman: exhibition of works. New York: Solomon R. Guggenheim Museum, 1972. 52p., ill. Introd. by Diane Waldman. 38 works. Exhib. March – May 1972.

Robert Ryman. Zurich: Galerie Annemarie Verna, 1972. 1p., ill. Includes a short statement by the artist. German text. Exhib. Sept. – Oct. 1972.

1973

Robert Ryman: exhibition of works. Milan: Galleria San Fedele, 1973. 28p., ill. Introd. by P. Alessio Saccardo, text by Luca M. Venturi. Includes statement by the artist. 26 works. Exhib. April 1973.

Robert Ryman: suite of seven aquatints 1972, nine unique aquatints, 1972. Amsterdam: Art & Project, 1973. Introd. by Naomi Spector. See *Art & Project Bulletin*, no.70. Exhib. Sept. 1973.

1974

Robert Ryman. Amsterdam: Stedelijk Museum, 1974. 48p., ill. Introd. by Naomi Spector. 64 works. Exhib. Feb. – March 1974.

1975

Robert Ryman. Basel: Kunsthalle Basel, 1975. 12p., ill. Introd. by Carlo Huber. German text. 18 works. Exhib. June – Aug. 1975.

1977

Robert Ryman. London: Whitechapel Art Gallery, 1977. 32p., ill. Introd. by Naomi Spector. Includes statement by the artist. 77 works. Exhib. Sept. – Oct. 1977.

1979

Robert Ryman: an exhibition of recent paintings. New York: Sidney Janis Gallery, 1979. 8p., illus. Exhib. Jan. 1979.

1980

Robert Ryman: paintings and reliefs. Zurich: InK, Halle für Internationale neue Kunst, 1980. 235p., ill. Introd. by Christel Sauer. Parallel German/English text. 57 works. Exhib. June – Aug. 1980.

1981

An exhibition of paintings by Robert Ryman. New York: Sidney Janis Gallery, 1981. Folded card, 4p., ill. 12 works. Exhib. May – June 1981.

Robert Ryman. Paris: Musée national d'art moderne, Centre Georges Pompidou, 1981. 104p., ill., portfolios. Introd. by Yve-Alain Bois and Christel Sauer. French text. 62 works. Exhib. Oct. – Nov. 1981.

1982

Robert Ryman: recent paintings. London: Mayor Gallery, 1982. Folded card, ill. Exhib. Nov. – Dec. 1982.

1984

Ryman: peintures récentes. Paris: Galerie Maeght Lelong, 1984. 32p., ill. (Repères: cahiers d'art contemporain; 13). Introd. by Jean Frémon. Parallel French/English text. Exhib. April – June 1984.

1987

Robert Ryman: The Charter Series, a meditative room for the Collection of Gerald S. Elliott. Chicago: Art Institute of Chicago, 1987. Folded card, 6p., ill. Introd. by Neal Benezra. Exhib. May – June 1987.

1988

Robert Ryman: The Charter Series: new works. San Francisco: Museum of Modern Art, 1988. Folded card, 8p., ill. Introd. by Neal Benezra. Exhib. Jan. – March 1988.

Robert Ryman. New York: Dia Art Foundation, 1988. 54p., ill. Introd. by Gary Garrels. Interview and statement by the artist. Exhib. Oct. 1988 – June 1989.

1990

Robert Ryman: new paintings. New York: Pace Gallery, 1990. 50p., ill. Introd. by Yve-Alain Bois. Exhib. April – May 1990.

1991

Robert Ryman. Paris: Espace d'art contemporain, 1991. 195p., ill. Introd. by Christel Sauer, Urs Raussmüller and Robert Storr. Includes a speech by the artist originally given on Jan. 9, 1991 at the Dannheiser Foundation, New York, in the context of 'The Guggenheim Museum's Salon Series'. Parallel French/German/English text. Exhib. [Oct. 1991 – July 1992].

1992

Robert Ryman: versions. Schaffhausen: Hallen für neue Kunst, 1992. 95p., ill. Introd. by Christel Sauer. Includes an interview between Urs Raussmüller and the artist. Parallel German/English/French text. 16 works. Exhib. May – Oct. 1992. Travelling to New York.

4 Group Exhibitions: Published Catalogues

1966

Systemic painting. New York: Solomon R. Guggenheim Museum, 1966. 65p., ill. Introd. by Lawrence Alloway. 1 work. Exhib. Sept. – Nov. 1966.

1967

Rejective art: an exhibition devoted to a new type of art known under the various titles of Primary Structures, Minimal, Systematic Painting, ABC Art and Reductive Art. New York: American Federation of Art, 1967. 7p., ill. Introd. by Lucy R. Lippard. 1 work. Exhib. 1967–8. Travelling to Houston and Clemson, South Carolina.

A Romantic minimalism. Philadelphia: Institute of Contemporary Art, University of Pennsylvania, 1967. Introd. by Stephen S. Prokopoff. Exhib. Sept. – Oct. 1967.

1968

Gordon, Lozano, Ryman, Stanley. Cincinnati: Contemporary Arts Center, 1968. 11p., ill. Introd. by Robert Christgau. 3 works. Exhib. May – June 1968.

Sammlung 1968 Karl Ströher. Munich: Galerie-Verein/ Neue Pinakothek, Haus der Kunst, 1968. Exhib. June – Aug. 1968.

Sammlung 1968 Karl Ströher. Hamburg: Kunstverein, 1968. Exhib. Aug. – Oct. 1968.

1969

Op losse schroeven: situaties en cryptostructuren. Amsterdam: Stedelijk Museum, 1969. 104p., ill. Curated by Wim Beeren. Dutch text. 1 work. Exhib. March – April 1969.

Sammlung 1968 Karl Ströher. Berlin: Neue Nationalgalerie, 1969. 200p., ill. Introd. by Jürgen Wissemann. German text. 2 works. Exhib. March – April 1969. Travelling to Düsseldorf and Berne.

Anti-illusion: procedures/materials. New York: Whitney Museum of American Art, 1969. 62p., ill. Essays by James Monte and Marcia Tucker. Exhib. May – July 1969.

When attitudes become form: works, concepts, processes, situations, information. London: Institute of Contemporary Arts, 1969. 168p., ill. Essays by Charles Harrison et al. 1 work. Exhib. Sept. – Oct. 1969. Previously at Berne, Krefeld.

Art on paper. Greensboro: Weatherspoon Gallery, University of North Carolina, 1969. Introd. by Gilbert F. Carpenter. Exhib. Nov. – Dec. 1969.

Art in progress IV. New York: Finch College Museum of Art, 1969. ill. Includes statement by the artist. Exhib. Dec. 1969 – Jan. 1970.

1970

18 Paris IV. 70. Paris: Michel Claura, 1970. 67p., ill. Introd. by Michel Claura. Parallel French/English/German text. 1 installation. Exhib. April 1970.

Modular painting. Buffalo, N.Y: Albright-Knox Art Gallery, 1970. 23p., ill. Introd. by Robert M. Murdock. 4 works. Exhib. April – May 1970.

Bildnerische Ausdrucksformen 1960–1970: Sammlung Karl Ströher. Darmstadt: Hessisches Landesmuseum, 1970. Exhib. April – June 1970.

Using walls (indoors). New York: Jewish Museum, 1970. 28p., ill. Introd. by Susan Tumarkin Goodman. Includes statement by the artist. 1 installation. Exhib. May – June 1970.

Drawings by American artists. Cologne: Galerie Ricke, 1970. Exhib. May – Sept. 1970.

Conceptual art, arte povera, land art. Turin: Galleria Civica d'Arte Moderna, 1970. 227p., ill. Includes statement by the artist. Italian/English text. 4 installations. Exhib. June – July 1970.

1971

Sixth Guggenheim International Exhibition 1971. New York: Solomon R. Guggenheim Museum, 1971. 43p., ill. Introd. by Diane Waldman et al. 1 installation. Exhib. Feb. – April 1971.

White on white: the white monochrome in the 20th century. Chicago: Museum of Contemporary Art, 1971. 16p., ill. Introd. by Robert Pincus-Witten. 1 work. Exhib. Dec. 1971 – Jan. 1972.

1972

Grids. Philadelphia: Institute of Contemporary Art, University of Pennsylvania, 1972. 31p., ill. Introd.

by Lucy R. Lippard. Includes statement by the artist. 2 works. Exhib. Jan. – March 1972.

Seventieth American exhibition. Chicago: Art Institute, 1972. 47p., ill. Introd. by A. James Speyer. 1 work. Exhib. June – Aug. 1972.

Documenta 5: Befragung der Realität, Bildwelten heute. Kassel: Documenta, 1972. 739p., ill. Exhib. June – Oct. 1972.

American art since 1945: a loan exhibition from The Museum of Modern Art, New York. Philadelphia: Museum of Art, 1972. 6p. Introd. by Evan H. Turner. 1 work. Exhib. Sept. – Oct 1972.

Actualité d'un bilan. Paris: Galerie Yvon Lambert, 1972. 133p., ill. Introd. by Michel Claura. Parallel French/English text. 3 works. Exhib. Oct. – Dec. 1972.

1973

Some recent American art. Melbourne: National Gallery of Victoria, 1973. 95p., ill. Introd. by Jennifer Licht. Includes statement by the artist. 4 works. Exhib. 1973. Travelling to Perth, Sydney, Adelaide, Auckland.

Young American artists: drawings and graphics. Copenhagen: Gentofte Kunstvenner, Gentofte Raadhus, 1973. Introd. by Steingrim Laurson. Exhib. 1973. Travelling to Oslo, Hamburg, Stockholm.

Bilder – Objekte – Filme – Konzepte: Sammlung Herbig. Munich: Städtische Galerie im Lenbachhaus, 1973. 240p., ill. Essay by Naomi Spector: 'Ryman brand paintings'. German/French/English text. 2 works. Exhib. April – May 1973.

Une exposition de peinture reunissant certains peintres qui mettraient la peinture en question: Daniel Buren, Alan Charlton, Giorgio Griffa, Bernd Lohaus, Brice Marden, Agnes Martin, Robert Ryman, Palermo, Niele Toroni. Paris: Michel Claura/René Denizot, 1973. 42p., ill. 3 works. Exhib. May – June 1973. Travelling to Mönchengladbach.

American drawings 1963–1973. New York: Whitney Museum of American Art, 1973. 63p., ill. Introd. by Elke M. Solomon. 3 works. Exhib. May – July 1973.

Eine Malerei: Ausstellung mit Malern die Malerei in Frage stellen könnten. Mönchengladbach: Städtisches Museum, 1973. 44p., ill. 3 works. Exhib. Nov. – Dec. 1973.

Contemporanea. Rome: Parcheggio di Villa Borghese, 1973. 574p., ill. Essays by Achille Bonito Oliva et al. Parallel Italian/English text. 5 works. Exhib. Nov. 1973 – Feb. 1974.

1974

Caldwell Collection. Berkeley: University Art Museum, University of California, 1974. Exhib. 1974.

American painting in the watershed year 1961. New York: Alan Frumkin Gallery, 1974. 16p., ill. Introd. by Alan Frumkin. 1 work. Exhib. 1974.

Strata. London: Royal College of Art, 1974. 12p. Introd. by Lynda Morris. 4 works. Exhib. Jan. – Feb. 1974.

Geplante Malerei. Münster: Westfälischer Kunstverein, 1974. 126p., ill. Introd. by Klaus Honnef. Parallel

German/English/Italian text. 2 installations. Exhib. March – April 1974.

Basically white. London: Institute of Contemporary Arts, 1974. 66p., ill. Introd. by Carel Blotkamp. Includes statement by the artist. 1 work. Exhib. March – April 1974.

Works in post-minimal exhibition. Edinburgh: Scottish Arts Council Gallery, 1974. 13p. 3 works. Exhib. Oct. – Nov. 1974.

1975

Fourteen abstract painters. Los Angeles: Frederick S. Wight Art Gallery, University of California, 1975. 35p., ill. Text by Gerald Nordland. Exhib. March – May 1975.

USA Zeichnungen 3. Leverkusen: Städtisches Museum Leverkusen, Schloss Morsbroich, 1975. Exhib. 1975.

Critiques – théorie – art. Paris: Galerie Rencontres, 1975. Text by Marcelin Pleynet. Exhib. 1975.

Four from the east/four from the west. Santa Barbara: Art Galleries, University of California, 1975. 22p., ill. Text by Phyllis Plous. Exhib. 1975.

Fundamentele schilderkunst/Fundamental painting. Amsterdam: Stedelijk Museum, 1975. 84p., ill. Introd. by Rini Dippel. Includes statement by the artist. Parallel Dutch/English text. 6 works. Exhib. April – June 1975.

Empirica: l'arte tra addizione e sottrazione. Rimini: Comune di Rimini, 1975. 249p., ill. text by Giorgio Cortenova. 4 works. Exhib. May – June 1975. Travelling to Verona.

Von Pop zum Konzept: Kunst unserer Zeit in Belgischen Privatsammlungen. Aachen: Neue Galerie Sammlung Ludwig, 1975. Loose leaves in folder., ill. Introd. by Wolfgang Becker. 5 works. Exhib. Oct. – Nov. 1975.

Painting, drawing and sculpture of the '60s and the '70s from the Dorothy and Herbert Vogel Collection. Philadelphia: Institute of Contemporary Art, University of Pennsylvania, 1975. 24p., ill. Introd. by Suzanne Delehanty. 1 work. Exhib. Oct. – Nov. 1975. Travelling to Cincinnati.

Prints: Bochner, LeWitt, Mangold, Marden, Martin, Renouf, Rockburne, Ryman. Toronto: Art Gallery of Ontario, 1975. 59p., ill. Introd. by Nancy Tousley. Includes statement by the artist. 2 portfolios. Exhib. Dec. 1975 – Jan. 1976.

1976

Yesterday, today, tomorrow. Coral Gables: Lowe Art Museum, University of Miami, 1976. Exhib. 1976.

Drawing now. New York: The Museum of Modern Art, 1976. 96p., ill. Introd. by Bernice Rose. 1 work. Exhib. Jan. – March 1976.

Cronaca: percorso didattico attraverso la pittura americana degli anni 60 e la pittura europea degli anni 70. Modena: Galleria Civica, 1976. 104p., ill. Text by Filiberto Menna et al. Parallel Italian/English text. 1 work. Exhib. March – May 1976.

Seventy-second American exhibition. Chicago: Art Institute, 1976. 47p., ill. Introd. by Anne Rorimer. 2 works. Exhib. March – May 1976.

Rooms P.S. 1. Long Island City, N.Y. P.S. 1, Institute of Art & Urban Resources, 1976. 136p., ill. Text by participating artists. 1 work. Exhib. June 1976.

Three decades of American art selected by the Whitney Museum. Tokyo: Seibu Museum of Art, 1976. 97p., ill. Japanese text. 1 work. Exhib. June – July 1976.

La Biennale di Venezia. Venice: Biennale, 1976. 2 vols., ill. Exhib. July – Oct. 1976.

Prospect/Retrospect: Europa 1946–1976. Düsseldorf: Städtische Kunsthalle, 1976. 176p., ill. Introd. by B.H.D. Buchloh. German text. Exhib. Oct. 1976.

America, America. Basel: Galerie Beyeler, 1976. 44p., ill. Parallel German/English text. 1 work. Exhib. Oct. – Dec. 1976.

Minimal Art: Druckgraphik. Hanover: Kestner-Gesellschaft, 1976. 61p., ill. Introd. by Norbert Lynton. Includes statement by the artist. German text. 1 installation. Exhib. Dec. 1976 – Jan. 1977.

1977

Biennial exhibition 1977. New York: Whitney Museum of American Art, 1977. 104p., ill. Introd. by Barbara Haskell et al. 1 work. Exhib. Feb. – April 1977.

Less is more. New York: Sidney Janis Gallery, 1977. 4p. 1 work. Exhib. April – May 1977.

Documenta 6. Kassel: Documenta, 1977. 4 vols., ill. 1 installation. Exhib. June – Oct 1977.

A view of a decade. Chicago: Museum of Contemporary Art, 1977. 44p., ill. Essays by Martin Friedman et al. 1 work. Exhib. Sept. – Nov. 1977.

Ferrara, Lichtenstein, Nevelson, Ryman. New York: Sarah Lawrence College Art Gallery, 1977. 24p., ill. Essay by Pamela Markham Heller. 9 works. Exhib. Sept. – Oct. 1977.

New York: the state of art. Albany: New York State Museum, 1977. 81p., ill. Curated by Courtney Sale. 1 work. Exhib. Oct. – Nov. 1977.

1978

Works from the Crex Collection, Zurich. Zurich: InK, Halle für Internationale neue Kunst, 1978. 135p., ill. Essay by Georg Jappe. Includes statement by the artist. Parallel German/English text. 3 works. Exhib. 1978. Travelling to Humlebaek, Munich and Eindhoven.

La Biennale di Venezia, 1978. Venice: Biennale, 1978. 283p., ill. 1 work. Exhib. 1978.

Three generations: studies in collage. Chicago: Margo Leavin Gallery, 1978. Exhib. Jan. – March 1978.

American painting of the 70's. Buffalo: Albright – Knox Art Gallery, 1978. 112p., ill. Essay by Linda L. Cathcart. 2 works. Exhib. Dec. 1978 – Jan. 1979. Travelling to other galleries throughout the United States.

1979

Tradition of minimalism. Ridgefield, Conn: Larry Aldrich Museum of Contemporary Art, 1979. Exhib. 1979.

The reductive object: a survey of the minimalist aesthetic in the 1960's. Boston: Institute of Contemporary Art, 1979. Exhib. March – April 1979.

Oeuvres contemporaines des collections nationales: accrochage 3. Paris: Musée national d'art moderne, Centre Georges Pompidou, 1979. Exhib. 1979.

Das Museum of Modern Art New York zu Gast im Kunstmuseum Bern und Museum Ludwig Köln: Amerikanische Kunst des 20. Jahrhunderts. Berne: Kunstmuseum, 1979. 238p., ill. Essays by Waldo Rasmussen et al. German text. Exhib. Feb. – April 1979. Travelling to Cologne.

Wall paintings: Marcia Hafif, Richard Jackson, Lucio Pozzi, Robert Ryman, Robert Yasuda. Chicago: Museum of Contemporary Art, 1979. 21p., ill. 2 works. Exhib. March – May 1979.

73rd American exhibition. Chicago: Art Institute, 1979. 51p., ill. Essay by Anne Rorimer. 3 works. Exhib. June – Aug. 1979.

1980

Kunst seit 1960: Werke aus der Sammlung Crex. Karlsruhe: Kunstverein, 1980. Exhib. 1980.

Minimal and conceptual art from the Panza Collection. Basel: Museum für Gegenwartskunst, 1980. 72p., ill. Introd. by F. Meyer. Exhib. Nov. 1980 – June 1981.

Out of the south. Atlanta: Heath Gallery, 1980. Exhib. 1980.

Printed art: a view of two decades. New York: The Museum of Modern Art, 1980. 144p., ill. Essay by Riva Castleman. 2 works. Exhib. Feb. – April 1980.

Seven decades of twentieth-century art from the Sidney and Harriet Janis Collection of The Museum of Modern Art and the Sidney Janis Gallery Collection. La Jolla: Museum of Contemporary Art, 1980. 111p., ill. Text by Marian Burleigh-Motley. 1 work. Exhib. March – May 1980. Travelling to Santa Barbara.

La Biennale di Venezia: visual arts 80. Venice: Biennale, 1980. 267p., ill. Introd. by Luigi Carluccio. 3 installations. Exhib. June – Sept. 1980.

1981

Minimal art from the Crex Collection. Madrid: Fundacion Juan March, 1981. 58p., ill. Introd. by Phyllis Tuchman. Spanish text. 6 works. Exhib. Jan. – March 1981.

A new spirit in painting. London: Royal Academy of Art, 1981. 262p., ill. Introd. by Christos M. Joachimides. 5 works. Exhib. Jan. – March 1981.

Westkunst: Zeitgenössische Kunst seit 1939. Cologne: Museen der Stadt, 1981. 524p., ill. Introd. by Laszlo Glozer. 2 works. Exhib. May – Aug 1981.

Amerikanische Malerei 1930–1980. Munich: Haus der Kunst, 1981. 303p., ill. Introd. by Tom Armstrong. 1 work. Exhib. Nov. 1981 – Jan. 1982.

1982

Kunst der sechziger Jahre in der Neuen Galerie Kassel: 38 Werkinterpretationen. Kassel: Neue Galerie, Staatliche und Städtische Kunstsammlungen, 1982. 86p., ill. Text by Bernhard Schnackenburg and Wilhelm Bojescul. 2 works. Exhib. 1982.

'60–'80: attitudes/concepts/images. Amsterdam: Stedelijk Museum, 1982. 2 vols., ill. Essay by Edy de Wilde. Includes statement by the artist. Parallel Dutch/English text. 5 works. Exhib. April – July 1982.

Documenta 7. Kassel: Documenta, 1982. 2 vols., ill. Introd. by R.H. Fuchs. Includes a statement by the artist. Parallel German/English text. 8 works. Exhib. June – Sept 1982.

1983

Ars 83. Helsinki: Ateneum Taidemuseo, 1983. 58p., ill. Introd. by Rosa Liksom et al. Exhib. Oct. – Dec 1983.

Abstract painting: 1960–69. Long Island City, N.Y.: P.S. 1, Institute for Art & Urban Resources, 1983. 58p., ill. Text by Carl Andre et al. Exhib. Jan. – March 1983.

1984

Crex Collection. Schaffhausen: Hallen für neue Kunst, 1984. Exhib. 1984.

New international art from the FMC Collection: acquisitions 1977–1984. Zurich: Kunsthaus, 1984. 118p., ill. 2 works. Exhib. May – June 1984.

The Becht Collection: visual art from the Agnes and Frits Becht Collection. Amsterdam: Stedelijk Museum, 1984. 240p., ill. Introd. by R.H. Fuchs. Parallel Dutch/English text. 1 installation. Exhib. March – May 1984.

American art since 1970: painting, sculpture and drawing from the collection of the Whitney Museum of American Art, New York. La Jolla: Museum of Contemporary Art, 1984. 122p., ill. Essay by Richard Marshall. Includes statement by the artist. 1 work. Exhib. March – April 1984. Travelling to Mexico City, Raleigh, Lincoln and Miami.

Experimental Sammlung I: une collection imaginaire. Winterthur: Kunstmuseum, 1984. 48p., ill. Introd. by Bernhard Bürgi. German text. 2 works. Exhib. April – May 1984.

Meditative surface. Chicago: Renaissance Society at the University of Chicago, 1984. 23p., ill. Introd. by Carter Ratcliff. 1 work. Exhib. April – May 1984.

La rime et la raison: les collections Ménil. Paris: Grand Palais, 1984. 419p., ill. Introd. by Walter Hopps. 1 work. Exhib. April – July 1984.

American art: minimal expressionism. London: Tate Gallery, 1984. 6p., ill. Text by Jeremy Lewison. 1 work. Exhib. July – Aug 1984.

From the Collection of Sol LeWitt. Long Beach, Calif.: University Art Museum, 1984. 48p., ill. Essays by John B. Ravenal et al. 1 work. Exhib. Oct. – Nov. 1984. Travelling to Asheville, N.C., Scranton, Pa., New York and Fort Lauderdale.

Le grande parade: hoogtepunten uit de schilderkunst na 1940. Amsterdam: Stedelijk Museum, 1984. 16p., ill. Introd. by D. Pieters. Dutch/English text. Exhib. Dec. 1984 – April 1985.

1985

The maximal implications of the minimal line. Annandale-on-Hudson, New York: Edith C. Blum Art Institute, Bard College, 1985. Exhib. 1985.

Selections from the William J. Hokin Collection. Chicago: Museum of Contemporary Art, 1985. 140p., ill. Exhib. April – June 1985.

New works on paper 3: Robert Morris, Bruce Nauman, James Rosenquist, Robert Ryman, Pat Steir, Robert Wilson. New York: The Museum of Modern Art, 1985. 42p., ill. Introd. by Bernice Rose. 7 works. Exhib. June – Sept. 1985.

From Twombly to Clemente: selected works from a private collection. Basel: Kunsthalle, 1985. 206p., ill. Introd. by Jean-Christophe Ammann. Parallel German – English text. Exhib. July – Sept 1985.

Contrasts of form: geometric abstract art 1910–1980. New York: The Museum of Modern Art, 1985. 288p., ill. Essay by Magdalena Dabrowski. 1 work. Exhib. Oct. 1985 – Jan. 1986.

Carnegie International 1985. Pittsburgh: Museum of Art, Carnegie Institute, 1985. 235p., ill. Introd. by John R. Lane et al. Includes statement by the artist. 4 works. Exhib. Nov. 1985 – Jan. 1986.

Vom Zeichnen: Aspekte der Zeichnung 1960–1985. Frankfurt-Am-Main: Kunstverein, 1985. 487p., ill. Introd. by Peter Weiermair. 2 works. Exhib. Nov. 1985 – Jan. 1986. Travelling to Kassel and Vienna.

1986

An American renaissance: painting and sculpture since 1940. Fort Lauderdale, Fla: Museum of Art, 1986. 269p., ill. Introd. by Sam Hunter et al. 1 work. Exhib. Jan. – March 1986.

Painting and sculpture: acquisitions 1973–1986. New York: Whitney Museum of American Art, 1986. 163p., ill. Introd. by Patterson Sims. 1 work. Exhib. Sept. – Nov. 1986.

Contemporary art from the F.M.C. Collection: acquisitions 1977–1986. Geneva: Musée Rath, 1986. 118p., ill. Introd. by Pierre Arnold et al. Parallel French/ German/English text. 1 work. Exhib. Oct. – Nov. 1986. Previously at Zurich.

Abstract painting of America and Europe: Brice Marden, Gerhard Richter, Helmut Federle, Robert Mangold, Robert Ryman. Klagenfurt: Ritter Verlag, 1988. Text by Rosemarie Schwarzwalder. Parallel German/English text. Published on the occasion of an exhibition 'Abstract paintings by three European and three American artists: Federle, Knoebel, Richter, Mangold, Marden, Ryman'. 8 works. Exhib. Galerie nächst St Stephan, Vienna, Oct. – Dec. 1986.

Individuals: a selected history of contemporary art 1945–1986. Los Angeles: Museum of Contemporary Art, 1986. 371p., ill. Edited by Howard Singerman. 5 works. Exhib. Dec. 1986 – Jan. 1988.

Art minimal II. Bordeaux: Musée d'art contemporain, 1986. 104p., ill. Introd. by Michel Bourel. Includes an essay on the artist by Jeremy Gilbert-Rolfe. 3 works. Exhib. Dec. 1986 – Feb. 1987.

1987

Primary structures. Chicago: Rhona Hoffman Gallery, 1987. Exhib. 1987.

Biennial exhibition. New York: Whitney Museum of American Art, 1987. 213p., ill. Introd. by Richard Armstrong et al. 3 works. Exhib. April – July 1987.

L'époque, la mode, la morale, la passion: aspects de l'art d'aujourd'hui, 1977–1987. Paris: Musée national d'art moderne, Centre Georges Pompidou, 1987. 660p.,

ill. Introd. by Bernard Ceysson et al. 4 works. Exhib. May – Aug. 1987.

Similia/Dissimilia: modes of abstractions in painting, sculpture and photography today. Düsseldorf: Städtische Kunsthalle, 1987. 187p., ill. Edited by Rainer Crone. Parallel German/English text. 1 work. Exhib. Aug. – Sept 1987. Travelling to New York.

1988

The Collection of the Van Abbemuseum of Eindhoven. Nîmes: Musée d'art contemporain, 1988. Exhib. 1988.

La couleur seule: l'expérience du monochrome. Lyon: Musée St Pierre, Art contemporain, 1988. Exhib. 1988.

1988: the world of art today. Milwaukee: Art Museum, 1988. 178p., ill. Essays by Dean Sobel et al. 1 work. Exhib. May – Aug. 1988.

Zeitlos. Berlin: Hamburger Bahnhof, 1988. 232p., ill. Introd. by Harald Szeemann. German/English text. 2 works. Exhib. June – Sept. 1988.

Carnegie International 1988. Pittsburgh: Carnegie Museum of Art, 1988. 201p., ill. Introd. by Vicky A. Clark et al. Includes statement by the artist. 5 works. Exhib. Nov. 1988 – Jan. 1989.

Three decades: the Oliver-Hoffmann Collection. Chicago: Museum of Contemporary Art, 1988. 127p., ill. Essays by Camille Oliver – Hoffman et al. 1 work. Exhib. Dec. 1988 – Feb. 1989.

Twentieth – century painting and sculpture: selections for the tenth anniversary of the East Building. Washington: National Gallery of Art, 1988. 155p., ill. Text by Jeremy Smith. 1 work. Exhib. Dec. 1988 – Dec. 1990.

1989

Bilderstreit: Widerspruch, Einheit und Fragment in der Kunst seit 1960. Cologne: Museum Ludwig, 1989. 544p., ill. Introd. by Siegfried Gohr et al. 4 works. Exhib. April – June 1989.

The private eye: selected works from collections of Friends of the Museum of Fine Arts, Houston. Bulletin of the Museum of Fine Arts, Houston, vol.XIII, no.1, Fall 1989. Houston: Museum of Fine Arts, 1989. 112p., ill. 1 work. Exhib. June – Aug. 1989.

Exploring abstraction. Basel: Galerie Beyeler, 1989. 78p., ill. Introd. by Willy Rotzler. Parallel German/ English text. 1 work. Exhib. July – Sept. 1989.

Art in place: fifteen years of acquisition. New York: Whitney Museum of American Art, 1989. 228p., ill. Introd. by Tom Armstrong, essay by Susan C. Larsen. 1 work. Exhib. July – Oct. 1989.

1990

Minimalist prints. New York: Susan Sheehan Gallery, 1990. 48p., ill. Exhib. 1990.

Minimal art. Osaka: National Museum of Art, 1990. Exhib. 1990.

Minimal and . . . Osaka: Gallery Yamaguchi, 1990. Exhib. 1990.

American masters of the 60's: early and late work. New York: Tony Shafrazi Gallery, 1990. 76p., ill. Introd. by Sam Hunter. 1 work. Exhib. May – June 1990.

Future of the object!: a selection of American art; minimalism and after. Antwerp: Galerie Ronny Van de Velde, 1990. 261p., ill. Introd. by Kenneth Baker. 2 installations. Exhib. May – July 1990.

1991

The picture after the last picture. Vienna: Galerie Metropol, 1991. Exhib. 1991.

After Reinhardt: the ecstasy of denial. New York: Tomoko Liguori Gallery, 1991. Exhib. 1991.

Artists' sketchbooks. New York: Matthew Marks, 1991. 56p., ill. Essay by Guy Davenport. 1 folder of drawings. Exhib. March – May 1991.

'Sélection': oeuvres de la collection. Pully/Lausanne: FAE Musée d'art contemporain, 1991. 175p., ill. Introd. by Charles A. Riley. Parallel French/English text. 1 work. Exhib. June – Oct 1991.

Devil on the stairs: looking back on the eighties. Philadelphia: Institute of Contemporary Art, University of Pennsylvania, 1991. 96p., ill. Introd. by Robert Storr. 1 work. Exhib. Oct. 1991 – Jan. 1992. Travelling to Newport Beach, Calif.

1992

de Opening. Tilburg: De Pont stichting voor hedendaagse kunst, 1992. 152p., ill. Introd. by Hendrik Driessen. Parallel Dutch/English text. 7 works. Exhib. Sept. 1992 – Jan. 1993.

Arte americana 1930–1970. Turin: Lingotto, 1992. 365p., ill. Essays by Furio Colombo et al. 1 work. Exhib. Jan. – March 1992.

Yvon Lambert collectionne. Villeneuve d'Ascq: Musée d'art moderne de la Communauté Urbaine de Lille, 1992. 321p., ill. Interview between Yvon Lambert and Joëlle Pijaudier. French/English text. 8 works. Exhib. Jan. – April 1992. Travelling to Tourcoing, Musée des beaux-arts.

5 Periodical and Newspaper Articles

1965

Barbara Rose. ABC art. Art in America, vol.53, no.5, Oct. – Nov. 1965, pp.57–69.

1967

Lucy R. Lippard. The silent art. Art in America, vol.55, no.1, Jan. – Feb. 1967, pp.58–64.

Joseph Kosuth. In the galleries: Robert Ryman. ArtsMagazine, vol.41, no.8, Summer 1967, pp.63–4. Review of exhibition, Paul Bianchini Gallery, New York, April – May 1967.

Diane Waldman. Reviews and previews: Robert Ryman. Art News, vol.66, no.4, Summer 1967, p.65. Review of exhibition, Paul Bianchini Gallery, New York, 1967.

1968

Lucy R. Lippard and John Chandler. The dematerialization of art. Art International, vol.12, no.2, Feb. 1968, pp.31–6.

The avant-garde: subtle, cerebral, elusive. *Time*, vol.92, no.21, 1968, pp.70–7.

1969

Ivan Karp. Here and now. *ArtsMagazine*, vol.43, no.5, March 1969, p.49. Review of exhibition, Steinberg Art Gallery, St Louis, 1969.

Amy Goldin. Sweet mystery of life. *Art News*, vol.68, no.3, May 1969, pp.46–51.

Hilton Kramer. Robert Ryman. *New York Times*, 3 May 1969, p.31. Review of exhibition, Fischbach Gallery, New York, 1969.

1970

Bernard Borgeaud. Paris. *ArtsMagazine*, vol.44, no.4, Feb. 1970, p.53. Review of exhibition, Galerie Yvon Lambert, Paris, 1970.

Willis Domingo. Ryman at Fischbach. *ArtsMagazine*, vol.44, no.5, March 1970, p.66. Review of exhibition, Fischbach Gallery, New York, 1970.

Grégoire Müller. After the ultimate. *ArtsMagazine*, vol.44, no.5, March 1970, pp.28–31.

Robert Pincus-Witten. Robert Ryman. *Artforum*, vol.8, no.8, April 1970, pp.75–6. Review of exhibition, Fischbach Gallery, New York, 1970.

Mel Bochner. Excerpts from speculation (1967–1970). *Artforum*, vol.8, no.9, May 1970, pp.70–3.

Carter Ratcliff. New York letter. *Art International*, vol.14, no.5, 20 May 1970, p.76. Review of 'Delta Series', Fischbach Gallery, New York, 1970.

Phyllis Tuchman. American art in Germany: the history of a phenomenon. *Artforum*, vol.9, no.3, Nov. 1970, pp.58–69.

Lawrence Alloway. Monumental art at Cincinnati. *ArtsMagazine*, vol.45, no.2, Nov. 1970, pp.32–6. Review of exhibition, Contemporary Arts Center, Cincinnati, 1970.

1971

Carter Ratcliff. New York letter. *Art International*, vol.15, no.2, 20 Feb. 1971, pp.69–70. Review of exhibitions, Fischbach Gallery, Dwan Gallery and Solomon R. Guggenheim Museum, New York, 1971.

Peter Schjeldahl. The ice palace that Robert Ryman built. *New York Times*, 7 Feb. 1971, p.D21. Review of exhibitions, Fischbach Gallery and Dwan Gallery, New York, 1971.

Willis Domingo. Robert Ryman. *ArtsMagazine*, vol.45, no.5, March 1971, pp.17–19.

Carter Ratcliff. Robert Ryman's double positive. *Art News*, vol.70, no.1, March 1971, pp.54–6, 71–2.

James Monte. Looking at the Guggenheim International. *Artforum*, vol.9, no.7, March 1971, pp.28–30.

Kenneth Baker. New York: Robert Ryman. *Artforum*, vol.9, no.8, April 1971, pp.78–9. Review of exhibitions, Fischbach Gallery and Dwan Gallery, New York, 1971.

Phyllis Tuchman. An interview with Robert Ryman. *Artforum*, vol.9, no.9, May 1971, pp.46–53. Reprinted in *Macula* (Paris), no.3/4, 1978, pp.132–141.

Jackson Ward. [Notes on Robert Ryman]. *Art Now: New York*, vol.3, no.3, Sept. 1971, p.3. Includes statement by the artist.

John Noel Chandler. The colours of monochrome: an introduction to the seduction of reduction. *Artscanada*, no.160/161, Oct. – Nov. 1971, pp.18–31.

1972

Guy Brett. Exclusively white. *Times* (London), 12 Dec. 1972, p.38. Review of exhibition, Lisson Gallery, London, 1972.

Marjorie Welish. Ryman at the Guggenheim. *ArtsMagazine*, vol.46, no.6, April 1972, p.63.

Don McDonagh. Robert Ryman: New York art. *Financial Times* (London), 22 May 1972. Review of exhibition, Solomon R. Guggenheim Museum, New York, 1972.

Denise Wolmer. In the galleries: Robert Ryman. *ArtsMagazine*, vol.46, no.7, May 1972, pp.64–5. Review of exhibition, John Weber Gallery, New York, 1972.

Peter Schjeldahl. Robert Ryman. *Art in America*, vol.60, no.3, May – June 1972, pp.33, 35. Review of exhibition, Solomon R. Guggenheim Museum, New York, 1972.

Robert Pincus-Witten. Ryman, Marden, Manzoni: theory, sensibility, mediation. *Artforum*, vol.10, no.10, June 1972, pp.50–3.

Dore Ashton. New York commentary. *Studio International*, vol.183, no.945, June 1972, pp.270–1.

Carter Ratcliff. Once more with feeling. *Art News*, vol.71, no.4, Summer 1972, pp.34–7, 67–9.

Carter Ratcliff. New York letter. *Art International*, vol.16, no.6, Summer 1972, pp.75–6. Review of exhibition, Solomon R. Guggenheim Museum, New York, 1972.

Bruce Boice. The quality problem. *Artforum*, vol.11, no.2, Oct. 1972, pp.68–70.

Richard Channin. The rise of factural autonomy in painting: part 1. *ArtsMagazine*, vol.47, no.2, Nov. 1972, pp.30–7.

Carter Ratcliff. Adversary spaces. *Artforum*, vol.11, no.2, Oct. 1972, pp.40–4. Review of exhibition, Documenta 5, Kassel, 1972.

Richard Cork. Anarchy achieving clarity and perfection: Robert Ryman. *Evening Standard* (London), 14 Dec. 1972. Review of exhibition, Lisson Gallery, London, 1972.

John Russell. Robert Ryman. *Sunday Times* (London), 17 Dec. 1972. Review of exhibition, Lisson Gallery, London, 1972.

1973

Caroline Tisdall. Robert Ryman. *Guardian* (London), 17 Jan. 1973. Review of exhibition, Lisson Gallery, London, 1973.

Marina Vaizey. Robert Ryman. *Financial Times* (London), 10 Jan. 1973. Review of exhibition, Lisson Gallery, London, 1973.

Richard Channin. The rise of factural autonomy: part II. *ArtsMagazine*, vol.47, no.4, Feb. 1973, pp.50–5.

Peter Fuller. Robert Ryman. *Connoisseur*, vol.182, no.732, Feb. 1973, p.151. Review of exhibition, Lisson Gallery, London, 1973.

Anthony Thompson. L'essential et son ambiguité: Robert Ryman. *Chroniques de L'Art Vivant*, no.39, May 1973, pp.8–10.

Germano Celant. Robert Ryman. *Casabella*, vol.37, no.379, July 1973, pp.32–6.

Bruce Boice. Robert Ryman. *Artforum*, vol.12, no.1, Sept. 1973, pp.78–81. Review of exhibition, John Weber Gallery, New York, 1973.

Naomi Spector. Robert Ryman: Suite of Seven Aquatints, 1972; Nine Unique Aquatints, 1972. *Art & Project Bulletin*, no.70, Sept. 1973, whole issue.

Paul Stittleman. New York galleries: Robert Ryman. *ArtsMagazine*, vol.48, no.2, Nov. 1973, p.59. Review of exhibition, John Weber Gallery, New York, 1973.

Lucio Pozzi. Colore e superficie [colour and surface]. *Data* (Italy), vol.3, no.10, Winter 1973, pp.86–91. Parallel Italian/English text.

1974

Mönchengladbach: 'Sammlung Panza'. *Magazin Kunst*, no.55/56, part 2, 1974, p.28.

Rini Dippel. Ryman. *Museumjournaal* (Amsterdam), vol.19, no.1, Feb. 1974, pp.7–11.

Barbara Reise. Robert Ryman: Unfinished I (Materials). *Studio International*, vol.187, no.963, Feb. 1974, pp.76–80.

Barbara Reise. Robert Ryman: Unfinished II (Procedures). *Studio International*, vol.187, no.964, March 1974, pp.122–8.

Barbara Reise. Robert Ryman: Senza Titolo III (Posizione). *Data*, vol.4, no.11, Spring 1974, pp.32–9.

Lucio Pozzi. Adesso la pittura dipinge la pittura. *Bolaffiarte* (Turin), vol.5, no.40, May 1974, pp.36–43.

Barbara R. Reise. Robert Ryman at the Stedelijk Museum. *Art in America*, vol.62, no.4, July – Aug. 1974, p.90. Review of exhibition, Stedelijk Museum, Amsterdam, 1974.

Marian Verstraeten. Robert Ryman: le geste. *O, Revue d'Art Contemporain* (Paris), Nov. 1974, pp.10–11. Reprinted in *Macula* (Paris), no.3/4, 1978, pp.141–5.

Jeremy Gilbert-Rolfe. Robert Ryman. *Artforum*, vol.13, no.4, Dec. 1974, pp.69–71. Review of exhibition, John Weber Gallery, New York, 1974.

Ellen Lubell. Robert Ryman. *ArtsMagazine*, vol.49, no.4, Dec. 1974, p.12. Review of exhibition, John Weber Gallery, New York, 1974.

1975

Louis Cane and Catherine Millet. Robert Ryman: peinture active/peinture 'a tempera'. *Art Press*, no.17, March – April 1975, pp.4–8.

Bruce Kurtz. Robert Ryman at Weber. *Art in America*, vol.63, no.2, March – April 1975, p.91. Review of exhibition, Weber Gallery, New York, 1975.

Amy Goldin. Patterns, grids and paintings. *Artforum*, vol.14, no.1, Sept. 1975, pp.50–4.

Judy Goodman. Post-minimal artists. *ArtsMagazine*, vol.50, no.1, Sept. 1975, p.30. Review of exhibition, Douglas Drake Gallery, Kansas City, 1975.

Max Kozloff. Painting and anti-painting: a family quarrel. *Artforum*, vol.14, no.1, Sept. 1975, pp.37–43.

Jeremy Gilbert-Rolfe. Appreciating Ryman. *ArtsMagazine*, vol.50, no.4, Dec. 1975, pp.70–3.

1976

Barbara Zucker. New York reviews: Robert Ryman. *Art News*, vol.75, no.1, Jan. 1976, p.121. Review of exhibition, John Weber Gallery, New York, 1976.

Peter Frank. Visual, conceptual and poetic sequences. *Art News*, vol.75, no.3, March 1976, pp.48–50. Review of exhibition, The Museum of Modern Art, New York, 1976.

Janet Kutner. The visceral aesthetic of a new decade's art. *ArtsMagazine*, vol.51, no.4, Dec. 1976, pp.100–3. Review of exhibition, Institute of Art, Detroit, 1976.

1977

Naomi Spector. Robert Ryman: 'Six Aquatints'. *Print Collector's Newsletter*, vol.8, no.1, March – April 1977, pp.10–12.

White in art is white? *Print Collector's Newsletter*, vol.8, no.1, March – April 1977, pp.1–4.

Robert Pincus-Witten. Entries: the white triangle: Robert Ryman and Benni Efrat. *ArtsMagazine*, vol.51, no.8, April 1977, pp.93–5.
Marina Vaizey. Robert Ryman. *Arts Review*, vol.29, no.20, 30 Sept. 1977. Review of exhibition, Whitechapel Art Gallery, London, 1977.

John McEwen. Sensations. *Spectator* (London), 15 Oct. 1977, pp.28–9. Review of exhibition, Whitechapel Art Gallery, London, 1977.

William Feaver. Pure white and flash taste. *Observer* (London), 9 Oct. 1977, p.27. Review of exhibition, Whitechapel Art Gallery, London, 1977.

Grace Glueck. The 20th century artists most admired by other artists. *Art News*, vol.76, no.9, Nov. 1977, pp.78–103.

Paul Overy. Addiction to white. *Times* (London), 18 Oct. 1977, p.14. Review of exhibition, Whitechapel Art Gallery, London, 1977.

Adrian Searle. Robert Ryman at the Whitechapel. *Artscribe*, no.9, Nov. 1977, p.42. Review of exhibition, Whitechapel Art Gallery, London, 1977.

William Feaver. Back to the woods. *Art News*, vol.76, no.10, Dec. 1977, p.126. Review of exhibition, Whitechapel Art Gallery, London, 1977.

1978

Naomi Spector. Robert Ryman: une chronologie. *Macula* (Paris), no.3/4, Sept. 1978, pp.115–31.

Naomi Spector. Six aquatintes de Robert Ryman. *Macula* (Paris), no.3/4, Sept. 1978, pp.145–9.

Barbara Reise. Procédures. *Macula* (Paris), no.3/4, Sept. 1978, pp.150–7.

Stephen Rosenthal. Notes sur le procés pictural. *Macula* (Paris), no.3/4, Sept. 1978, pp.158–62.

Christian Bonnefoi. A propos de la destruction de l'entité de surface. *Macula* (Paris), no.3/4, Sept. 1978, pp.163–6.

Jean Clay. La peinture en charpie. *Macula* (Paris), no.3/4, Sept. 1978, pp.167–85.

Dossier Robert Ryman. *Macula* (Paris), no.3/4, Sept. 1978, pp.113–85.

1979

Robert Ryman. *Art World*, vol.3, no.5, 18 Jan./15 Feb. 1979, p.8. Review of exhibition, Sidney Janis Gallery, New York, 1979.

Joseph Masheck. Iconicity. *Artforum*, vol.17, no.5, Jan. 1979, pp.30–41.

Ross Neher. Mentalism versus painting. *Artforum*, vol.17, no.6, Feb. 1979, pp.40–7.

Eric Gibson. Robert Ryman. *Art International*, vol.22, no.10, March 1979, p.47. Review of exhibition, Sidney Janis Gallery, New York, 1979.

Jeff Perrone. Robert Ryman. *Artforum*, vol.17, no.7, March 1979, pp.61–2. Review of exhibition, Sidney Janis Gallery, New York, 1979.

Robert Ryman. *Flash Art*, no.89, April 1979, p.25. Review of exhibition, Sidney Janis Gallery, New York, 1979.

Donald B. Kuspit. Ryman, Golub: two painters, two positions. *Art in America*, vol.67, no.4, July – Aug. 1979, pp.88–90.

Marcia Hafif. Robert Ryman: another view. *Art in America*, vol.67, no.5, Sept. 1979, pp.88–9. Response to Donald Kuspit's essay.

1980

G. Chapman. Painterly painting, into the seventies: Robert Motherwell, Robert Ryman and Jake Berthot. *Rutgers Art Review* (USA), vol.1, Jan. 1980, pp.49–66.

Bernard Marcelis. Robert Ryman: an analysis from Europe. *Domus*, no.603, Feb. 1980, pp.52–3.

Oystein Hjorth. Andre, Dibbets, Long, Ryman. *Louisiana Revy* (Humlebaek), no.2, March 1980, pp.14–18.

Thierry de Duve. Ryman irreproductible: nonreproducible Ryman. *Parachute*, no.20, Fall 1980, pp.18–27.

Hermann Kern. Robert Ryman: Kunstraum München E.V. *Neue Kunst in München*, no.4, Nov./Dec. 1980, pp.9–10.

1981

Marcia Hafif. Getting on with painting. *Art in America*, vol.69, no.4, April 1981, pp.132–9.

Carter Ratcliff. Mostly monochrome. *Art in America*, vol.69, no.4, April 1981, pp.111–31.

Vivian Raynor. Robert Ryman. *New York Times*, 29 May 1981, p.C22. Review of exhibition, Sidney Janis Gallery, New York, 1981.

Yve-Alain Bois. Ryman's tact. *October*, no.19, Winter 1981, pp.93–104.

1982

Gerard-Georges Lemaire. Robert Ryman. *Artforum*, vol.20, no.8, April 1982, p.88. Review of exhibition, Centre Georges Pompidou, Paris, 1982.

Peter Winter. Robert Ryman. *Kunstwerk*, vol.35, no.2, April 1982, pp.59–60. Review of exhibition, Städtische Kunsthalle, Düsseldorf, 1982.

Donald B. Kuspit. Out of the south: eight southern-born artists. *Art Papers*, vol.6, no.6, Nov. – Dec. 1982. pp.2–5. Text first appeared as catalogue essay for exhibition, Heath Gallery, Atlanta, 1982.

1983

Roberta Smith. Reductivism redux. *Village Voice*, vol.28, no.8, 22 Feb. 1983, p.89. Review of exhibition, P.S. 1, New York, 1983.

Roberta Smith. Expression without the ism. *Village Voice*, vol.28, no.13, 29 March 1983, p.81. Review of exhibition, Bonnier Gallery, New York, 1983.

Tiffany Bell. Responses to Neo-Expressionism. *Flash Art*, no.112, May 1983, pp.40–6.

Maurice Poirier and Jane Necol. The 60's in abstract: 13 statements and an essay. *Art in America*, vol.71, no.9, Oct. 1983, pp.122–37. Includes statement by the artist.

Suzanne Muchnic. Robert Ryman. *Los Angeles Times*, 25 Nov. 1983, pt.6, p.2. Review of exhibition, Daniel Weinberg Gallery, Los Angeles, 1983.

1984

Gerrit Henry. New York reviews: Robert Ryman. *Art News*, no.4, April 1984, pp.162, 167. Review of exhibition, Maeght Lelong Gallery, New York, 1984.

1985

Alan G. Artner. The paintings of Robert Ryman have broken new ground. *Chicago Tribune*, 24 May 1985, p.47. Review of exhibition, Rhona Hoffman Gallery, Chicago, 1985.

Christopher Lyon. Ryman retains subtle style. *Chicago Sun-Times*, 10 May 1985. Review of exhibition, Rhona Hoffman Gallery, Chicago, 1985.

Vivian Raynor. Art: contemporary drawings at the Modern. *New York Times*, 5 July 1985, p.C21. Review of exhibition, The Museum of Modern Art, New York, 1985.

Kay Larson. Privileged access: 'new works on paper 3'. *New York Magazine*, 22 July 1985, pp.61–2. Review of exhibition, The Museum of Modern Art, New York, 1985.

Arthur C. Danto. Works on paper. *Nation*, vol.241, no.4, 17–24 Aug. 1985, pp.122–5. Review of exhibition, The Museum of Modern Art, New York, 1985.

Charlotte Moser. The nation: Robert Ryman. *Art News*, vol.84, no.7, Sept. 1985, p.120. Review of exhibition, Rhona Hoffman Gallery, Chicago, 1985.

Ida Panicelli. Robert Ryman. *Artforum*, vol.24, no.2, Oct. 1985, pp.128–9. Review of exhibition, Rhona Hoffman Gallery, Chicago, 1985.

Amy Baker Sandback. Art on location. *Artforum*, vol.24, no.3, Nov. 1985, pp.4–5. Includes statement by the artist.

Waldemar Januszczak. 'Bricklaying with Andre'. *Guardian* (London), 12 Dec. 1985, p.12. Article on the atmospheric strength of minimal exhibitions.

1986

Michael Brenson. Robert Ryman. *New York Times*, 31 Jan. 1986, p.c26. Review of exhibition, Leo Castelli Gallery, New York, 1986.

John Russell. Art. *New York Times*, 3 Feb. 1986. Review of exhibition, Maeght Lelong Gallery, New York, 1986.

Kay Larson. Gasping for air. *New York Magazine*, 3 Feb. 1986, p.76. Review of exhibition, Maeght Lelong Gallery, New York, 1986.

Ellen Handy. Robert Ryman. *ArtsMagazine*, vol.60, no.7, March 1986, p.143. Review of exhibition, Leo Castelli Gallery, New York, 1986.

Robert Storr. Robert Ryman: making distinctions. *Art in America*, vol.74, no.6, June 1986, pp.92–7.

Nancy Grimes. White magic. *Art News*, vol.85, no.6, Summer 1986, pp.86–92. Includes statement by the artist.

1988

Roman Hollenstein. Der Meister der weissen Bilder: zum Werk des amerikanischen Malers Robert Ryman. *Neue Zuercher Zeitung* (Zurich), no.6, 9/10 Jan. 1988, p.67.

Kenneth Baker. Ryman opens 'New York' series: successor to Museum's 'Biennial'. *San Francisco Chronicle*, 29 Jan. 1988, p.E3. Review of exhibition, Museum of Modern Art, San Francisco, 1988.

Bill Berkson. Robert Ryman. *Artforum*, vol.26, no.9, May 1988, pp.154–5.

Jeremy Gilbert-Rolfe. Nonrepresentation in 1988: meaning-production beyond the scope of the pious. *ArtsMagazine*, vol.62, no.9, May 1988, pp.30–9.

Roberta Smith. Works by Robert Ryman in redone Dia Galleries. *New York Times*, 7 Oct. 1988, p.c29. Review of exhibition, Dia Art Foundation, New York, 1988.

Kay Larson. Review. *New York Magazine*, 24 Oct. 1988. Review of exhibition, Dia Art Foundation, New York, 1988.

Carter Ratcliff. Dandyism and abstraction in a universe defined by Newton. *Artforum*, vol.27, no.4, Dec. 1988, pp.82–9.

1989

Review of museums and dealers catalogues: Dia Art Foundation. *Print Collector's Newsletter*, vol.19, no.6, Jan. – Feb.1989, p.232. Review of exhibition catalogue, Dia Art Foundation, New York, 1989.

Meyer Raphael Rubinstein and Daniel Wiener. Robert Ryman. *Flash Art*, no.144, Jan. – Feb. 1989, p.121. Review of exhibition, Dia Art Foundation, New York, 1989.

David Carrier. New York: Robert Ryman at DIA. *Burlington Magazine*, vol.81, no.1030, Jan. 1989, pp.66–7. Review of exhibition, Dia Art Foundation, New York, 1989.

Peter Schjeldahl. White-out. *7 Days*, 15 Feb. 1989, pp.55–6. Review of exhibition, Dia Art Foundation, New York, 1989.

Donald B. Kuspit. Red desert and Arctic dreams. *Art in America*, vol.77, no.3, March 1989, pp.120–5.

Pat McCoy. Robert Ryman. *ArtsMagazine*, vol.63, no.8, April 1989, p.77. Review of exhibition, Dia Art Foundation, New York, 1989.

Grace Glueck. A leading art collector is selling and the market wonders why. *New York Times*, 23 Nov. 1989, Arts section, pp.c15, c26. Article on Charles Saatchi.

Paul Gardner. Mesmerized by minimalism: the modest Vogel's major collection. *Contemporanea*, vol.11, no.9, Dec. 1989, pp.56–61.

Roman Hollenstein. Die magisch weissen Bilder von Robert Ryman. *Du*, no.12, Dec. 1989, pp.24–33.

1990

Jean-Pierre Criqui. Signé Ryman. *Artstudio*, no.16, Spring 1990, pp.78–89.

Roberta Smith. Robert Ryman. *New York Times*, 4 May, 1990, p.c30. Review of exhibition, Pace Gallery, New York, 1990.

Pace Gallery: Robert Ryman. *Print Collector's Newsletter*, vol.21, no.3, July – Aug. 1990, p.114. Review of exhibition, Pace Gallery, New York, 1990.

Robert Hagen. Robert Ryman. *Artforum*, vol.29, no.1, Sept. 1990, pp.154–5. Review of exhibition, Pace Gallery, New York, 1990.

Terry Myers. New York reviews: Robert Ryman. *ArtsMagazine*, vol.65, no.1, Sept. 1990, p.92. Review of exhibition, Pace Gallery, New York, 1990.

David Carrier. New York: extending the language of abstraction. *Art International*, no.12, Autumn 1990, p.60. Review of exhibition, Pace Gallery, New York, 1990.

Alain Spira. Claude Berri: comment on devient le premier producteur français. *Paris Match*, no.2167, 6 Dec. 1990, pp.3–9.

1991

John Russell. Where little nothings turn into big somethings. *New York Times*, 7 April 1991, pp.H33, H35. Review of exhibition on artists' sketchbooks, Matthew Marks Gallery, New York, 1991.

Dan Cameron. Robert Ryman: ode to a clean slate. *Flash Art*, vol.24, no.159, Summer 1991, pp.90–3.

Catherine Millet. Robert Ryman: une rétrospective sans chronologie. *Art Press*, no.162, Oct. 1991, pp.43–5.

1992

Matthew Collings. Art reviews: Robert Ryman. *City Limits* (London), 30 Jan. – 6 Feb. 1992, p.18. Review of exhibition, Espace d'art contemporain, Paris, 1992.

Jean-Pierre Criqui. Robert Ryman. *Artforum*, vol.30, no.8, April 1992, p.108. Review of exhibition, Espace d'art contemporain, Paris, 1991.

Alice Rawsthorn. Paris galleries: bounty in contemporary spaces. *Financial Times* (London), 8 May 1992, p.15. Review of exhibition, Espace d'art contemporain, Paris, 1992.

Thomas McEvilly. Absence made visible. *Artforum*, vol.30, no.10, Summer 1992, pp.92–6.

6 Books and Sections in Books

Christie, Manson & Woods International Inc. *Minimal and conceptual art from the collection of the Gilman Paper Company*. New York: Christie, Manson & Woods, Int., 1987, p.52, Item 44, 1 installation. Auction: 5 May 1987.

Colpitt, Frances. *Minimal art: the critical perspective*. London: U.M.I. Research Press, 1990 (Studies in the Fine Arts: Criticism, 34).

Contemporary artists, Colin Naylor (ed.). 3rd ed. London: St James Press, 1989, p.819.

Diamonstein, Barbaralee. *Inside New York's art world*. New York: Rizzoli, 1979, pp.330–40. Contains interview with Robert Ryman and includes a quote on the artist by Chuck Close.

Frémon, Jean. *Robert Ryman: le paradoxe absolu*. Caen: L'Échoppe, 1991.

Illustrated catalogue of acquisitions 1982–1984. London: Tate Gallery, 1986. 1 work: Ledger, 1982, p.317.

Schjeldahl, Peter. *Art of our time: the Saatchi Collection*. [Vol.] 1. London: Lund Humphries, 1984. 159p., ill. 9 works. Includes an essay on Minimalism.

Schwarzwälder, Rosemarie. *Abstract painting of America and Europe: Brice Marden, Gerhard Richter, Helmut Federle, Robert Mangold, Robert Ryman*. Klagenfurt: Ritter Verlag, 1988. 8 works. Published on the occasion of an exhibition 'Abstract paintings by three European and three American artists: Federle, Knoebel, Richter, Mangold, Marden, Ryman', Galerie nächst St Stephan, Vienna, Oct. – Dec. 1986. Parallel German/English text.

Glossary of Technical Terms

ACRYLIC: Acrylic resins are a group of clear, thermoplastic polymers and co-polymers made from the polymerisation of acrylic and methacrylic acid esters. Acrylic polymer resins dispersed in water form the binder for many artists' acrylic paints such as the Lascaux acrylic used by Ryman. When dry, these paints form flexible, water-resistant and non-yellowing films. Ryman has also used acrylic in sheet form. See: Acrylivin; Lumasite; Plexiglas.

ACRYLIVIN: Brand name for a flexible, tough plastic sheet used as a building material.

ANODIZED ALUMINIUM: Aluminium alloy treated by an electrolytic process to produce a protective oxide coating.

BAKED ENAMEL: An enamel paint which is cured by heating after application.

BLACK OXIDE STEEL PLATES/BOLTS: Ryman selects steel coated with black oxide for its appearance rather than its anti-corrosion properties.

BLUE CHALK: A mixture of chalk, plaster of Paris and blue pigment. Ryman applies it using a 'snap line', a stretched string coated with chalk used by builders to mark a long, straight line.

BRISTOL BOARD: A rigid paper board manufactured for artwork. It may be a homogeneous board or a wood pulp core faced with a good quality paper.

CASEIN: A protein derived from skimmed milk used as a binder for artists' paints and as an adhesive.

CHARCOAL: Charcoal for artists' use is usually made from carbonised willow or vine sticks.

COLOURED PENCILS: The 'lead' in coloured drawing pencils is composed of compressed pigments and clays with various binders.

CORRUGATED BOARD: A corrugated sheet of paper faced on one or both sides with a flat, strong paper such as kraft paper. It is extensively used in carton making.

COTTON DUCK: A plain weave, cotton canvas extensively adopted by artists as a painting support during the second half of the twentieth century.

ELMER'S GLUE: A white woodworking glue based on a polyvinyl acetate (PVA) emulsion.

ELVACITE: Brand name for a range of acrylic polymers. The grade used by Ryman can be mixed with oil paint to improve its stability when applied to a plastic support.

ENAMELAC: Brand name for a pigmented, shellac lacquer.

FEATHERBOARD: Brand name for a lightweight board made of a foam core faced with paper.

FIBREPLATE: Brand name for polyester-coated fibreglass sheeting. Developed to line a mural at the Metropolitan Museum of Art, New York, it is strong, pliable and manufactured in large sheets.

FIBREGLASS MESH: Strands of glass formed into a mesh commonly used as the basis for making glass-reinforced plastics.

GATOR BOARD: Brand name for a range of lightweight, rigid boards made of an expanded polystyrene foam core faced with paper.

GESSO: Traditional gessos are absorbent painting and gilding grounds made from white pigments such as chalk or plaster of Paris bound with an animal glue. In his 1961 paintings, Ryman uses a traditional gesso probably of the ready prepared 'cold water gesso' type.

GOUACHE: Opaque watercolour paint bound with gums.

GRAPHITE PENCILS: In most modern drawing pencils the 'lead' is composed of compressed and extruded mixtures of graphite, a form of carbon, and clays which are treated with oils and waxes to produce a range of hardnesses.

GRIPZ: Brand name for a pigmented shellac sealer similar to Enamelac.

HONEYCOMB FIBREGLASS PANEL: Rigid panels made from a core of aluminium honeycomb faced on both sides with glass reinforced plastic sheeting and edged with inset redwood battens.

HOUSEHOLD ENAMELS: Trade paints of high gloss manufactured for domestic use. They are made from a wide range of air-drying media including oils, synthetic resins and alkyds.

IMPERVO ENAMEL: Brand name for a high quality, enamel paint.

INDIA INK: A traditional writing and drawing ink made from lamp black, a fine carbon black, bound with animal glue and scented. Modern waterproof varieties contain resins to render them insoluble in water on drying.

INTERFERENCE COLOURS: These paints contain pigments made from mica platelets coated with many thin layers of titanium dioxide. Different angles of light striking them produce a changing and irridescent appearance.

JUTE: A plant fibre used for making robust, coarse woven fabrics such as sacking.

KRAFT PAPER: A strong packing paper, originally made from old ropes; in the twentieth century it is manufactured from sulphate wood pulp, often with a glazed finish.

LASCAUX ACRYLIC: Brand name for a range of artists' acrylic paints made in Switzerland.

LINEN: Linen yarn is made from the fibres of the flax plant and woven into linen canvas, which has been the most common support for oil painting for several centuries.

LUMASITE: Brand name for a tough plastic similar to Acrylivin.

MASKING TAPE: A cream-coloured, pressure-sensitive tape. It is not durable. Ryman has used masking tape on a number of his 'Surface Veil' paintings of 1970–2 and in framing a number of his early works.

MYLAR: Brand name for colourless plastic film made from polyethylene terephthalate.

NEWSPRINT: Paper made from variously treated mechanical wood pulps.

OIL PAINTS: traditional artists' oil paints are based on a binding medium of vegetable drying oil such as linseed, poppy, walnut or safflower oils.

OXIDIZED COPPER: Copper will oxidize naturally to a green or brown colour, or oxidation can be chemically induced, which usually produces a darker colour.

PASTELS: Artists' pastels are made from pigment mixed with a filler and the minimum of binder, such as gum or starch. They are produced in a range of hardnesses. Oil pastels have waxes and oils as binders.

PLEXIGLAS: Brand name for rigid acrylic (polymethyl methacrylate) sheeting, commonly used for glazing.

POLYESTER FABRIC: A wide range of woven fabrics are available made from fibres formed from polymerized polyethylene terephthalate.

POLYMER: Polymer is a term for any organic molecule made by combining two to thousands of identical monomers. Co-polymers are formed by combining two or more types of monomer units to form the larger molecule. Synthetic polymer resins such as polyvinyl acetate and acrylics form the basis for many modern adhesives, paint binders and painting media used by artists.

SILVERPOINT: A metal point of silver which is used for drawing onto a slightly abrasive ground.

TRACING PAPER: Strong, thin papers treated with gums, resins and oils to render them transparent, with suitable surfaces to accept pencil or ink.

VARATHANE: Brand name for an air-drying polyurethane coating material.

VINYL: Vinyl resins are a group of clear, Thermoplastic synthetic polymers used to produce liquids, flexible films and hard solids.

VINYL ACETATE/POLYVINYL ACETATE: These are used in the formulation of adhesives, binders for paints and varnishes. Polyvinyl acetate emulsion, which can be thinned with water, but dries to a water-resistant film, is used in the manufacture of some artists' polymer paints and 'white' adhesives of the type used by Ryman to size canvas.

WAX PAPER: Wax impregnated paper is commonly used in the packaging industry. Ryman uses Cut-Rite brand wax paper for the soft reflective quality of its surface and translucency.

Lenders

All works belong to the artist except the following:

Thomas Amman Fine Art, Zurich 37, 62
Bonnefantenmuseum Maastricht, The Netherlands 76
Constance R. Caplan, Baltimore, Maryland 79
Crex Collection, Hallen für neue Kunst, Schaffhausen 16, 40, 54, 55, 56, 71, 74, 80, 81
Musée d'Art Contemporain, Pully/ Lausanne 69
Museum für Moderne Kunst, Frankfurt-am-Main 39
Barbara Gladstone 75
Ralph and Helyn Goldenberg 73
The Greenwich Collection Ltd 36
Solomon R. Guggenheim Museum, New York 43, 49, 50, 51

Staatliche Museen, Neue Galerie, Kassel (on loan from a private collection) 41
Galerie Lelong 66
Lucy R. Lippard 14
Linda and Harry Macklowe 78
Franz Meyer 57
The Museum of Modern Art, New York 38, 46, 58
Private collections 26, 27, 32, 44, 45, 47, 61, 64, 68, 70, 72, 77
John E. Ryman 1
Hannelore B. Schulhof 65
Emily and Jerry Spiegel 48, 53
Stedelijk Museum, Amsterdam 15, 42, 52, 59, 67

The following works were not shown in London:
Nos. 31, 46, 49, 58, 65, 77

Photographic Credits

Bill Jacobson 1, 2, 7, 8, 9, 11, 14, 17, 24, 27, 31, 33, 34, 35, 38, 46, 47, 48, 53, 58, 60, 65, 68, 70, 75, 77, 78, 81. All details and 1992 studio shots.
Jean-Pierre Kuhn (for the Hallen für neue Kunst, Schaffhausen) 6, 10, 13, 18, 19, 20, 21, 22, 23, 25, 28, 29, 32, 74, 79, 80
Paolo Mussat (for the Hallen für neue Kunst, Schaffhausen) 3, 4, 5, 12, 16, 30, 36, 40, 45, 54, 55, 56, 61, 71, 72
Stedelijk Museum, Amsterdam 15, 42, 52, 59, 63, 67
David Heald (Copyright: Guggenheim Museum) 43, 49, 50, 51

Thomas Ammann Fine Art, Zurich 36, 37, 62
Alex Saunderson 26
Deimel & Wittmar 39
Staatliche Museen, Neue Galerie, Kassel 41
Lisson Gallery 44
Franz Meyer, Switzerland 57
Tom Haartsen 64
Galerie Lelong 66
Musée d'Art Contemporain, Pully/ Lausanne 69
Michael Tropea 73
Bonnefantenmuseum Maastricht 76
The Pace Gallery All installation views in the Chronology